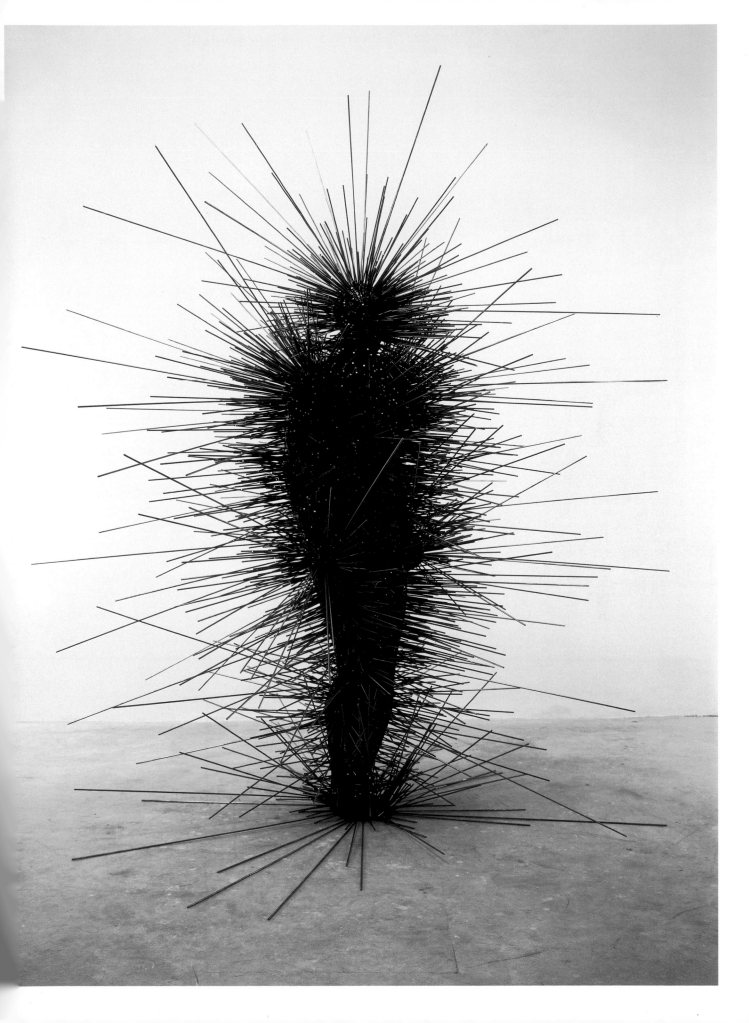

MODERN ARTISTS

First published 2010 by order of the Tate Trustees
by Tate Publishing, a division of Tate Enterprises Ltd,
Millbank, London SW1P 4RG
www.tate.org.uk/publishing
© Tate 2010

A catalogue record for this book is available from the
British Library
ISBN 978 1 85437 797 5
Distributed in the United States and Canada by
Harry N. Abrams, Inc., New York
Library of Congress Control Number: 2009931141
Designed by Mr & Mrs Smith
Printed and bound in Singapore
by C S Graphics

Mixed Sources
Product group from well-managed
forests and other controlled sources
www.fsc.org Cert no. SGS-COC-006248
© 1996 Forest Stewardship Council
FSC

Front cover (detail) and previous page:
CAPACITOR 2001
Mild steel tubes and rods
Tubes: 12mm (outer dim.), 5.5mm (inner dim.)
Rods: 5mm x various lengths
Bodyform: 190 x48 x35
Fully extended work: 271 x 242 x 229

Overleaf: LEARNING TO THINK 1991
Lead, fibreglass, air
5 bodyforms: each 173 x 56 x 31
Installation view, Old City Jail, Charleston, South Carolina

Measurements of artworks are given in centimetres,
height before width before depth, unless stated otherwise.

Author's acknowledgements
Thanks first and foremost to Antony Gormley for his
wholehearted support and his patience, and for good
conversations over long hours in his studio. Thanks also
to all those at the studio, particularly Lisa Maddigan,
Shela Sheikh and Isabel de Vasconcellos; to Lewis Biggs,
for wise counsel and much forbearance; and at Tate
Publishing to Mary Richards, Alice Chasey , Mary Scott,
Vicky Fox and Roanne Marner; and to White Cube,
for access to archives. Closer to home, my gratitude to
Alan Caiger-Smith (for example), to Patrick and Robin
Caiger-Smith (for refuge); and to Frances Morris, as ever,
for expert guidance, and for time lost.

Artist's acknowledgements
I would like to thank everyone who has made this
experimental life of making, feeling and thinking possible.
This book and all the works and projects it describes
would not have been possible without help. That support
has come from near and far, from the wonderful team of
makers here at the studio, and from family, friends, teachers,
curators, writers, organisers, funders and collectors. I am
more than grateful, recognising that whatever effect the
works may have had on others (including the author of this
book), is the result of many co-ordinated efforts.

ANTONY GORMLEY

Martin Caiger-Smith

Tate Publishing

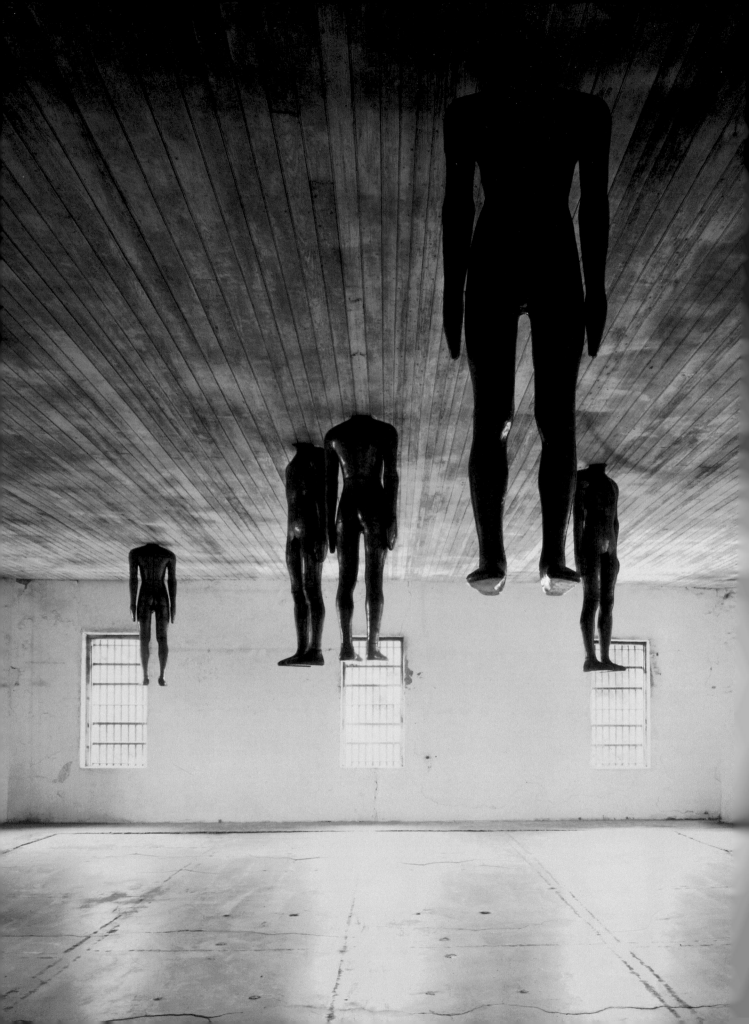

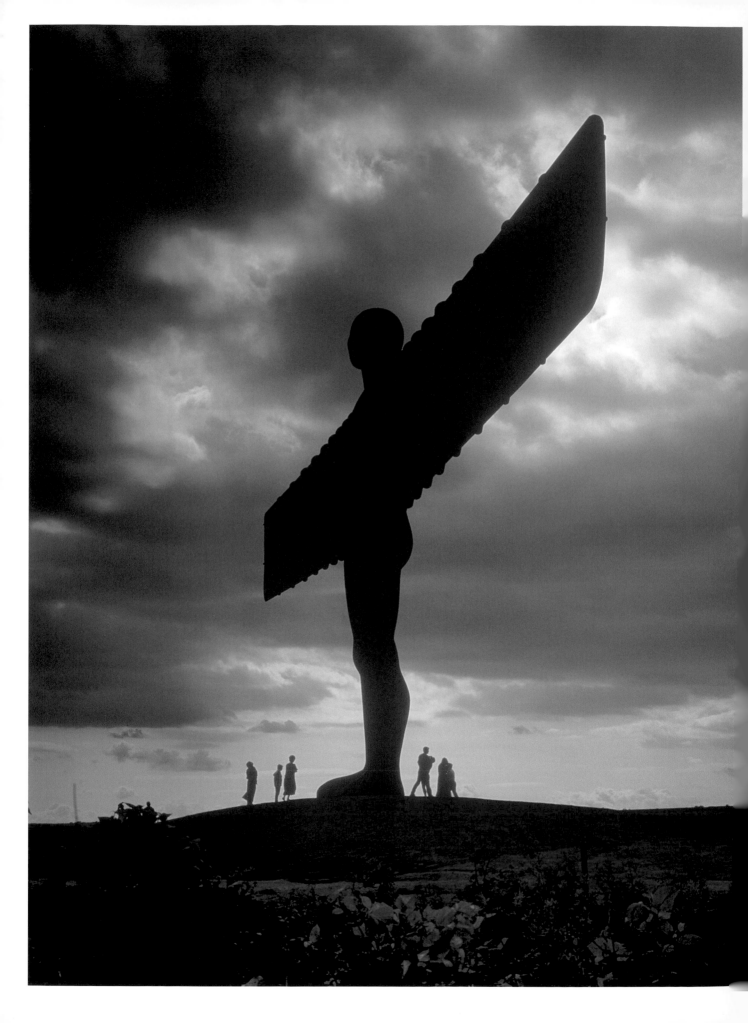

ANGEL OF THE NORTH 1995–8 [1]
Steel
22 x 54 x 2.2 m
Permanent installation
Commissioned by Gateshead
Metropolitan Borough Council

INTRODUCTION

Antony Gormley's sculptural presence is something of a phenomenon in the world. His work is, in its very nature, expansive and inclusive. It seeks the busiest stage, the broadest audience, the longest view. You can come across it in a contemporary art gallery, the British Museum, a cathedral's crypt, a civic square; on a contemporary dance stage, a Lancashire beach, in a Norwegian fjord or the salt-pan wastes of Western Australia. His sculpture can invoke, or call to mind, the earliest works of man or the latest theories of particle physics. It can result from a rapid, private act or a prolonged process of engagement with the public. Gormley's materials range from the pebbles of the seashore and the mud of the desert to the metals of the forge and the steel mill; his means vary from advanced computer imaging to the press of a hand in soft clay. While much of the artist's work is determinedly human in scale, he is most widely known for his large projects. Gormley's *Angel of the North* 1998 has – like Nelson's Column, the London Eye, even the Statue of Liberty – become a recognised benchmark for public projects and built structures, both for its physical size and for the scale of its endeavour. Like no other recent artwork it is recognised in the public imagination; it has been taken to brand the North East, and even, on occasion, Britain as a whole.

Gormley's works are made to take their place in the world and in time, to speak of hope and resistance, of collective memory and experience. For him, sculpture is, in essence, a stone stood on end, still and silent, the mark of human presence and action, 'a sort of witness in time'. His position as a practising artist for over forty years at the turn of the millennium, with his embrace of the body as the principal carrier of meaning, has at times seemed a lonely one, at a tangent to the main currents of contemporary art, but his art has always remained responsive and aware of its context and purpose, seeking to engage, as audience and often as co-creator, the world at large. This book looks beyond the commonly-held view of Gormley as a maker of large-scale public sculptures. It traces the development of Gormley's art as a series of distinct themes and ideas, sustained over time and yet inflected by the circumstance and discoveries of each new work – ideas that relate and interlace, come together and continue to form a body of work. In Gormley's own words: 'The project moves forward by making, and looking at what has been made. Things demand to be made, but that demand comes from things that have already been made. At times it is difficult to know who is the maker, and who the made...'[1]

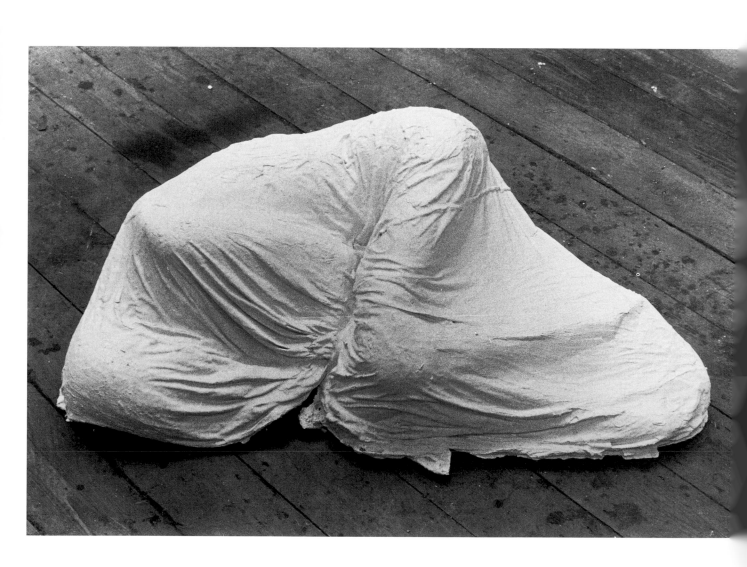

1

SEEDS

'The work is a point between origin and becoming. Like a seed, between death and the new life there is a point of stasis and silence, a time for reflection. Sculpture can use that time.'[2]

Beginnings often appear to us in black and white. Antony Gormley's *Sleeping Place* (fig.2), an early sculpture of 1973, no longer exists: it is known to us only as a photograph, of an apparently abstracted form (made of plaster and linen) lying on the floor, which reveals itself as a recumbent body hidden beneath draped cloth. A similar work of the same year – also destroyed – bore the title *Figure*. They were, according to Gormley, a 'lasting image of India', and a response to the most commonplace scene he encountered daily in his travels across the subcontinent in his early twenties: sleeping bodies in public places, by the roadside or on the station platform, covered only by a thin cloth or dhoti. These haunting photographs of the forms of shrouded figures recall the casts of bodies – or of the spaces where bodies once lay – brought out of the lava in Pompeii. They are everyman, universal; at once intimations of mortality and signs of being, faceless and hiding individual identity yet revealing, in their surface, the form beneath, a body: the body as a private place; the place of a life. Over thirty years later, the artist sees these as his 'first sculptures', saying of them: 'they carry in seed everything that has happened since.'[3]

As records of an Indian experience they are doubly significant, for it was in India, towards the end of a period of extended travel in 1971–3, that Gormley came to the decision to become an artist – or, more particularly, to return home to train as a sculptor. What had led him to this moment of realisation, and what options awaited him back in England?

Gormley's upbringing and early years had been, broadly speaking, conventional, cultured and comfortable. Born in 1950, the youngest of seven children (two girls and five boys), he grew up in a large house in Hampstead Garden Suburb, an affluent green enclave of north-west London. His Irish/English father ran a successful pharmaceutical company (one of the first in Britain to produce penicillin commercially) with factories scattered overseas: he was 'always coming back from India, Malaya or Australia or somewhere', recalled Gormley.[4] His German mother was a physiotherapist. The family were devout Catholics; Antony was christened with the initials AMDG (Ad maiorem Dei gloriam, 'For the greater glory of God'). The routine of the large home was one of strict order, governed by 'a belief in domestic hygiene and discipline',[5] with domestics and regular family prayers. There were weekend visits to the museums of London: he has early memories of the 'challenging, unforgettable, powerful' black basalt figure sculptures that towered above him in the Egyptian galleries at the British Museum.[6] With this large family there came, evidently, a competitive intensity, and, despite his mother's close attention to him, an 'economy of affection' and struggle for space that affected him as the youngest child. He has spoken of the 'isolation and insulation' of his upbringing, of his sense of 'anomie' and 'unsaid things'[7]; 'I felt that I didn't really belong in the family,' he was once to say.[8] For refuge there was the garden shed – 'my first studio and laboratory'[9] – and the wilds: the isolation and liberation of the Yorkshire Moors, the Sussex coast and the sea, and the woods (the Black Forest, home of his German grandparents). Schooled for six years by the Benedictine monks at Ampleforth College in Yorkshire, he found support and a measure of escape from his family in the enclosed world of the abbey. His interest in art was encouraged; he was introduced by his art teacher to the sculpture of Eric Gill and

Jacob Epstein, and made enthusiastic early forays into sculpture, and painting: 'oozing landscapes' of 'swirling mess', of 'the beginning and end of the world', populated by 'thousands of little figures . . .'[10] The school twice awarded him the art prize, and bought eight of his pictures.

Such an upbringing appears to have engendered in him habits of physical and intellectual questing and rigour, a deeply-engrained work ethic, and (understandably) a healthy streak of rebellious independence, of combative non-conformism. He surprised everyone by securing a place at Trinity College, Cambridge, in 1968; there he read first archaeology and anthropology and then art history. He has talked of losing faith almost immediately on leaving school, though he has remained 'conflicted' ever since. Gormley recalls the stimuli of Cambridge in the late 1960s as 'drugs and demonstrations, trying to find alternative ways of using your mind – plus the anthropology...' Reading, at the age of nineteen, Marcel Mauss, Claude Lévi-Strauss and Margaret Mead's Coming of Age in Samoa provided him with 'a fantastic opportunity to re-evaluate the Gods, the laws and the ritual behaviours of my own culture from a much wider perspective'.[11] University also brought contact with artists, a decade older than him and embarked on their careers – in residence at nearby King's College – including Michael Craig-Martin and Mark Lancaster. His art history thesis in his final year, on the post-war paintings of Stanley Spencer and the artist's struggle to unite the sacred and the profane, religion and sex, he still regards as 'the finest bit of scholarship I did'.[12]

Gormley graduated from Cambridge with little firm direction beyond a wish to escape the strictures of home and to experience life without the expectations of an institution or a career. He had already spent vacations in India and Egypt and, as others of his generation and upbringing, headed back out of England, again to India, travelling slowly on the hippy trail through Turkey, Syria, Iran and Afghanistan, and drifting around from Darjeeling down to Sri Lanka. A stay with the Maharajah of Jodhpur led to an extended engagement with the Buddhist teacher S.N. Goenka, and a winter in a monastery in Bihar learning meditation, a seminal, 'life-changing' experience for him, after the loss of his Catholic faith. He painted in India, and all along he made drawings, though more as a travel record than a conscious form of self-expression. As for sculpture, as he later recalled:

I didn't become convinced that sculpture was for me until being in India when I felt that I had got to the end of one kind of drawing and there was no other way to go on ... The reason I chose sculpture is because sculpture deals with the real, and is not about making illusions or pictures isolated from the world by a frame. It is about being in the world.[13]

The London to which he returned after three years of wandering, its art schools still absorbing the experiences of the turbulent late 1960s, must have presented a dauntingly confused scene to an aspiring sculptor. Over the last decade, art education in Britain had been redefined, from above and below, as the educational establishment stumbled through major shifts in thinking and as students, unsettled or impatient for change, protested, organised sit-ins and generally took matters into their own hands. The turmoil masked a deeper shift, set in train by the Coldstream Report on art education in 1960, away from academic, studio-based teaching with its emphasis on talent and the learning of practical skills, and towards more discursive, ideological and inter-disciplinary approaches. This institutional change or generational shift had of course blown across the country more widely; it was also matched, and spurred

OPEN DOOR 1975 [3]
Wooden door
206 x 206 x 1.2

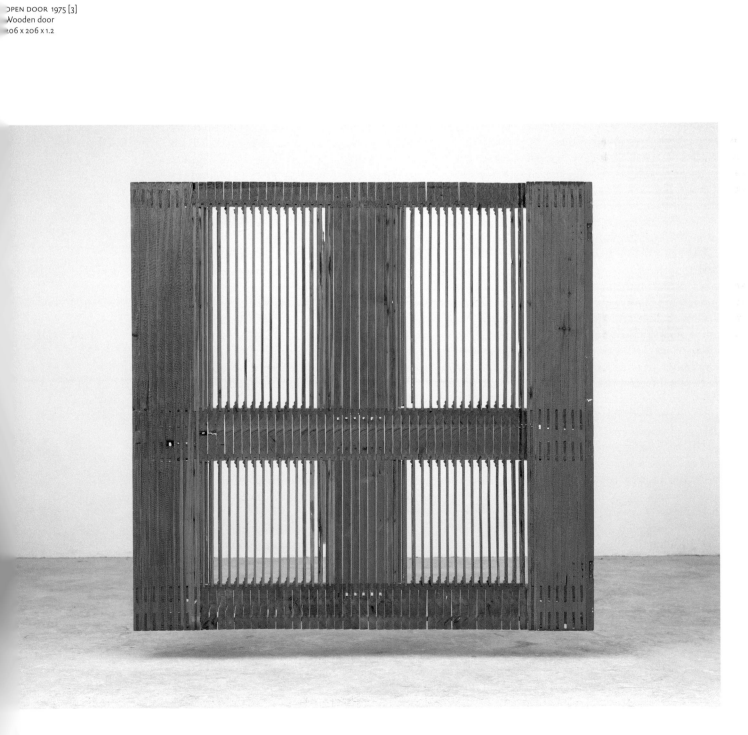

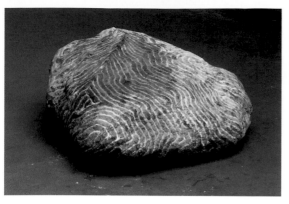

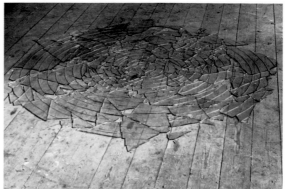

SKIN V 1979 [4]
Sarsen stone
91 x 121 x 45

GLASS POOL 1978 [5]
Glass
Height: 0.8; diameter: 182

by, seismic developments in the nature of progressive art itself, not least in sculpture.

The period of the late 1960s and 1970s in British sculpture has been described as one of 'quiet revolution', and the years between 1965 and 1972 in particular, as witnessing 'an orgy of rule-breaking'.[14] The approach of Anthony Caro, Phillip King and William Tucker was still a pervasive and dominating force. These influential sculptor-teachers rejected the monumental and symbolic functions of sculpture as well as the traditional sculptural processes of carving, casting and modelling. Theirs was a materialist and perceptual approach to sculpture: they saw it as abstract, autonomous, based on ideas of 'rightness of form'. Tucker wrote in 1975 of the 'condition of sculpture', describing it as 'the language of the physical' with a necessary direct relation to the world, and under threat – as he saw it – from 'avant-garde theory'.[15] But by 1975 there were few if any sculptural certainties, and Tucker's definitions of sculpture, like those of Caro, were being challenged by new generations of students and emerging sculptors. Sculpture, it was argued, was no longer necessarily an object in space, 'subject to gravity and revealed by light'. Performance art and 'happenings' – new art forms of the 1960s – were fast becoming common currency, as was Land art and site-specific installation, all of them approaches and activities adopted by artists who persisted in calling what they did 'sculpture'. The scene was increasingly and ever more rapidly responsive to developments in America and Europe. The term 'Conceptual art' was introduced to Britain in 1969, the year of the landmark avant-garde exhibition *When Attitudes Become Form*, organised by the revered Swiss curator Harald Szeemann; the exhibition travelled from the Kunsthalle Berne to London's Institute of Contemporary Art (ICA), where it bore the subtitle '*Works, Concepts,*

Processes, Situations, Information', and exhorted artist and viewer alike to '*Live in Your Head*'.

At art schools, debate was loud, heated and factionalised, and nowhere more so than in central London. At the Royal College of Art, where Tony Cragg and Richard Wentworth were studying, 'conceptualists' trading in ideas confronted 'materialists' who maintained faith in the object and substance; and at St Martin's School of Art, where Caro and King taught, students were engaged in 'sculptural' activity which might take the form of a photograph (Bruce McLean, John Hilliard), a text recording a walk in the mountains (Richard Long) or a feat of endurance such as the epic performances of the 'living sculptures', Gilbert & George. As Barry Flanagan, then a young student at St Martin's, had put it as early as 1965: 'I might claim to be a sculptor and do everything else but sculpture. This is my dilemma.'[16]

What can Gormley have made of this fascinating and complex situation? Reviewing his options, he can have had little to go on. On the advice of a friend, he plumped for the Central School of Art and Design – a mistake, for him, as he soon realised: 'It turned out to be more like a hospital than a school'. His transfer to Goldsmiths College in south-east London the following year marked, as he later put it, 'the beginning of my art education … My recollection of that time was that it was fluid, lively and highly confusing'.[17] Jon Thompson, the Dean of Fine Art, had recently brought in younger artists such as Michael Craig-Martin and Richard Wentworth, both of whom taught Gormley in his first year there; later he was tutored by sculptors of an older generation, Michael Kenny and Ivor Roberts-Jones. These teachers were joined by a host of visiting artists and lecturers, including the sculptors Paul Neagu (whose 'anthropocosmic' theories and challenging performances must have interested

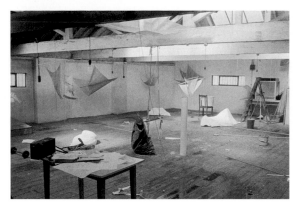 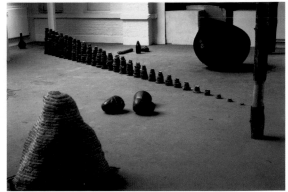

Studio view, Kings Cross Road,
1974 [6]

Studio view, Slade School of Fine Art,
with RE-ARRANGED TREE 1978 (centre)
and END PRODUCT 1979 (back right) [7]

Gormley) and Carl Plackman. Gormley's *Open Door* 1975 (fig.3) is one of his few very early works to have survived: a panel door, sawn lengthways into thin strips, each of which is turned through ninety degrees and laid flat again, in a straightforward yet radical reconfiguration of the surface and hollow interior space of an everyday object. It remains at the same time an entrance and a barrier – and a threshold.

But Gormley's use of the things around him in his art soon led beyond the orbit of the studio and the city, to materials and processes more natural, elemental and, in a sense, conventional for the sculptor. On leaving Goldsmiths he visited the marble quarries of Carrara in Italy, which had supplied Michelangelo. He produced a number of modestly-scaled carved works – *First Hole* 1977 and *Broken Spiral* 1977 – tentative, almost self-consciously embryonic modifications of fragments of rock, which were followed by further experiments, back in England, with Derbyshire grit stone, sandstone and greenstone. A series of works of these years, titled *Skin* 1977-9 (fig.4) are experiments in a kind of 'superficial carving', a scoring of lines across the surface that followed the forms and fissures of the rocks themselves, 'attempts to find a structure and content within the material'.[18] Much as he admired the work of the modern pioneers of direct carving in the early twentieth century, Henri Gaudier-Brzeska and Jacob Epstein, he saw this drawing on stone, this 'inscribing ideas into material', as too conventional for him now. He had to get beneath the surface of things, to find 'the tree within the tree, the seed within the wood'.[19]

'I try to allow the object or material to disclose itself in its own terms, with a process that is appropriate to it,' Gormley explained in an early lecture.[20] The search for a 'dialogue with substance' led him in the late 1970s to explore, analyse and reconfigure the forms and

essential properties of materials. Just as marble demanded to be carved and stone incised, so lead was hollowed and beaten, glass smashed, wood stripped and burned, cut and stacked. Some of these exercises with materials are deft, simple gestures: the two slates pitched to form a rudimentary shelter in *Eave*, the circle of reflective shards of *Glass Pool* (fig.5), both works of 1978. Others reveal a more methodical process, a kind of revelation of the whole through its parts. *Bare Tree, Final state* 1978 presents a slender trunk painstakingly stripped, layer by layer, to its skeletal core, and *Re-arranged Tree* 1978 (fig.7), a thirty-year-old pine trunk sliced into round sections and stacked in an ascending line of thirty piles, each pile composed of one to thirty sections.

From 1977 to 1979, the years when these works were made, Gormley was a postgraduate student at the Slade School of Fine Art: a rather unrewarding experience, as he recalls. He was increasingly working away from the school, at the studio/living space in Frederick Street, King's Cross, or the squatted factory around the corner in King's Cross Road, where he was for six years from 1974. These works betray the lingering influence of Craig-Martin, and also, maybe, an interest in the slices, stacks, serried rows and floor-strewn object arrangements of his near-contemporary Tony Cragg, who was already showing at the influential Lisson Gallery, and in the language of line, circle and laid stones through which Richard Long described his incursions into the landscape. Much of what emerged from the art schools in the late 1970s reflected investigations of material and process reminiscent of the catalogue of actions on raw material which the American 'post-minimalist' sculptor Richard Serra famously recorded in his notebook in 1967/8 as a list of verbs that began: TO ROLL / TO CREASE / TO FOLD / TO STORE / TO BEND / TO SHORTEN / TO TWIST...[21]

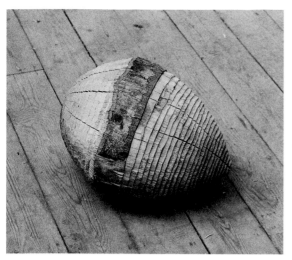

TREE SEED 1978 [8]
Beech
Length: 39; diameter: 33

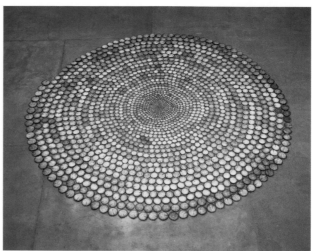

FLAT TREE 1978 [9]
Larch
Diameter: 6.78 m

The influence of the European avant-garde was pervasive, too, and in particular the Italian Arte Povera movement, with its socially aware, almost anthropological examination of the relations of nature and culture, and its emphasis on natural forces, progressions and processes. The spirals of growth that underlie much of Mario Merz's work, for example, and Giuseppe Penone's stripped trees (unknown at the time, apparently, to Gormley)[22] are formal and conceptual lines of enquiry that echo in Gormley's work and that of many of his contemporaries.

Gormley's own meditations on the relations of space and time, on the rhythms of creation and destruction, found early expression in *End Product* 1979 (fig.7), a sculpture worked from the base of a dead elm tree, rough-cut and then scorched into the shape of a giant seed. Here dead matter is transformed, through a natural process of consumption, into a form that signals the potential for new life. Another seminal work of this period, *Full Bowl* 1977–8 (fig.10), comprised a series of lead bowls each beaten within the form of the last, a series with the potential to go on growing; the work can be taken apart and laid out in a line of bowls of decreasing size or packed one within the other, their rims giving the appearance of the cross section of a tree trunk, 'emulating the language of trees'.[23]

Gormley began to use lead as a material while at the Slade. He has on occasion described the metal as 'aesthetically neutral' but in many ways it was also highly charged, as he (alongside other artists, such as Joseph Beuys and Anselm Kiefer) has recognised: 'Lead brings silence and stillness. It is a wonderful material – it is so inert, so dense, its greyness combines all colours, its quality as an insulator is important. It protects against all forms of radiation – and that is part of its power. It renders things inert but because of its nature that inertia is potent: like a seed.'[24]

In 1977 Gormley had wrapped a granite stone, brought back from an Irish beach, in a sheet of lead. Some time later he re-opened it, and used the same stone to mould two more similarly-sized sealed lead cases; one was left empty but for air, one filled with water, and one held the original stone. A gas, a liquid and a solid; 'the world in three equal parts, contained in lead, unrecognisable'.[25] Three 'seeds', holding matter in three states, taken from the real, perceptible world in which they could be seen, touched and smelled, and consigned beneath their impenetrable casing to the realm of the imagination. Gormley describes *Land, Sea and Air I* 1977–9 (fig.11), as 'the foundation of my work'. With it came the idea of taking the 'indexical imprint' of an object from the object itself, an idea that the artist developed into a sustained exploration of absence and presence, of revealing and hiding, and a conceptual binding of the visible and invisible, matter and mind, substance and thought.

In works of the late 1970s Gormley continued to use lead to envelop series of objects, natural and man-made, in provocative combination and pointed displacement of their original form and function. In *Fruits of the Earth* 1978–9 (fig.12) he wrapped a machete, a wine bottle and a loaded revolver (his father's) in cocoons of lead sheet, layer on layer until the objects lost all but a vestige of their own distinct form and identity and came to resemble seed pods. The rhetoric of these works – the conflict and resolution of man and nature, of man and man, reflect a common preoccupation of those years at the end of the Cold War, a time of 'inter-continental missile proliferation', as Gormley admits. *Natural Selection* 1981 described a line on the floor of wrapped objects increasing in size from a pea to a ball – a bullet, a banana, a gourd, a grenade and so on. Phallic and ovoid forms, male and female, they contain agents of life and of death. *Three Bodies* 1981 (fig.13) used the

ULL BOWL 1977–8 [10]
.ead
 X 17 X 17

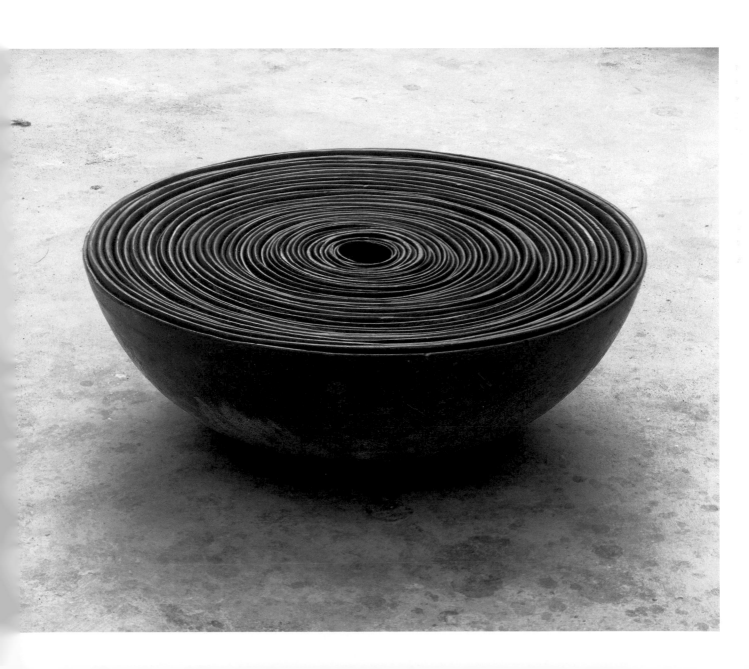

LAND SEA AND AIR I 1977–9 [11]
Lead, stone, water, air
3 elements: each approx 20 x 31 x 20

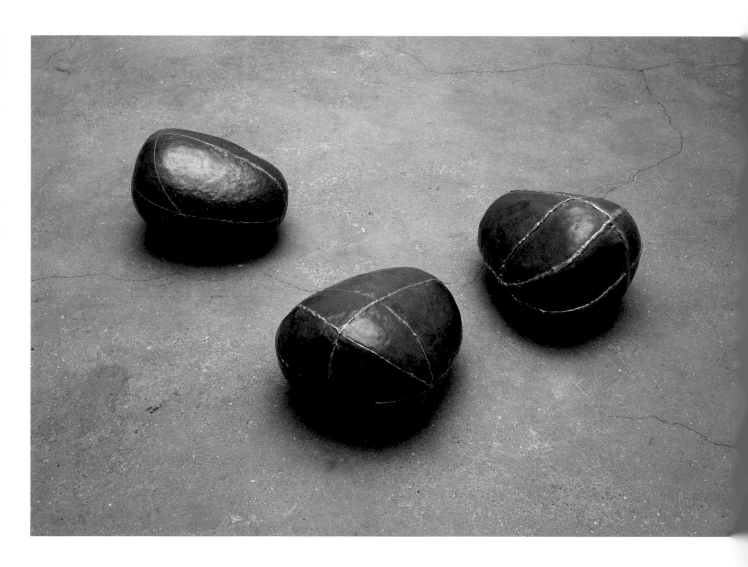

FRUITS OF THE EARTH 1978–9 [12]
ead, revolver, bottle of wine, machete
elements: largest approx 60

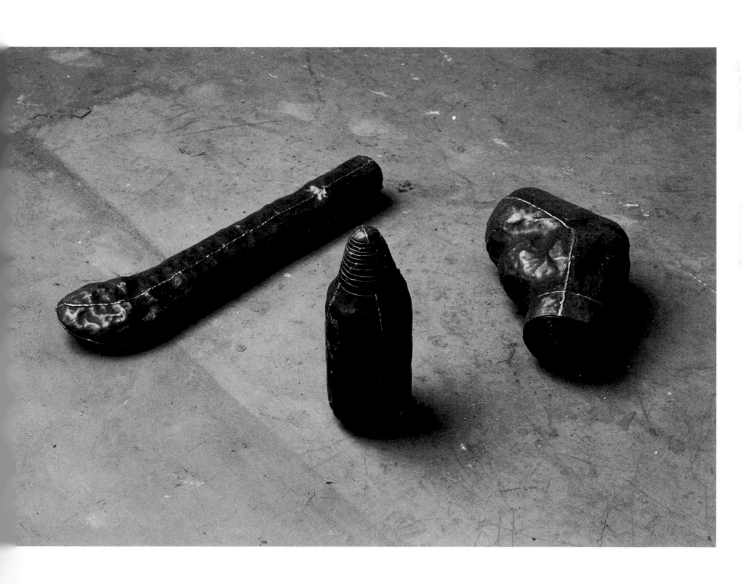

17

THREE BODIES 1981 [13]
Lead, fibreglass, earth
Rock: 96 x 60 x 54; pumpkin: 80;
shark: 18 x 193 x 60

BREAD LINE 1979 [14]
Bread
1 x 1500 x 3
Installation view, ICA, London 1981

forms of three objects, one animal, one vegetable and one mineral (a shark, a pumpkin, a rock) to shape lead cases, which were then filled with earth.

These formative years after art school, from 1979 to 1981, marked Gormley's public arrival as an artist. In 1980 he married the painter Vicken Parsons, and they moved into the house in Peckham that was to serve them as family home and studio. To survive, he took part-time teaching jobs, at art schools in Maidstone and Brighton, during the mid-1980s. 'We were still a generation that did the work and waited for the institutions and the market to find us,' recalled Gormley later.[26] In the summer of 1981 he was invited to take part in a group exhibition organised by Arnolfini in Bristol and the ICA in London, *Objects and Sculpture*, alongside Richard Deacon, Anish Kapoor, Peter Randall-Page and others. Though it shied away from defining a new movement in sculpture, the exhibition identified a shared interest amongst this new generation of sculptors in work that was 'neither figurative nor abstract', but 'associative, and in some cases … also symbolic or metaphorical'.[27] This was presented as a move away from both the manufactured, welded sculpture material of the 'New Generation' of Caro and King and the idea-oriented, consciously avant-garde conceptual approaches of artists in the late 1960s. Some critics attempted to find labels (the 'New Object Tendency' was one)[28] or to locate the work in a shared practice of 'urban assemblage', but this loose array of artists proved hard to corral, as time would prove. Gormley himself was not disposed to seek group allegiance, but acknowledged this group show as his 'launch'. Shortly after this, he was offered a one-man show – following Tony Cragg – at the Whitechapel Art Gallery in East London by the young Director, Nicholas Serota. There, on the Gallery's upper floor, he showed one drawing and four

sculptures: *Natural Selection*, *End Product* and two major works – *Room* 1980 (fig.16) and *Bed* 1981 (fig.15) – both of which pointed obliquely to a growing preoccupation with the human body, in their engagement with food and clothing, staples of the human condition, our shelter and survival. Gormley later came to see them as 'the turning point'.[29]

Since leaving the Slade, Gormley had been making a number of works that used bread as their base material. After first attempting to carve and collage the loaves, he started to bite (what process could be more natural, more appropriate?). *Bread Line* 1979 (fig.14) echoed the format of the earlier *Natural Selection*, a 'redescription', in his own words, of a loaf of bread bitten off and laid out in a long line 'one bite at a time'.[30] Then came *Bed*, made from 8,640 slices of white bread impregnated with wax, in the creation of which Gormley ate, over time, a volume of sliced bread equivalent to his own body, an amount expressed in the work in the form of its absence, as two half-body cavities lying adjacent to each other in a gridded stack, negative space in a bed of bread; 'This bread is my body …' Visual and metaphorical allusions abound: to the stuff of life and to death, to the Eucharist of Christian ritual, to the funerary monument, and to the grids of the American minimalists – most closely, perhaps, to the stacked bricks of Carl Andre's *Equivalent VIII* 1966 – the 'pile of bricks' that had caused such a furore in the press five years earlier following its purchase by the Tate Gallery.

Room is a contrasting presentation of personal and lived-in space. 'Whilst thinking about skin in relation to carving, I began to think in terms of the human form. There has always been a fascination for me about clothes – particularly when there aren't people in them. They're like man's first container.'[31] The work involved a radical transformation of the clothes he stood up in,

BED 1981 [15]
Bread, wax
28 x 220 x 168
Tate

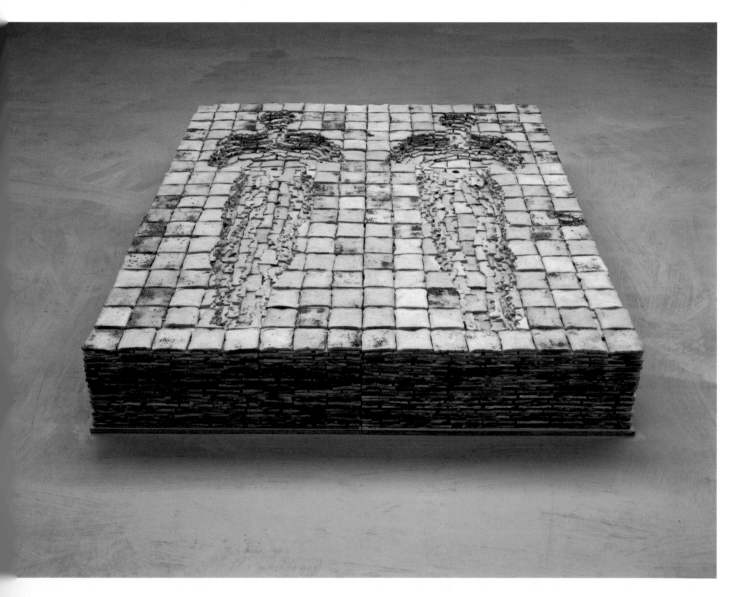

ROOM 1980 [16]
Socks, shoes, pants, trousers,
shirt, pullover, vest, jacket, wood
Dimensions variable
Installation view, Whitechapel
Art Gallery, London 1981

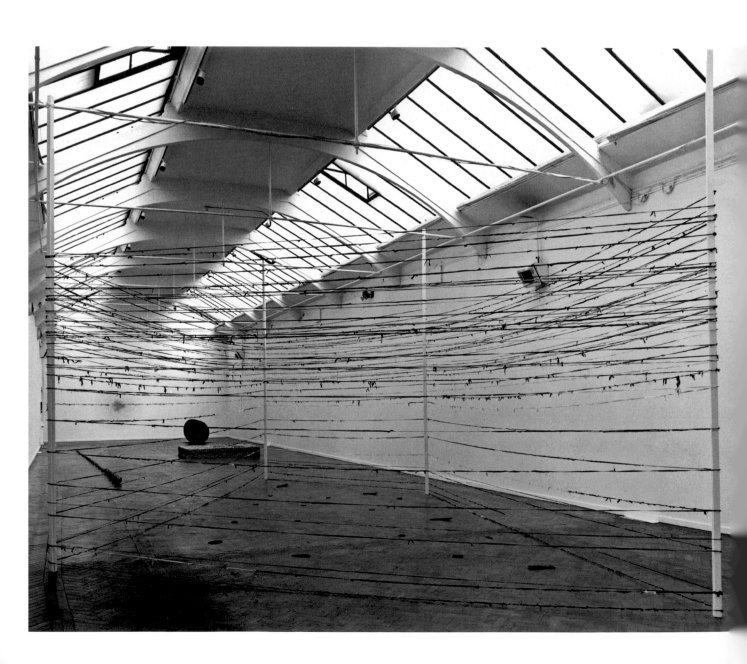

which were shredded fine and strung out in lines around posts set four-square to create a room-sized enclosure, or place of encounter; an empty arena, a fragile barrier that keeps us out or could hold us in: the 'place' of another, absent, body.

All Gormley's works in the years up to 1981 reveal an analytical approach to the physical world. Along with other young artists around him, he *interrogated* objects, took them apart in order to understand them and then put them back together, redirected, reconfigured and represented – to make them, as he put it, 'more eloquent'. He saw each work he made as a proposition physically realised. Yet from around 1981 he began to situate his art increasingly in relation to those big, often unasked questions that dwell on Man's creativity, spirit and destiny: What is art? What is the business of the artist, and how is the artist's sense of what it means to be a human being – to be in and to experience the world – to be conveyed? To proceed, he needed a different kind of vessel, as he came to realise: 'Art that deals with objects is never going to use art to its full potential. Objects cannot talk about experiences – they can talk about knowledge, about ideas, about culture . . . but I don't think they can carry feeling.'[32] Gormley's search for a vessel that could carry feeling, convey experience, was to lead him away from the pack, and back to the human body. Not an imagined body, but a real one: his own.

21

THREE WAYS: MOULD, HOLE AND PASSAGE 1981; LAND, SEA AND AIR II 1982; THREE PLACES 1983; THREE CALLS 1983–4

'I don't need to invent a body, I have one that I am inside . . . I want as direct a means as possible.'[33] With this series of three-part works Gormley found a new space for his art, 'the space we all inhabit when we close our eyes'.[34] These works marked the beginning of a way of making sculpture that has come to define his public image as an artist: they were the first works for which he used his own body as a direct starting point. The very first body-case sculpture, *Mould*, was made in 1981 in his studio on the first floor of 37 Frederick Street in King's Cross, with the assistance of his wife Vicken Parsons. The process of making involved a sort of ritual that he was to repeat many times over the ensuing years. He described it fully in an interview with Roger Bevan in 1993:

ANTONY GORMLEY Each work starts with a real body in real time and comes from a real event. It is not dissimilar to a photograph. I adopt the position which I have selected for a sculpture and am wrapped in scrim, which is an open-weave jute cloth, and plaster. Because the plaster dries quickly, within ten minutes, the work is divided into different sections. Usually I stand on a piece of scrim which wraps around my feet. Then my torso is covered. There are two sections for my legs, front and back. Finally my assistant wraps my head. The whole process takes about an hour, perhaps an hour and a half. Then I am cut out of my mould and it is reassembled.

ROGER BEVAN Do you have a picture of the sculpture while you are being wrapped?

AG Up to a certain stage, I do, and then I have to rely on an internal feeling.

RB You are forced to be absolutely immobile. Is it difficult to maintain?

AG It's a bit like going to hospital to have an X-ray. Breathe in and hold it, the technician says. You are aware that there is a transition, that something that is happening inside you is registered externally. But for accuracy it must be a moment of stillness, of concentration. I am trying to make sculpture from the inside, by using my body as the instrument and the material. I concentrate very hard on maintaining my position and the form comes from this concentration.

RB Do you regard being wrapped in scrim as a spiritual exercise or merely a functional necessity?

AG It is functional, of course, but it has become ritualised and I do find it very therapeutic. It is a meditative experience and I suppose that I learned about the space within the body from meditation, but it is not a replacement for meditation.

RB So you have created a mould or a shell around your body . . .

AG The mould has the same relationship to my body as a violin case to a violin. It is not a representation of my body, but a case around the space that I occupied. Then I simplify and consolidate the feeling in the piece.[35]

In the next stages of the process, the mould made from the body is reassembled, and worked on. It may be altered, and individual parts adjusted or remade, but the original posture of the artist's body determine the work. The mould is then strengthened with fibreglass, and plates of roofing lead are beaten over

the moulded form and soldered or welded to create a skin, a contour slightly larger than the artist's own body, with what the artist describes as 'an indexical, precise print of the body inside'.[36] The poses were preconceived, originating from sketches and drawings in his workbook; he would take two or three of these into the studio each month to work up. Though the process was a lengthy one, the pace of making quickened over the years. Gormley would work closely with Vicken on the plaster and scrim mould; a fibreglass technician would then strengthen the body and other assistants would shape and solder the lead casts.

The first body case, *Mould*, came to form part of a three-part work, *Three Ways: Mould, Hole and Passage* 1981, which considered the body as a processing place, a site of continual 'energy transfer'. Each of the three bodies adopts a different posture – foetal, kneeling and lying – and each is pierced with a single aperture that marks one of the 'portals' connecting the inside of the body with the outside world – the 'three ways': the mouth, the anus, the penis.

Land, Sea and Air II, which followed in 1982, established the three-part work as a recurring strategy, testing a vocabulary of body positions in groupings that have 'no narrative but a kind of syntactical structure'.[37] The title (a repeat of the first lead-case work five years earlier, *Land, Sea and Air I*, the wrapped Irish shore stone) almost demands an outdoor setting – a place out in the real world – and an early photograph shows the work on a bleak shoreline before the waves of a grey Channel. The figure of *Land* crouches, its head turned to the ground, ears open, and listens. *Sea* stands straight, arms by

its sides, open eyes looking across the flat expanse of water to the horizon. *Air* kneels, torso erect and head tilted upright to address the sky, its nose holes open. Set together, they remain isolated one from another, united without interacting, abstracted, in their attachment to the world around. The work, says Gormley, 'uses the body as an agency to experience the elements'.[38]

The figures in *Three Places* 1983 are hermetically sealed cases, in three basic body positions: lying (horizontal), sitting upright (right-angled) and standing (vertical). *Three Calls (Pass Cast and Plumb)* 1983–4 describes another progression, through three stages or levels of human activity: thought, speech and action. In the series as a whole, which mapped out a territory that Gormley was to explore obsessively over the next decade and more, the artist proposed the body as 'less a thing, more a place; a site of transformation, and an axis of physical and spatial experience'. He saw it as a place of boundless dimensions: 'All you have to do is close your eyes and you are in a world which is infinite. As infinite as the sky.'[39]

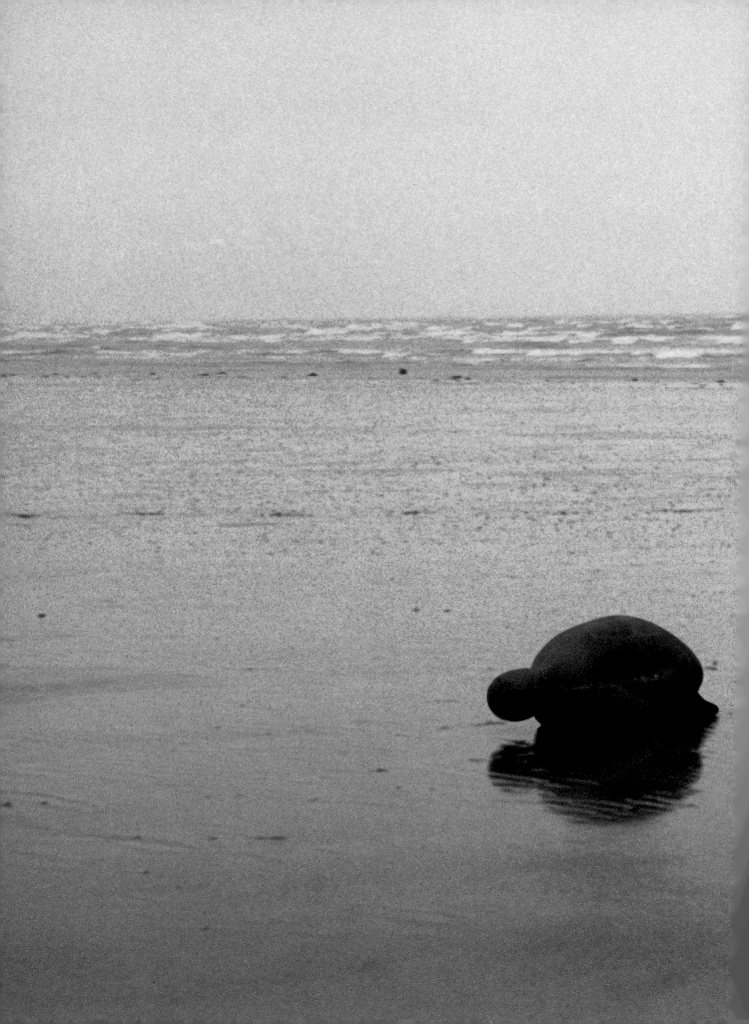

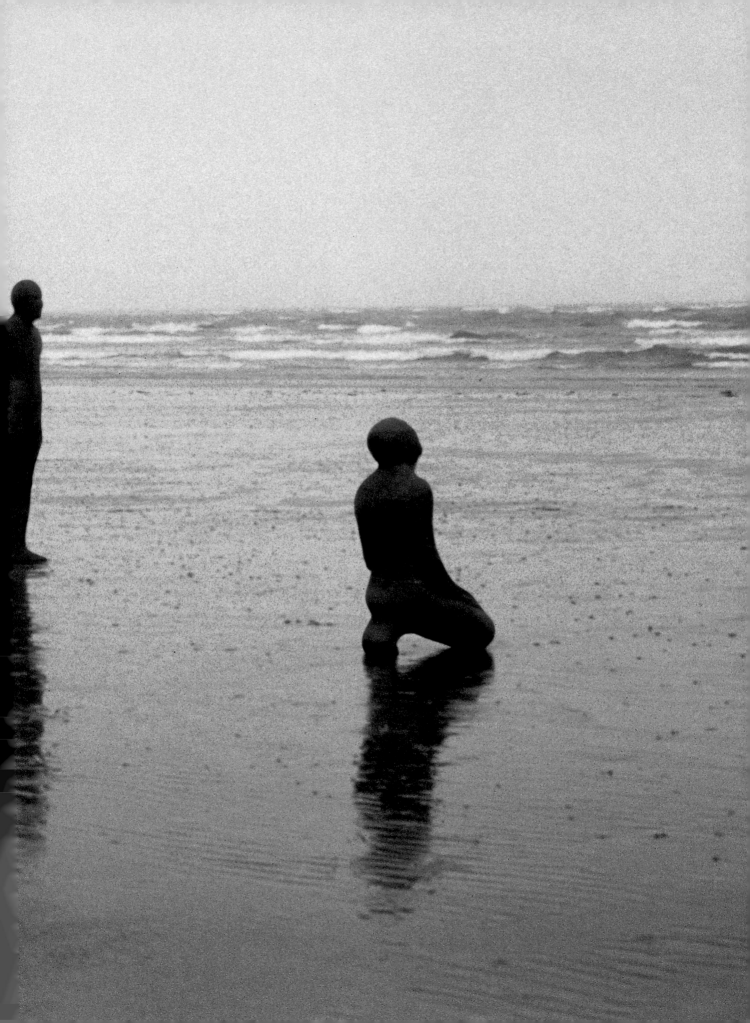

LAND, SEA AND AIR II 1982 [17]
(preceding page)
Lead, fibreglass
LAND (crouching): 45 x 103 x 50;
SEA (standing): 191 x 50 x 32;
AIR (kneeling): 118 x 69 x 52

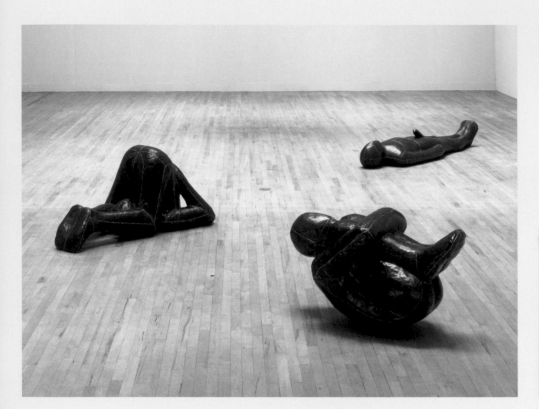 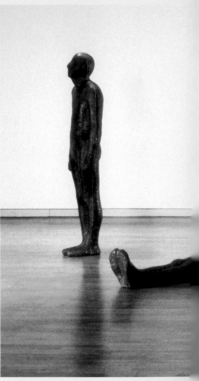

THREE WAYS: MOULD, HOLE
AND PASSAGE 1981 [18]
Lead, plaster
MOULD: 60 x 98 x 50; HOLE: 62 x 123 x 80;
PASSAGE: 34 x 209 x 50
Installation view, Tate Britain, London
Tate

THREE PLACES 1983 [19]
Lead, fibreglass
LYING: 31 x 207 x 50; SITTING: 100 x 57 x 132;
STANDING: 190 x 50 x 35
Installation view, Hayward Gallery, London
Nasher Collection, Dallas, Texas

THREE CALLS: PASS, CAST AND
PLUMB 1983–4 [20]
Lead, plaster, fibreglass, air
PASS: 190 x 56 x 95; CAST: 101 x 68 x 66;
PLUMB: 70 x 57 x 74

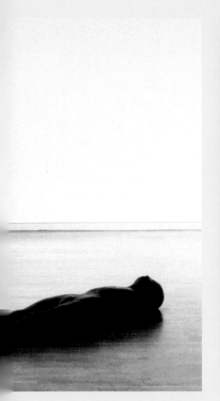

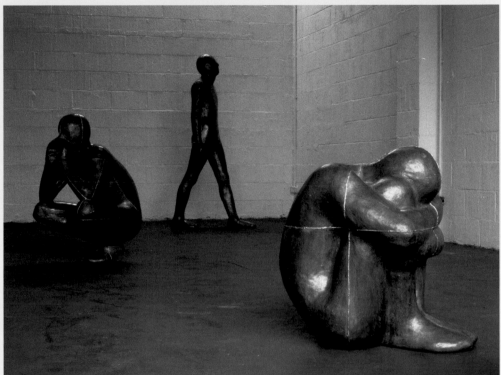

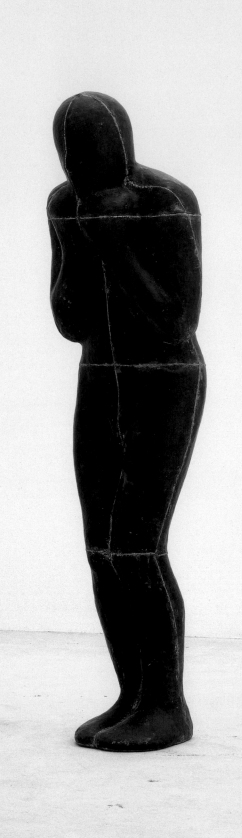

VENT 1984 [21]
Lead, plaster, fibreglass
178 x 48 x 50
Collection of the Louisiana Museum,
Humlebæk, Denmark

EMBODIMENT

Much of human life is hidden.
Sculpture, in stillness, can transmit what
may not be seen.
My work is to make bodies into vessels
That both contain and occupy space.[40]

Vent 1984 (fig.21) is a standing, life-size naked figure, tall, thin and male, made of lead; separate lead sheets beaten to shape over a strengthened plaster body-shaped mould and then soldered to make a single hollow form. The pose is static, compact and intense, but difficult to interpret. The body leans forward; there is a slight bend to the knees, the arms are braced against the torso, and the hands clenched tight under the chin. It could suggest a state of fear, or of anger. There is little surface detail, of facial features, fingers, skin or hair. The solder lines are rough, mapping a grid of horizontals and verticals across the body. A circular opening at the top of the head connects outside and in, allowing a glimpse of the form's dark hollow interior. The sculpture is a typical example of the body-case works that Gormley made in the early 1980s. It is worth considering what else it is, and what it is not, what it does and doesn't do, in order to grasp the particular nature of Gormley's proposition and his stance in relation to – or distinct from – the sculpture of the body, present or past.

Vent is a sculpture based on a cast of a real body, the artist's own. As such it is a record of a particular extended moment, a 'lived' moment. It records a particular pose that results from and aims to convey a particular condition of the body or mental state, a sense of how it feels and what it means to be in a body and experience the world through it. It is not in itself a body, but a surrogate for it, a stand-in; it marks the space where a body has been. It carries a title, but it cannot be named. It is not a portrait or a representation of a particular person or a particular type. Least of all is it an autobiographical statement. It presents no telling details, no particularities. It offers no narrative, no cause or reason for the figure's emotional state; it does not convey a dramatic gesture that could be interpreted as specific or symbolic action. Its material is neither precious nor polished; it is not in any conventional sense a beautiful sculptural object, nor does it seek to convey the ideals of human form. As Gormley would say, *Vent* is a 'vessel that both contains and occupies space'. It is our size. It stands in our space, and asks that we approach it and address it, occupy and feel it.

The same could be said of all the body-case sculptures that Gormley made over this decade. His way of making the body sculptures has been described as minimalist, in its sustained development of a single basic artistic proposition, according to a set of defined rules and procedures, self-imposed and rigorously adhered to. He made, in all, around eighty separate body-case sculptures based on his own form: 'My body contains all possibilities', he wrote in his workbook in 1984.[41] He recognised that this turn to the body as the prime vehicle for his art constituted a 'radical shift' in his work; he was also aware that it was a step against the flow, out of the mainstream of contemporary art.

Body art, as a strategy of the avant garde developed through the 1960s and 1970s related to happenings, Actions or performance, was itself on the wane; it had walked into a minefield of positions and counter-positions charged by the politics of gender, race and identity. And despite his interest in the art of performance and actionism Gormley was and is always, fundamentally, a maker of objects. There were other young artists of his generation here and abroad beginning to make sculptures of and from the body – Stephan Balkenhol, Kiki Smith, Juan Munoz, Thomas Schütte and Katharina Fritsch – some of whom were

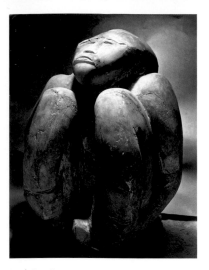

Jacob Epstein
ELEMENTAL 1932 [22]
Alabaster
Height: 81
The Epstein Archive at
The New Art Gallery, Walsall

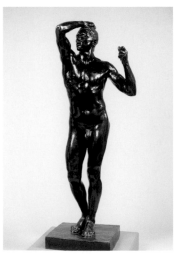

Auguste Rodin
THE AGE OF BRONZE c.1876 [23]
Bronze
Height: 180
Victoria and Albert Museum,
London

shown in exhibitions with Gormley on occasion. But their works, and their motives, had little in common either with each other's or with his. Gormley, for his part, showed no inclination to define his work in relation to any wider programme or strategies: 'I want to deal with experience rather than imagination,' he was to say.[42]

In the autumn of 1981, shortly after his solo show at the Whitechapel Art Gallery, Gormley exhibited there again; his wood sculpture End Product 1979 (see fig.7) was shown in an expansive survey exhibition, British Sculpture in the Twentieth Century. Another exhibit in the show grabbed Gormley's particular attention: Jacob Epstein's carved alabaster figure sculpture, Elemental, of 1932 (fig.22). Its flattened features stare blankly upwards, its head is tilted back and its limbs bunched together in a foetal position, in what Epstein believed to be an African burial posture, situating it somewhere between the unborn and the dead. 'It carried this extraordinary punch of compressed human energy,' Gormley recalls.[43] His first response on seeing the sculpture had been to turn to carving again, but there is little doubt that it also prompted him to consider more broadly the form of the body as a carrier of expression and meaning. It was only months after this that he made his first body-case sculpture, the foetal, hunched figure lying on its back, Mould 1981 (see fig.18).

It is ironic that the exhibition that provided him with such an inspiration – a survey of eighty years of British sculpture – should present sculpture of the human figure as a virtually eclipsed tradition with no persuasive standard-bearer to fight the new orthodoxies of contemporary art. As one writer in the catalogue put it, 'no-one since Rodin seemed to offer an alternative of real authority';[44] and Rodin had died in 1917.

Two years later, Mould appeared as more or less the only sculpture of the human figure in the

catalogue of the Arts Council's sweeping survey of the contemporary British scene, The Sculpture Show in 1983. And it was not only in Britain that such work occupied marginal terrain. Modernism had torn the figure from its pedestal in every sense, and figure sculpture, from the early twentieth century, appeared consigned to the academy and the museum. Those major sculptors who dealt with it at all – Constantin Brancusi, Jacques Lipchitz, Julio González, Henry Moore – treated it in increasingly abstract terms. In progressive art of all forms, abstraction held sway for decades.

An important exhibition at the Museum of Modern Art in New York in 1959, New Images of Man, attempting to define and orchestrate a retrieval of the human subject for art among painters and sculptors worldwide in the post-war years, advanced the work of such as Jean Dubuffet, Alberto Giacometti, Willem de Kooning, Eduardo Paolozzi, Jackson Pollock and Germaine Richier as an 'expression of the fight for humanity' against the 'dehumanising structure of totalitarian systems and the dehumanising consequences of technical mass civilisation'. Seeking affirmation from the art of the past, these artists were looking beyond the Western tradition to the Etruscans, the late Romans, to Aztec and Neolithic art. They were trying, claimed the show's organisers, to 'depict as honestly as they could, true representations of the human predicament, as they experienced it within and outside themselves'.[45] Such words might almost seem to have been written for Gormley some twenty years later. The Western tradition of sculpture, from classical Greece to the Renaissance and on, from Praxiteles to Michelangelo to Rodin, had little to offer Gormley as a model for his own art. He rejected all its tenets – its emphasis on naturalism, on physical resemblance, its recourse to symbolism or narrative detail, its pursuit of an ideal

beauty and grace and proportion, its reliance on the *contrapposto* pose and the expressive gesture. The forceful direct carving of the early modernist sculptors, Epstein and Henri Gaudier-Brzeska, offered something else. He saw in the totemic forms of their sculpture a quality of immanence (a key term for him), a fusion of the power of the sacred and the intensely physical. And it provided a connection between the modernist impulse in art and that of earlier and other cultures.

'I didn't want to continue where Rodin left off, but to re-invent the body from the inside, from the point of view of existence,' he claimed.[46] He wanted not to inscribe his work in a tradition, but to redo the tradition for now. Rodin may not have held out a baton to him, but Gormley has frequently singled out the artist's early work, *The Age of Bronze* c.–1876 (fig.23), for particular acclaim. Rodin had described its subject as 'man awakening to his humanity'; Gormley sees in it a 'moment of becoming – a moment of self-consciousness within the body'.[47] Gormley's own work, *Moment* 1985 (fig.24), seems to propose something similar. (It is, maybe, another irony that Rodin's *Age of Bronze*, made from an original model in clay, was to prompt the unfounded accusation from the critics of his day that the artist must have cast the figure from life.) It was precisely this quality that Gormley recognised in the sculpture of the more distant past that strikes so many chords in his own work: whether in Egyptian statuary, in the mummified statue-columns of Osiris on the Temple of Hatshepsut at Luxor, in sixth-century Jain figures from India, or in the rigid figure sculptures of Cycladic Greece: 'There is something very powerful about the way that both Rodin's *Age of Bronze* and the Cycladic heads connect with the infinity of the sky, suggesting human potential, but not in terms of movement.'[48]

Gormley's *Moment* is an intense but not a demonstrative pose. It contains a feeling that can be read in the lift of the heels, the curve of the palms, the tilt of the neck as much as in the face, that privileged site of emotion where we would normally look for a sign. 'The body has to be an expressive whole. I'm using the whole body as if it were a face. Gestures have to involve the whole body.'[49] Gormley's first challenge in making his body cases was to find that integrity and stillness in himself, and enact it in the studio. 'Each work starts with a moment of bare attention, where my concentration is completely integrated with this bit of the material world, which happens to be my body. That is my radicalism, that's the proposition that I am making which, I think, separates my work from the history of the body in sculpture.'[50]

This insistence on unity of mind and body, and on the body as the prime location of experience, is a central tenet of Buddhism, and demonstrated in its art. 'Buddhist statues', Gormley observed years later, 'have a certain posture. And this posture corresponds to a particular mental state. And it is the same, I think, in my works.'[51] He describes the technique of Buddhist meditation that he learned as a young man, in India in 1972, as a mindfulness of breathing and a concentration on the inner space and darkness of the body. It was about being still; about experiencing the feeling of being here, now. It called for an unselfconscious awareness of the present moment, a bringing together of mind and matter, just as the sculptural process did: 'When I'm standing or in a particular position for a pose, I am attempting to unite my physical and mental self into a total form.'[52] The repeated ritual of Gormley's body casting called for a sort of minimalist performance, a 'rite of passage', as he has called it. The mummification of the plaster involves a drawing and holding of breath and a sort of surrender, an entry into a state of dependence. It has a lot to do with meditation, he acknowledges: 'I think that sitting in meditation and

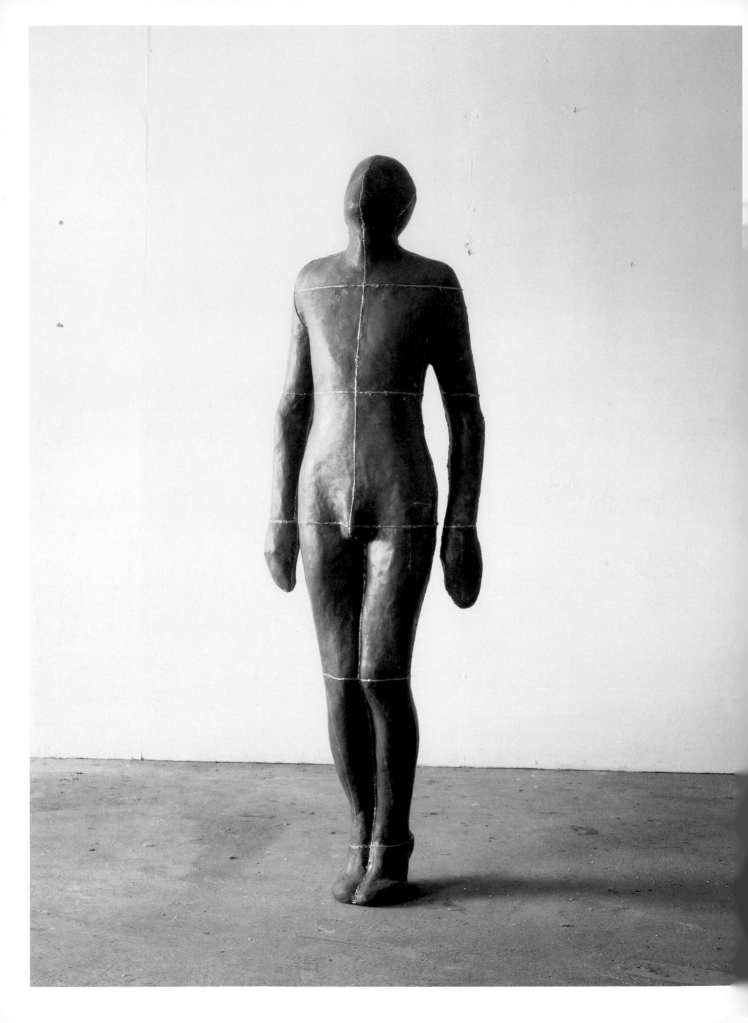

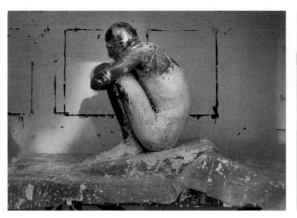

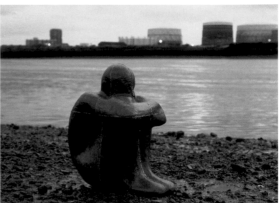

MOMENT 1985 [24]
Lead, fibreglass, plaster, air
106 x 67 x 30

Casting process, London 1985 [25]

NIGHT 1983 [26]
Lead, air, fibreglass
79 x 41 x 65

the condition of sculpture are very similar. The essential qualities of sculpture are stillness and silence and these are the two qualities which one learns to love and appreciate in meditation.'[53]

If the body sculpture was, for Gormley, a 'container for emotional expression', the next challenge, of course, was to invest that intensity of awareness in the work itself, in such a way as to convey to the viewer the sense of a moment keenly felt, to be just as keenly experienced. 'I get out of the mould, I reassemble it and then I appraise the thing I have been, or that place that I have been and see how much potency it has ... The potency depends on the internal pressure being registered.'[54] As the critic Daniel Birnbaum recognised of the works, 'not only are they about the body ... but they are also *experienced* with the body'.[55] The pioneering American artist Bruce Nauman, whose practice lay somewhere between Body art, theatre and sculpture in the 1960s, had recognised something similar. Nauman spoke, in relation to his own enactments, of the need to 'pay attention to yourself': 'If you really believe in what you're doing, then there will be a certain amount of tension – if you are honestly getting tired ... there has to be a sympathetic response in someone who is watching you. It is a kind of body response.'[56]

For Gormley, 'the work comes from a lived moment and what I hope is that the viewer equally gives the sculpture a lived moment'.[57] The exchange that he calls for, and believes in (the 'wager of the work'), relies on an empathy that is elemental and universal, body to body: a 'language before language'.[58]

The series of three-part works he made between 1981 and 1984 (see figs. 17, 18, 19, 20) established a basic, almost programmatic lexicon of body positions for him: both philosophical propositions in body form and materialisations of physical and ecstatic states. Single figures, from 1983 on, extended the range of possibilities. These figures refuse to offer an easily readable gesture or to act anything out. They challenge us to engage with their uniqueness rather than to fall back – as we might wish – on the language and rhetoric and ritualised forms of sculpture and art. And there is much to negotiate: bodily attitudes that we might take as trance, supplication or admonition, the pose of the meditating Buddha or the teaching Christ, Annunciation or Ascension, the Crucifixion or the Fall. Gormley is of course well aware of all this, and makes his position clear: 'Any body when it accepts stasis consciously becomes hieratic and is in dialogue with sacred sculpture, whether Hindu, Christian, Buddhist or Oceanic. My work is totally a-religious, but that idea of the contemplative icon ... is central to me.'[59]

Works such as *Night* 1983 (fig.26) offer a dense, impregnable pose of self-containment, introspection and isolation – a body and mind hermetically sealed. This is the darkness of the body as 'a place that has no dimensions' – a darkness he equates with the space of imagination. *Desert (for Walter)* 1983 (fig.28) – a figure lying front down, one arm straight out to its side – dwells on the intimate relationship of the body to the world – here the ground itself, as point of origin and measure. *Rise* 1983–4 is horizontal too, on its back, yet the rise of its head, slight yet significant, is a sign of sentience, a first moment, an awakening.

Gormley's sculpture *Three Ways* 1981 (fig.18) was shown in the 'Aperto' section at the Venice Biennale in 1982. It brought him to the attention of the Italian dealer Salvatore Ala and led to his first relationship with a commercial gallery: he showed with Ala in Milan and New York for a decade. A version of the large exhibition at Ala's New York gallery in 1984, his first solo show in America, was brought to the Riverside Studios in West London later that year. It provided Gormley with an

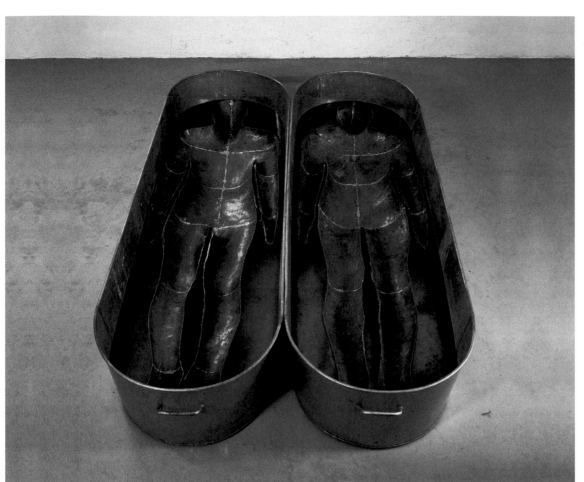

CHROMOSOME 1984 [27]
Lead, zinc, water
46 x 200 x 120
Collection of Museum Würth,
Künzelsau, Germany

DESERT (FOR WALTER) 1983 [28]
Lead, fibreglass
22 x 215 x 126

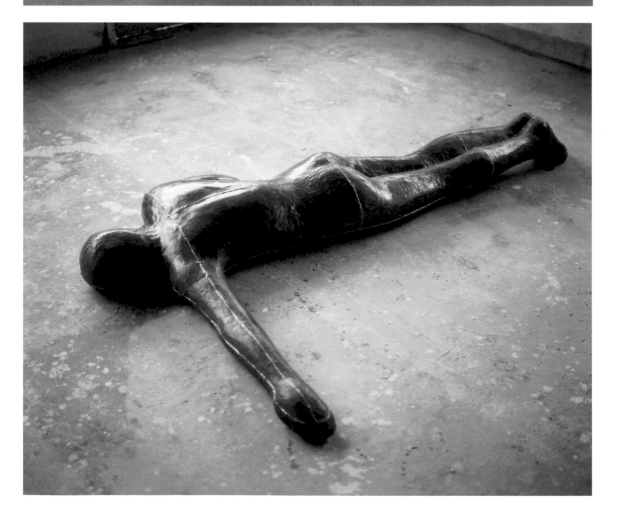

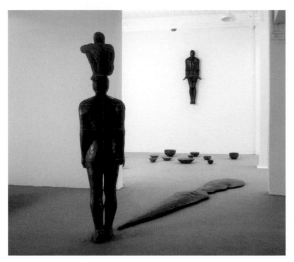

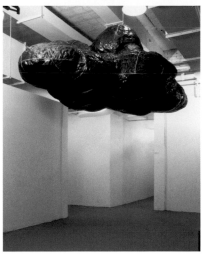

THE BEGINNING THE MIDDLE THE END
1983–4 [29]
Terracotta, lead, air, plaster, fibreglass
235 x 300 x 75
Installation view, Riverside Studios,
London

MIND 1983–4 [30]
Lead, fibreglass, lifting gear
155 x 440 x 275
Installation view, Riverside Studios,
London

opportunity to bring together and make an account of the range of his recent works. He showed body works mainly, alongside a few earlier pieces and a number of tableau-type works that included terracotta figures and forms, on the floor, walls and ceiling of the gallery. It included, too, *Chromosome* 1984 (fig.27), the first work since *Bed* 1981 in which the artist presented a 'doubling' of the body form, an ongoing interest of his. The exhibition brought works into close contact with each other, around an enveloping theme of mind and matter, material and immaterial. A body's shadow is rendered as a hovering lead form, and a giant body cloud, *Mind* 1983–4 (fig.30) – the first wholly 'invented' form he had ever made – hangs from the ceiling, heavy metal as weightless matter, a solid construct for a fugitive form. With *Tree* 1984 the exhibition introduced the first of a series of sculptures in which Gormley subjected the body form to extreme distortion, extending its neck till the head reached ceiling height, objectifying a common 'out of body' experience, an expression of the mind reaching beyond the body's bounds. A different sensation of the uncanny is generated by a number of works from 1985 on which attach to the architecture of their surroundings and, in their orientation, defy gravity and test the viewer's own sense of stability. *Edge* 1985 (fig.33) is neither a standing nor a lying figure, but emerges rigid and horizontal from the wall, like a 'lever on the space' at our knee height – or the height of a bed – evoking a state of dreaming, another out of body experience rendered insistently present in our own real space.

In the later 1980s, as Gormley's bodies come increasingly to engage with specific sites and the space they occupy, the stiff, upright, hieratic pose comes to dominate. He had become mindful, too, of the toxic properties of the lead, and the dangers they posed to him and to those around him. In a significant move,

Gormley began in the late 1980s and 1990 to make, alongside the lead body-cases, solid body-forms in cast iron (a 'concentrated earth material'), heavy works weighing almost a ton, which could be replicated. The lead body-cases in these years became, in his words, 'increasingly hermetic', wholly internalised pressure chambers. *Sovereign State* 1989–90 (fig.31) and *Instrument II* 1991 (fig.32) have expanded the volume of the body; they resemble sarcophagi, sealed systems, no longer asserting a connection between the hidden interior and the revealed surface. In the two works entitled *Still Feeling* 1992–3 (fig.34) the body has become an irresponsive, linear element, a unit, abjectly turned towards the wall.

'My project has been to find again the place of the body in the space created for art by modernism,' Gormley declared in 1991.[60] On a number of occasions he has spoken of the body as the 'lost subject' of modern art; he sets his faith in its affective potential, its power to provoke feelings of empathy and engagement, against the prevailing attitude in modernism of objectivity, appraisal and detachment exemplified by Marcel Duchamp's 'readymades' and the widespread currency of the 'found object'. His body sculpture *Lost Subject* 1994 (fig.35) reacts against the repression of vitality that had entered his own body sculptures in the late 1980s, and seems to connect, finally, to a potent seam of physicality and sensuality running back through the Romantic tradition, to Michelangelo's writhing slaves and the languid, overt sexuality of works such as the reclining Graeco-Roman *Barberini Faun*. *Lost Subject*, lying on its back, is no longer regimented and symmetrical but at ease. Gormley recognised it as a sort of last gasp, a relaxation of the rules, an end point of one particular line of enquiry. By 1990, however, he had found other ways out of the impasse.

SOVEREIGN STATE 1989–90 [31]
Brass, lead, plaster, fibreglass,
air, rubber hose
Figure: 66 x 172 x 98; hose length:
300m; hose diameter: 3.5

INSTRUMENT II 1991 [32]
Lead, fibreglass, plaster, air,
optical lens
213 x 74 x 51

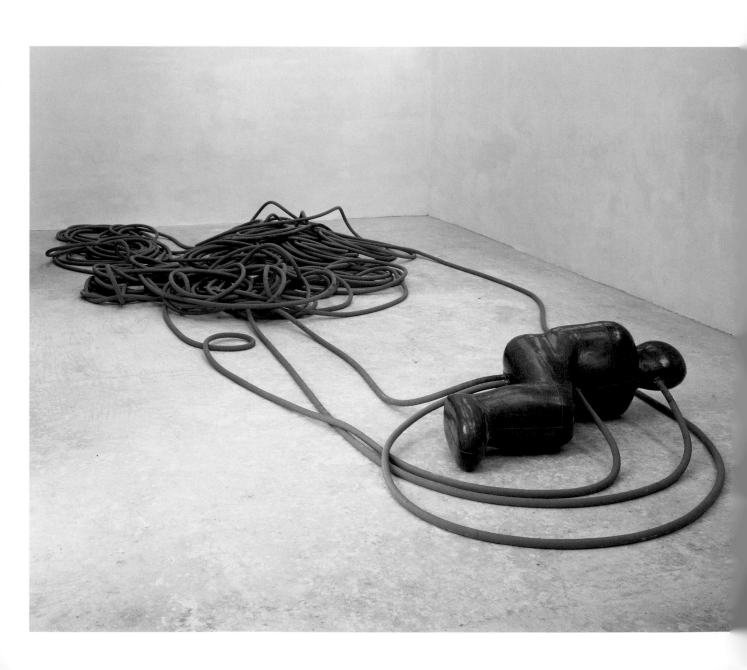

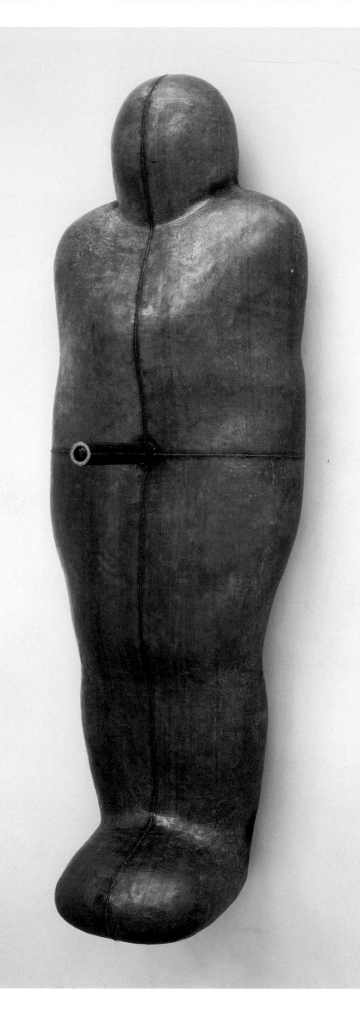

EDGE 1985 [33]
Lead, fibreglass, plaster, air
25 x 58 x 195

STILL FEELING (CORNER) 1992–3 [34]
Lead, fibreglass, air
197 x 53 x 36

LOST SUBJECT I 1994 [35]
Lead, fibreglass, air
37 x 149 x 228
Collection of Israel Museum,
Jerusalem

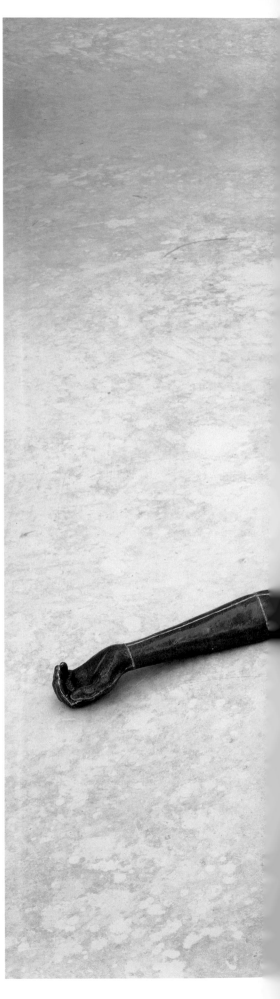

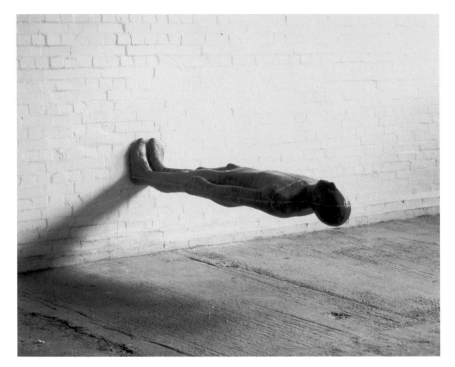

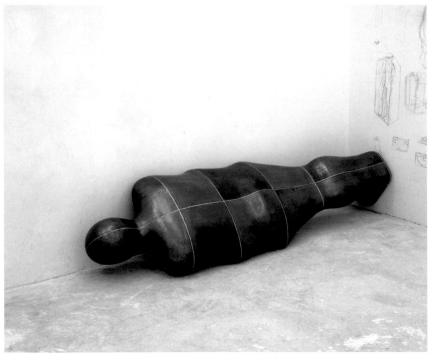

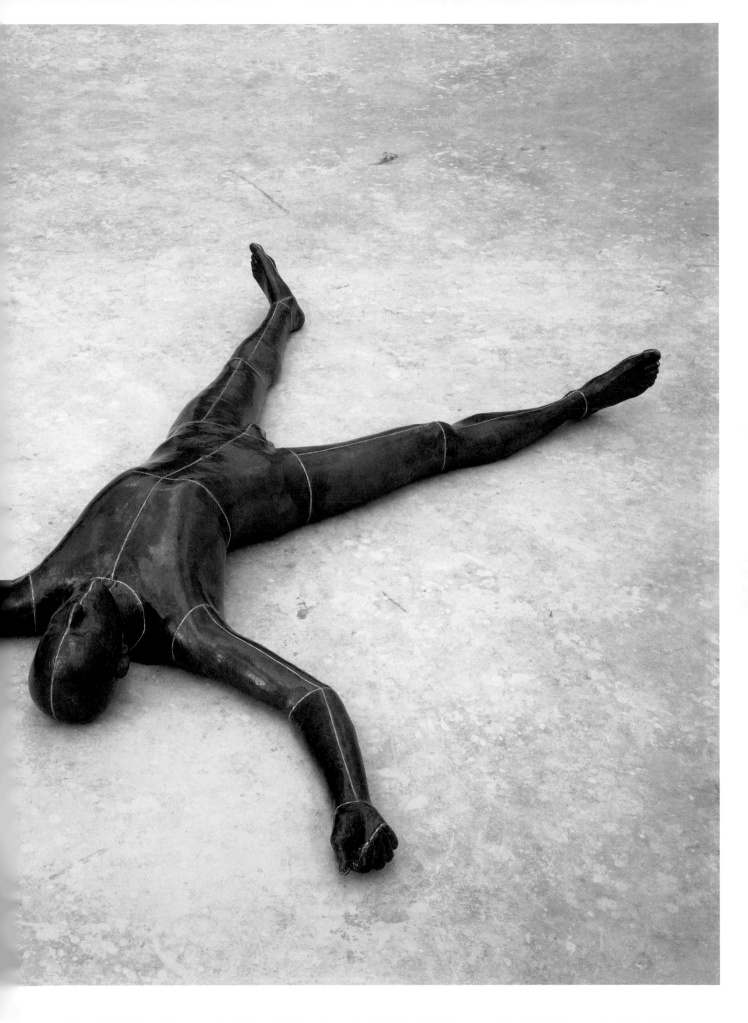

858 centimetres from wingtip to wingtip, *A Case for an Angel II* spans the space in which it is shown, almost touching the wall to each side, impeding passage: the level top line of the wings, around eye level, acts as a horizon up close, denying most of those who approach it a view beyond. The work insists on a confrontation: the artist describes it as 'a barrier against which the viewer tests himself'. It establishes a dialogue both with the viewer and with the space it occupies, the room as a container. Gormley made three versions between 1989 and 1990; 'I wanted to make a bodywork that was a visual block – like a wall or a piece by Richard Serra. These sculptures are the final expression of the extended works.'[61]

A Case for an Angel is an extension, in every sense, of the line of standing figures, arms outstretched such as *Standing Ground* 1986–7, that punctuate Gormley's progress through a wide range of bodily attitudes over the 1980s. Messenger and mediator between heaven and earth, divine and human, the angel embodies the coexistence of mind and matter, the principles of rootedness and liberation. The insistent vertical of the figure and the stretched horizontal of the wings suggests, among other things, an encounter with minimalism and abstraction. The 'extended works' that Gormley speaks of, such as *Field* 1984–5 (fig.38), a standing figure with a 6-metre arm span, and *Tree* 1984, a figure with a similarly elongated neck, were expressions of a mental state or aspiration that strained against the bounds of the body. Another work, also a precursor, was *Vehicle* 1987 (fig.39), a full-scale lead case for a one-man glider, an airborne structure that itself can be seen as an extension of the human body, affording it the greatest possible self-reliance in the defiance of gravity.

A Case for an Angel addresses the entrapment of the human body, the difficulty of floating free, but also man's enduring aspiration to transcend this difficulty. 'Angels are the quintessential creatures of imagination and are an argument for the very existence of Art itself,' Gormley has written. And, in an interview in 1993 with Declan McGonagle, he acknowledged 'the sense that the shape of my life was known somewhere else was something that I grew *up* with, and is both a limitation and a kind of enabler, because I don't think I would have set off at eighteen into the unknown without a guardian angel'.

DECLAN MCGONAGLE So *A Case for an Angel* is a declaration of faith?

ANTONY GORMLEY Each *Case for an Angel* is a declaration of inspiration and imagination. It is an image of a being that might be more at home in the air, brought down to earth. On the other hand it is also an image of somebody who is fatally handicapped, who cannot pass through any door and is desperately burdened . . .

A Case for an Angel is not ironic. I do believe that we can be transported or be the agent of our own transcendence. Maybe transcendence is the wrong word – but the idea that flight, in gliding, depends on weight and its correct position, is fantastic. I like the marriage of anatomy and technology. It isn't a kind of Icarus – you know, the little bird feathers. I want something that is very concrete. In terms of the idiom, you can see the technology and we know that it works.[62]

A CASE FOR AN ANGEL II 1990 [36]
Plaster, fibreglass, lead, steel, air
197 x 858 x 46
Installation view, Konsthall Malmö,
Malmö 1993
Collection of Takaoka Art Museum, Japan

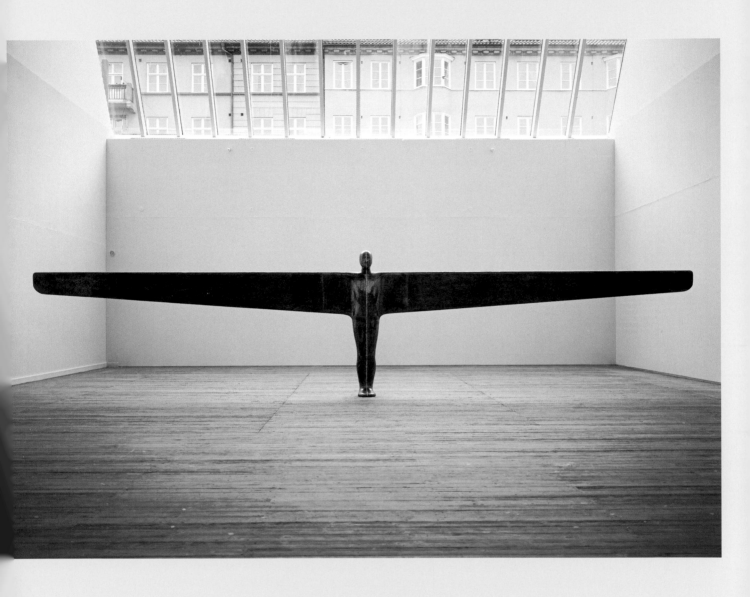

A CASE FOR AN ANGEL II 1990 [36]
Plaster, fibreglass, lead, steel, air

creation is its own metaphor
intelligence is its own mirror

The first two versions of *A Case for an Angel* are very similar, displaying clearly their evolution from the form of the glider. *A Case for an Angel III* 1990 has a much shorter wingspan; the wings are less tapered and elegant, more of a physical barrier. *Poles Apart* 1996 (fig.40) presents two similar figures, body forms cast in iron, facing each other across an enclosed space that the viewer, entering to stand between them, senses as a charged arena of confrontation. But the greatest transformation, and the culmination of the idea, envisaged in 1995 and finally erected in 1998, was *Angel of the North* (fig.1). Gormley's comments on the landmark sculpture permanently installed outside Gateshead in north-east England reveal the artist's ambiguous stance:

It's evidently an object that's been made from the ground up, it's never going to fly. It's burdened as much as it is blessed by these hopelessly out-of-proportion wings. I'm trying to present there my own perplexity about what happens to human beings when they accrue to themselves attributes that were formerly considered divine. The idea of being able to fly – up until 1911, with the flight of the Kitty Hawk – that was also something divine, miraculous. We've assumed these things as normal parts of human existence. And I suppose the Angel *is an attempt to embody questions about how we have changed as a result of assimilating these divine attributes, to what extent are our bodies now dependent upon and implicated in technology?*

The wing is a way of describing the fact that we have become irrevocably associated with techniques that we are now indistinguishable from. And that's a transformation. Even though it reads like a crucifixion and something very familiar, I think it is an attempt to say that technology is a handicap as well as an advantage…[63]

FIELD 1984–5 [38]
Lead, fibreglass, plaster, air
195 x 560 x 66

VEHICLE 1987 [39]
Lead, fibreglass, wood, steel, air
147 x 750 x 1520
Installation view, Salvatore Ala
Gallery, New York

POLES APART 1996 [40]
Cast iron
2 figures: each 194 x 469 x 33
Installation view, Jablonka
Gallery, Cologne 1998

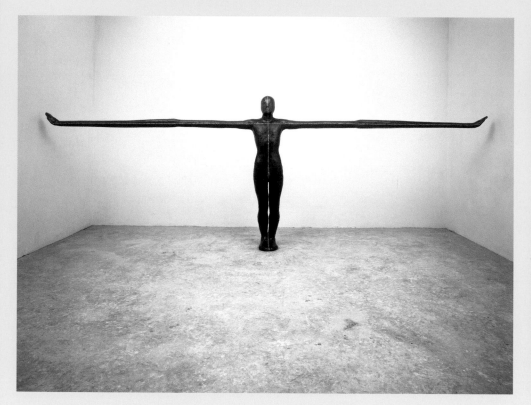

FIELD 1984–5 [38]
Lead, fibreglass, plaster, air
195 x 560 x 66

VEHICLE 1987 [39]
Lead, fibreglass, wood, steel, air
147 x 750 x 1520
Installation view, Salvatore Ala
Gallery, New York

POLES APART 1996 [40]
Cast iron
2 figures: each 194 x 469 x 33
Installation view, Jablonka
Gallery, Cologne 1998

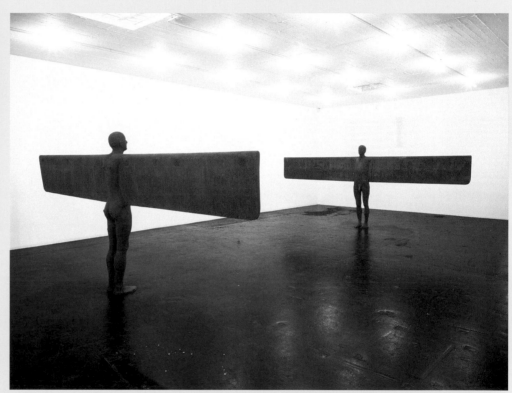

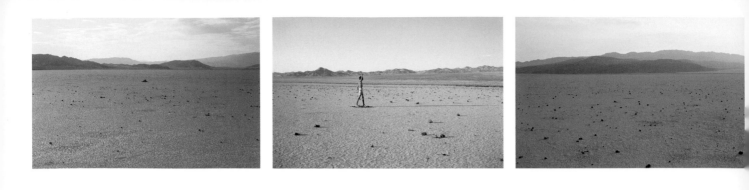

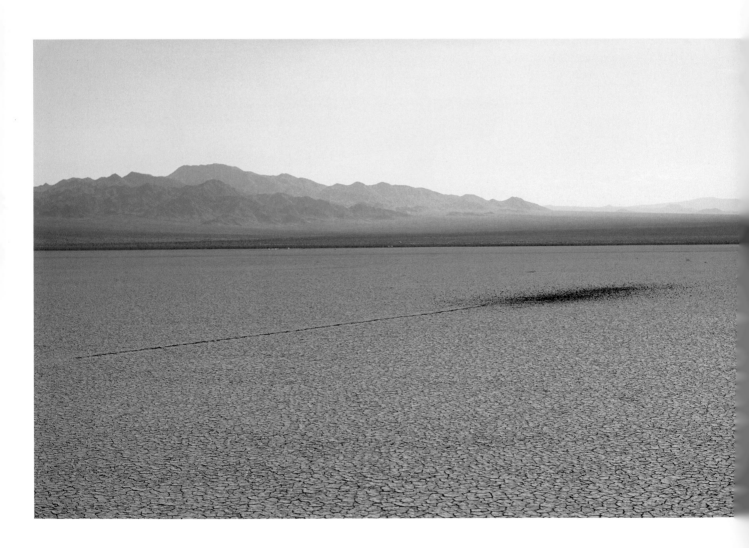

REARRANGED DESERT 1979 [41]
Temporary installation, Death
Valley, Arizona

EXERCISE WITH MUD
(ARIZONA) II 1979 [42]
Mud
Length: 10m
Temporary installation

EARTH ABOVE GROUND

'The earth supports us, and provides us with common ground. It is the earth which makes communication possible, and the earth seems to reoccur in my work as a first principle.'[64]

Although Gormley talked of his work in such expansive terms in 1981, his artistic activity throughout the 1980s led, in one sense, almost to a retreat. It was to be largely studio-bound, and his body forms and his materials – lead and iron – involved working processes that were laborious, time-consuming and, in every sense, centred on the artist. By the end of the decade he was, as he put it himself, feeling 'extremely isolated', confined by the conditioned spaces and narrow concerns of the art world, and in need of 'a way out of the body'.

He had always been drawn to the idea of sculpture – ancient or modern – rooted in the earth, from the megaliths carved in volcanic rock on Easter Island to the projects of the American Land artists of the 1960s and 1970s. He made an early visit to the United States in 1979 (funded by a bursary from the Slade) in search of the masters of the American school and, as he describes it, of 'a sort of lineage' for himself as a sculptor.[65] He went first to New York, where he met the veteran Japanese-American artist and stone carver Isamu Noguchi, a one-time assistant of Constantin Brancusi, and the sculptor Richard Serra. From there, he struck out west, in a pilgrimage to find the celebrated monumental 'site-specific' earthworks of Michael Heizer and Walter De Maria, Land art sculptures on a gigantic scale which subjected desert sites of untouched nature to the artists' strategies of ordering, measurement and wholesale transformation.

The desert afforded Heizer a vastness of scale and sense of geological time, the 'kind of unraped, peaceful, religious space artists have always tried to put in their work', as he put it.[66] In 1969 Heizer had made a colossal earthwork, *Double Negative*, in the Mohave Desert of Nevada, two passages cut 30 metres through the sandstone bed of the mesa, facing each other across a deep ravine. 'We looked very hard for *Double Negative* but couldn't find it,' recalled Gormley. He was more fortunate with De Maria's *Lightning Field* 1977 in New Mexico, a grid of 400 thin stainless-steel rods, driven into the earth 67 metres apart in a rectilinear grid 1 km x 1 mile across, with the distant blue mountains as backdrop and the immense sky (and electrical storms) above. It was, Gormley recalls, 'an incredible moment for me: the feeling of space, and the fact that the work was completely indistinguishable from where it was … it endured in the way the Parthenon endures, without any need to mythologise or monumentalise, a sort of acupuncture of the landscape.'[67]

Such works demanded an immense terrain; they were at one with it, with the flat earth, unbounded to the horizon. In the midst of this American Sublime, and in the Arizona Desert where De Maria, ten years before, had made his *Mile Long Drawing*, Gormley made works of his own, slight in themselves and yet prophetic: a series of actions, which he recorded in photographs. In *Rearranged Desert* 1979 (fig.41), he gathered in a cairn, from the desert floor, stones from within the radius of a stone's throw, and then threw them again as far as possible from the central position of the cairn: the desert rearranged.

This action might perhaps owe something to Richard Serra who, ten years earlier, had made a work, *Splashing* 1969, by throwing molten lead against his studio wall. Gormley describes his work like this:

Rearranged Desert is the first artwork which implicates the body in a field effect … it was also trying to think about the legacy of Richard Long and what he'd left out … not about leaving an abstract mark in

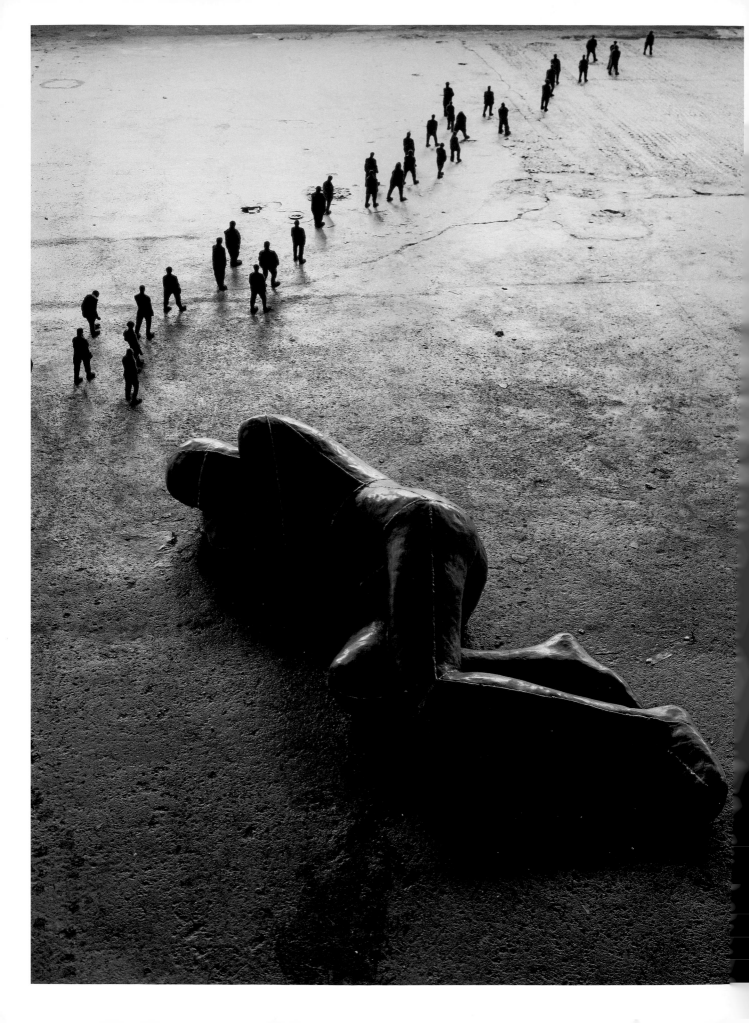

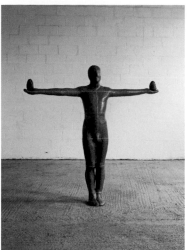

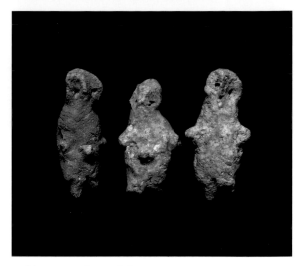

MAN ASLEEP 1985 [43]
lead, plaster, fibreglass, air, terracotta
large figure: 50 x 185 x 63;
small figures: overall 14 x 600 x 30

WORK 1984 [44]
Lead, terracotta, fibreglass, air
195 x 192 x 30
Bonnier Collection, Stockholm

Neolithic terracotta figurines [45]

an organic environment but doing something different …where the strength of the human body was somehow registered in a way that left very little trace at all…there were molecular allusions, cosmological allusions…the desert didn't look that different after I'd left.[68]

He made a second piece at the same time, *Exercise with Mud* 1979 (fig.42), in which he moved across the desert floor picking up the sundried plates of mud in his path a piece at a time, first in a straight line and then in a spiral, throwing them behind him so that they shattered into dust, to effect a 'relocation of earth'. The American Land artists, working between the desert and the New York galleries, had already proposed the idea of relocation as a conscious artistic strategy. Robert Smithson, in 1967, had coined the term 'Nonsite' to describe material brought from a particular (often faraway) place to be displayed as abstract forms in the gallery; 'a dialogue between indoors and outdoors', as he explained. The world brought into the gallery has remained a powerful idea for Gormley. Around this time he visited De Maria's New York *Earth Room*, a sculptural work first shown in the city in 1997 and permanently installed there in 1980, consisting of 250 cubic metres of black soil spread deep across the floor of a SoHo gallery. The experience was to stay with him and resurface in his own work.

Gormley had already used earth in some of his sculptures in his early works: it filled the three-part lead sculpture *Three Bodies* 1981 (see fig.13). But, as the artist recounts, 'In about 1984 I discovered that clay was an important material. The forms arose naturally from the space between my hands; clay was another way of dealing with the flesh. Out of this the very first ideas of the *Field* work came.'[69] Many of the works in his 1984 Riverside Studios exhibition had combined and contrasted the lead of the body cases with

terracotta figures and other forms, which in their freedom and spontaneity seemed to stand for the imaginative faculty, the creative principle. Since Neolithic times clay has been sculpture's most available and most readily formed material, and Gormley has frequently referred to clay's capacity, essential to life, to store and transfer energy.

In *Work* 1984 (fig.44), a lead body-form stands with outstretched arms, a clay figure in each hand; the 'work' of the title is the act of creation itself. Gormley saw the sculpture as 'a sort of talisman for *Field*'.[70] Clay is packed and kneeded around the erect penis of his body case *Matter* 1985. In *Man Asleep* 1985 (fig.43), tiny clay figures file past a recumbent, unconscious body: a joining of man and humanity at large, those who came before, or those yet to come? And in works that followed, *Night and Day* and *Twenty Four Hours*, both of 1988, multiple small clay figures march in line, as Gormley conjured a cipher that 'stood for the human population'.[71] But these works, as Gormley realised in retrospect, remained *illustrative* of an idea rather than embodying it, as *Field* was to do.

The first version of *Field* (fig.47), shown at the Salvatore Ala Gallery in New York in 1989, included around 150 small clay figures: simple, prehistoric-looking hominoid forms, covered in black slip, set on the floor in radiating straight lines to form a circle. For the first time, these small figures appeared as a distinct entity in themselves, independent of the life-size form of the artist's body. A second version, and a significant stage further, followed less than a year later. Gormley's sculpture *Work* 1984 had been included in *The British Show*, a large survey of young and mid-generation British artists that toured Australia and New Zealand in the mid-1980s, and the exhibition led to an invitation, some time later, from the show's curator Tony Bond to undertake a residency and make a

Forming a figurine for FIELD
(AMERICAN), December 1990 [46]
St. Mathias, Cholula, Mexico

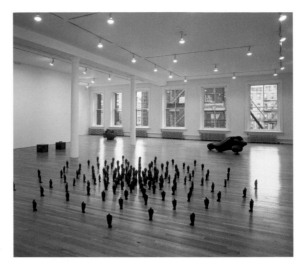

FIELD II 1989 [47]
Terracotta
Each element approx. 20
Installation view, Salvatore
Ala Gallery, New York

project there. And to another desert: the Great Australian Desert, a remote expanse of red dust and clay pans in the interior. In two works made in Australia in 1989, Gormley sited a concrete shell construction, a container scaled to accommodate a crouching figure, in the middle of this barren terrain: *Room for the Great Australian Desert* (fig.60). Back at the gallery, in Sydney, he installed a counterpoint, a second version of *Field* 1989, later to be entitled *Field for the Art Gallery of New South Wales* (fig.48). Here a total of 1,100 clay figures – fashioned from the desert's red clay – were arrayed in a form that suggested a magnetic field or the cross section of a brain, around 10 metres across. A clear pathway through the work allowed the viewer in between two hemispheres to the dense core of this 'field of energy', the point to which each small figure turned its gaze.

As the idea of *Field* developed over the next years in successive versions, its dimensions and scale increased exponentially: the very spontaneity and simplicity of the making process allowed for an expansiveness and – crucially – a new working process. For the first time, in Australia, the artist engaged the help of others directly in the making of the work. A handful of students helped make the figures, which Gormley 'finished' by piercing their eyeholes. And here the leap was made: he was no longer acting alone. Of course he had relied on the practical help of assistants before – most notably from his wife Vicken, who applied and prised him from his shell of plaster, and from others, for technical aid and to hasten the laborious process of making the lead cases – but here, in the repetitive making of many clay figures, he had enlisted the help of a tribe, and to a measured but significant extent passed over to them a share in the work's creation.

The first full-scale version *Field III* 1990 (figs.54–7), made in Mexico in 1990, celebrated and enshrined this

new way of working: Gormley shared the act of making the work fully with many others, locals and craftsmen, who worked to his basic instructions but independently of him. He saw *Field* as a 'monument in pieces', and has spoken of it as a 'folk object', a 'crude return to a tribal condition, in terms of relying on a form of collective making'.[72] It signalled his escape from the studio and the narrowing concerns of the contemporary art world, a release from the role of author, originator and subject of his work. *Field* was a controlled experiment in collaboration. It engaged and celebrated the contingencies and inspirations of individual and communal activity and creativity and fully expressed, maybe for the first time, Gormley's aspirations for an art that connected with the earth and with the people who worked it. The making of the work justified the work itself: the makers were the only audience the work needed.

Field was first shown not in Mexico but at Ala's New York gallery. The front room of the space, lit but empty, led via a corridor to a further room, occupied by the terracotta figures tightly packed from wall to wall, facing the viewer who was held at the threshold. The first impression was of a sea of undifferentiated forms extending across and beyond the field of vision; the next, almost immediately, of each figure's mute, unflinching return of the viewer's gaze. Outnumbered 35,000 to one, the viewer again became the object of scrutiny.

Gormley has spoken of *Field* as 'the infection of the white cube by earth,'[73] and, in more expansive terms, as 'the unconscious and the third world brought right into our living room to occupy space'.[74] He has described it as an assertion of the one-ness of humanity, the globalisation of culture, of a shared consciousness – at once an omen and an alarm, sending a host of silent questions from the natural realm to the developed and unsustainable world of urban civilisation. *Field* yields

FIELD FOR THE ART GALLERY
OF NEW SOUTH WALES 1989 [48]
Terracotta
23 x 1140 x 1050
Installation view, the Art Gallery
of New South Wales, Sydney
Collection of the Art Gallery
of New South Wales

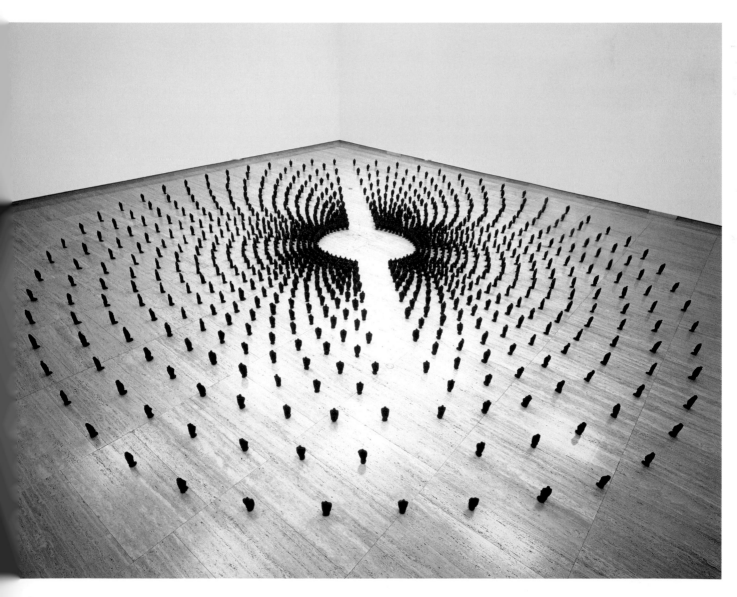

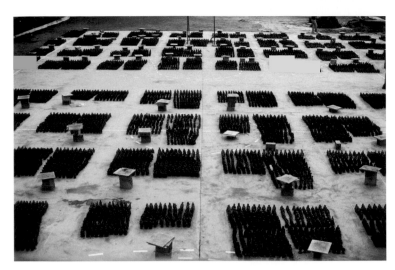

Making ASIAN FIELD 2003 [49]

readily to multiple readings, and while the work has attracted negative or sceptical comment from some quarters on its subsequent worldwide travels – the accusation of 'exploitation' of an innocent workforce being an easy and obvious one – the phenomenal ability of *Field* to provoke feelings of awe and anxiety in the viewer has proved hard to deny. Rod Mengham has recounted his 'sense of being on the receiving end of something very remote from modern sensibilities'.[75] 'We give these rudimentary beings personalities where none exists,' wrote the critic Adrian Searle; 'it is entirely our imaginations which are at work in the baked clay forms'.[76]

After its public debut in New York, *Field* embarked on a two-year tour of North America, showing in museums and public galleries in Fort Worth, Texas, in Mexico City, in La Jolla, California, Washington, D.C. and Montreal. Another *Field* took shape the following year (1992) in Porto Velho, in the Amazon Basin, and was shown at the Museo de Arte do Rio de Janeiro in an exhibition, *Arte Amazonas*, at the time of the Earth Summit held in the city. Hardly had these two projects come to a rest before two further versions, each of around 40,000 figures, took shape on another continent. *European Field*, made in the spring of 1993 in a village outside Malmö in Sweden, was exhibited at the Malmö Konsthall and travelled south through Eastern Europe – to Warsaw, Ljubljana, Zagreb, Budapest and Prague, Tallinn, Riga and Vilnius. *Field for the British Isles*, made in St Helens on Merseyside, showed in Liverpool and Dublin before travelling widely over the next two decades to dozens of towns and cities across Britain, where it was installed in spaces as bereft as a vacant supermarket building in Colchester city centre and as hallowed as the Joseph E. Hotung Gallery at the British Museum in London, a stone's throw from the Egyptian galleries that had struck Gormley so forcibly as a child.

The last and largest version of *Field*, a decade later, marked a culmination of what had become a truly global project. *Asian Field* 2003 took shape in the yard of a primary school in Xiangshan village, near Guangzhou in China. A total of 214,000 figures were fashioned from 127 tonnes of clay by 100 clay workers and 340 'makers', often 3 generations of the same family, labouring long hours over an intense 5-day period. *Asian Field* was shown first in an underground car park beneath an apartment block in Guangzhou (at the height of the SARS epidemic that originated in the province), and later at the National Museum of Modern Chinese History in Beijing. Looking at the ranks of assembled body forms in the photographs that documented the work's making in Xiangshan,[77] it is hard not to think of China's terracotta army of horsemen, the majority of them still buried beneath the earth of Shaanxi Province. Yet even with this tour de force, Gormley was reluctant to admit any sense of finality. To a Chinese interviewer he confessed: 'I hope that *Field* is never finished, that it is never fully possessable, that it is more like an infection.'[78]

On its first showing in a non-gallery space, at the Old Jail in Charleston, South Carolina, back in 1991, *Field* had been shown alongside a singular and oddly compelling installation of Gormley's, *Host* 1991, an entire room flooded with thousands of litres of dark mud and water from the nearby estuary, which gave off its elemental, overpowering odours, and reflected on its flat surface the outdoor light from the windows. *Host* was another form of 'field', a landscape, a rectangular, minimal, 'modernist tabula rasa', as Gormley put it: it was an uncultivated outside brought indoors and yet 'the potential for life was there'.[79] Six years later, in 1997, *Field* and *Host* were again installed side by side, in the Kunsthalle at Kiel in Germany (fig.51). Here *Field* ranged across the galleries of the

ASIAN FIELD 2003 [50]
Clay from Guangdong province, China
210,000 hand-sized clay elements
made in collaboration with 350 people
of all ages from Xiangshan, northeast
of Guangzhou, South China
Installation view, Xinhuahuayuan
Huajingxincheng, Guangzhou
Commissioned by the British Council 2003

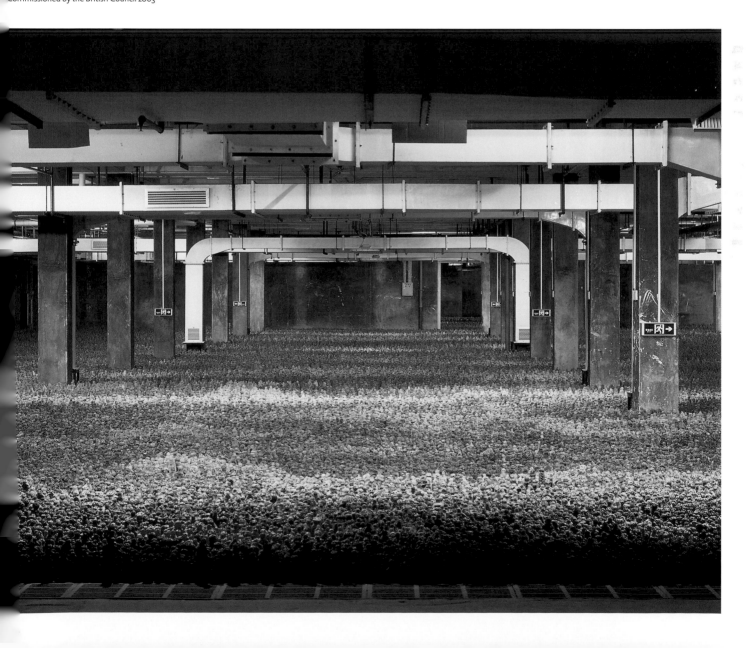

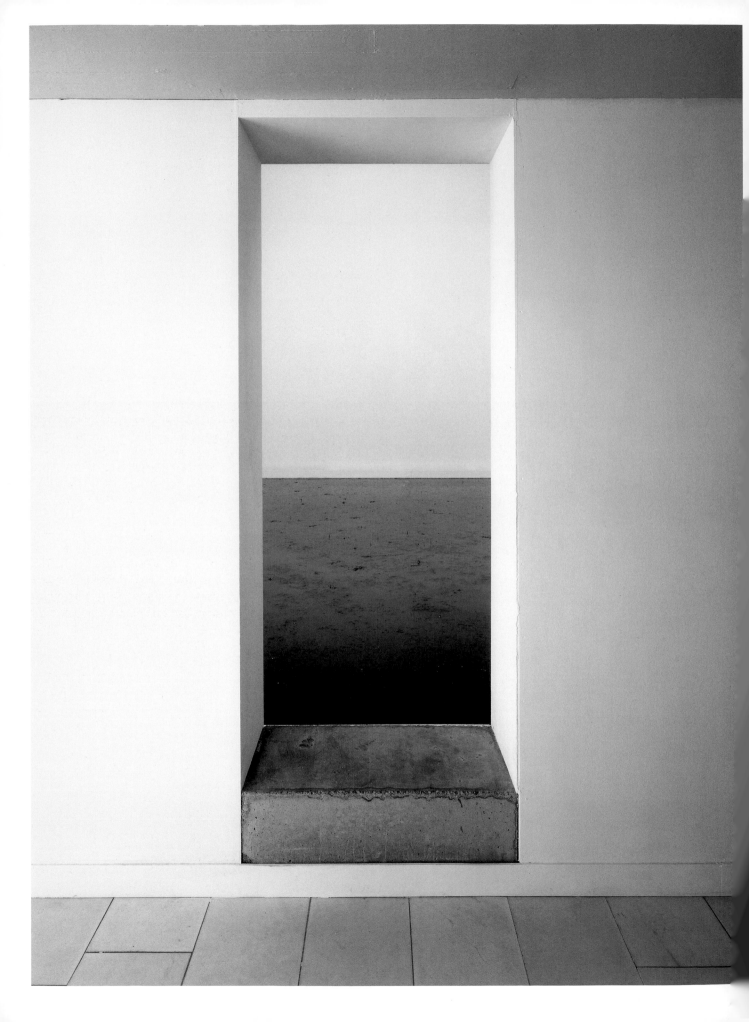

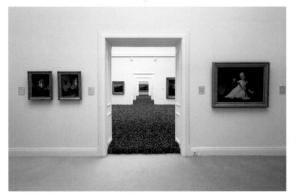

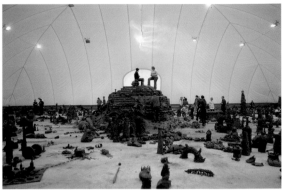

HOST 1997 [51]
Mud, seawater
Overall depth: 13
Installation view,
Kunsthalle zu Kiel, Kiel

EUROPEAN FIELD 1993 [52]
Terracotta
Approx. 40,000 elements:
variable sizes, each 8–26 high

CLAY AND THE COLLECTIVE BODY
2009 [53]
An IHME project commissioned by
the Pro Arte Foundation, Helsinki,
Finland 2009

historic collection under the watchful presence of the paintings – two cultures, two histories, face to face – while *Host* spread through the contemporary wing of the museum, using mud pumped from a nearby inland heath. The very prospect of this incursion into the fine white spaces of the museum, as can be imagined, caused as much of a stir as the appearance of *Field* in the adjoining galleries: the work constituted an intrusion of primeval chaos as well as a blank canvas, 'a place where all possible forms to come lie … it invites the viewer to to invent them.'[80]

The conditions for creativity and chaos were marshalled again – in a yet more extreme form – in a project called *Clay and the Collective Body*, which Gormley orchestrated in April 2009, in Station Square in the centre of the Finnish capital, Helsinki. A hundred and two tonnes of soft clay, in the form of a gigantic cube, was presented in an inflatable dome in the middle of the city, to be worked with and transformed, at Gormley's invitation, over a period of ten days by hundreds of the city's inhabitants. The rules of engagement were deliberately set open, with no defined end in mind as there had been with *Field*. Gormley, as artist, withdrew, and people of all ages – another tribe – made of the material what they wished. They worked individually or (as time went on) together, down on the ground, for hours or even days, removed from the noise and diversions of the outside world, sheltered and fed and cocooned in a huge, bright, white protective sac, a 'warm and humid space' filled with the clinging smell of wet clay.

The rigid geometry of the 'starting block' was dismantled bit by bit, by human hand: the cube became a ziggurat as block upon block was cut from it, then sagged and collapsed; figures, animals, heads, skulls and more inchoate shapes, comic, touching or grotesque, were formed and reformed across the floor

space. Gormley saw the work as a challenge to the very notion of the artwork as a finished object, a commodity with an exchange value. Here he witnessed other forms of exchange enacted with a calm intensity and intimacy over time: exchange of energy, between people, between body and clay, the base material. The participants, the makers of the work, were their own audience, and the work itself resided as much in their memories of the experience as in the resulting clay forms, the residue of a collective activity. The scene was an 'entropic field' to be viewed over time, day after day, a landscape of infinitely varied and varying physical forms and actions in a state of simultaneous becoming and disintegration. 'This is about reconnecting flesh with earth through touch,' he claimed. 'We are all makers, we are all making a world.'[81]

'The work should be natural like breathing; you grab a piece of earth and mould it into a shape, just like an extension of your body.'[82]

The first full-scale version of the work, *Field III*, was made in the small village of San Matias, near Cholula in the state of Puebla, east of Mexico City, over three weeks in December 1990, by around sixty members of one extended family called Texcla. Gormley described the making of the piece at the time of its first showing in New York soon after:

There are large numbers of brick makers in this area of Mexico (population 100,000) working in family units out of doors and in open-walled buildings called 'gallerias'. They understand working in large numbers of units, but this project was not such mechanical labour. Each person found his or her own way of working and their own form of work. There were few instructions – to make the pieces hand-sized and easy to hold – to make sure the eyes were deep and close – and to try to get the proportions of the head to the body as it should be (in general there was a tendency to make the heads larger).

It was extraordinary how confidence grew from tentative and primitive beginnings to a growing familiarity in the rhythms of the work. The procedure was kneading the ball of clay that felt good in the hand, moulding the body quickly between the palms, pulling up the head, pushing in a sharp point to form the eyes (at first with a nail, then as days passed a wetted, sharpened ice-lolly stick seemed preferable). The pieces were allowed to dry a while on their backs and finally stood up, checking that their heads looked up. The process of finding a way of working was not without tension. I had wanted us to work together but because of the geography and the independence of parts of the family it became easier to work in two places – a certain rivalry came into it, a certain pride in having made 'better' or more work than the cousins . . . The rhythm of work went through good and bad days – sometimes when the feeling was there it was wonderful – with everyone enjoying being together and the children reluctant to go to school. Sometimes it was difficult – like after the fiesta of Our Lady of Guadalupe on 12 December, when the family was reluctant to shed the holiday atmosphere and go on with the work.

There was some interest in the growing field of figures outside the 'galleria' and some speculation as to what it was. I explained that what I hoped for was to make an image of the people yet to be born – of a future made of the earth. I think they liked the idea of the men and women of the future.

Making FIELD (AMERICAN), San Matias,
Cholula, Mexico 1990 [54–57]

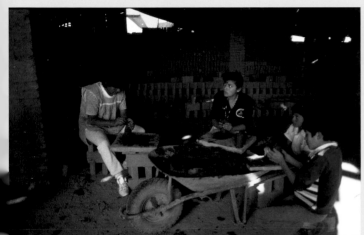
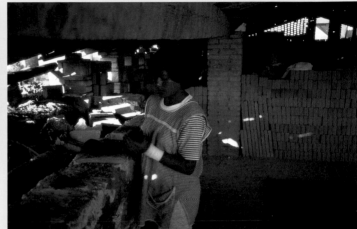
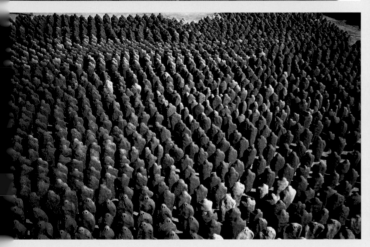
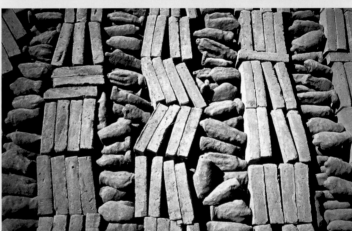

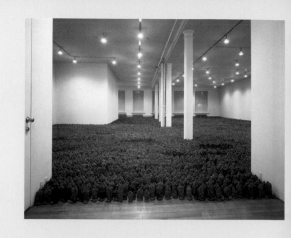

The pieces were oil-fired in three kilns – by interweaving them with layers of bricks and tiles. The firing lasted 24 hours. The colour of the individual pieces reflects their position in the kiln – the ones nearer the flame being darker – those to the top and sides being lighter – the majority being a rich red. The clay comes from the valley floor a few miles to the southwest of San Matias.

I went to Mexico hoping to find people who would work with clay in a natural way – I found that and much more. The work conveys this better than words.[83]

Speaking of the work since, Gormley has laid stress on the hand as the point of transference, between idea and object, mind and matter, and between people: 'With *Field* joy in material contact is there: it is about touch and touch expressed for its own sake. Touch not just of my hands but of many people's hands.'[84] He has described the process of its making as a 'collision between identical (serial) production and organic form'; 'we liberated this bit of earth, this clay, from being the uniform brick,' as he put it.[85] In reflections on the work and its genesis, the artist casts the activity of making as a natural process, close to the land and the rhythms of the land, connecting back to patterns and rhythms of productivity and creativity over time:

Making one thing after another for minutes, hours, days, weeks – making each moment a form that arises from the hands like a bird from the nest, a fruit from a tree, a breath from the body. Part of the unfolding rhythm of life, working in the clay, like walking. First learning to walk and then just moving, the flow of time punctuated by making the eyes. Often, row follows row until at dusk a hundred or two hundred little people stand looking back at you.[86]

It is a kind of harvesting – it's about tilling the earth with your hands but instead of making something grow, it is the earth you are forming directly. The harvest comes from within the people, or the thing that is growing comes out of the people. Everyone has their own row and throughout the project they continue to do row after row on the same strip like the old medieval strip field and they build up a very strong relationship with that patch of earth. Those gazes they are seeding in the clay look back at them as they are working, suggesting consciousness is not only inside.[87]

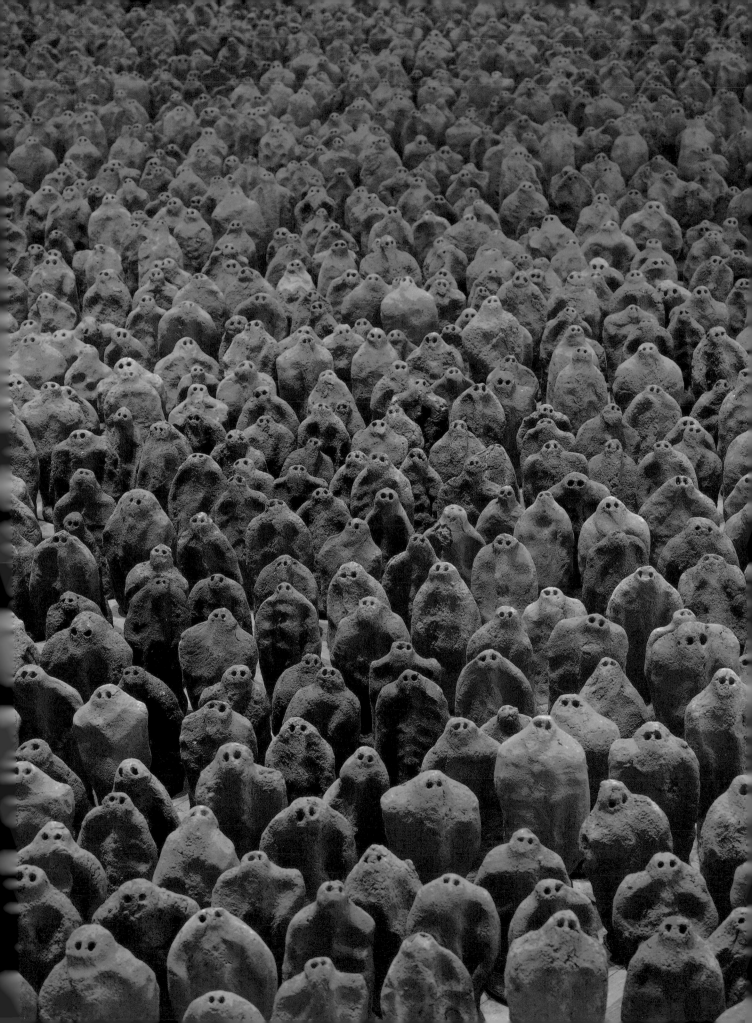

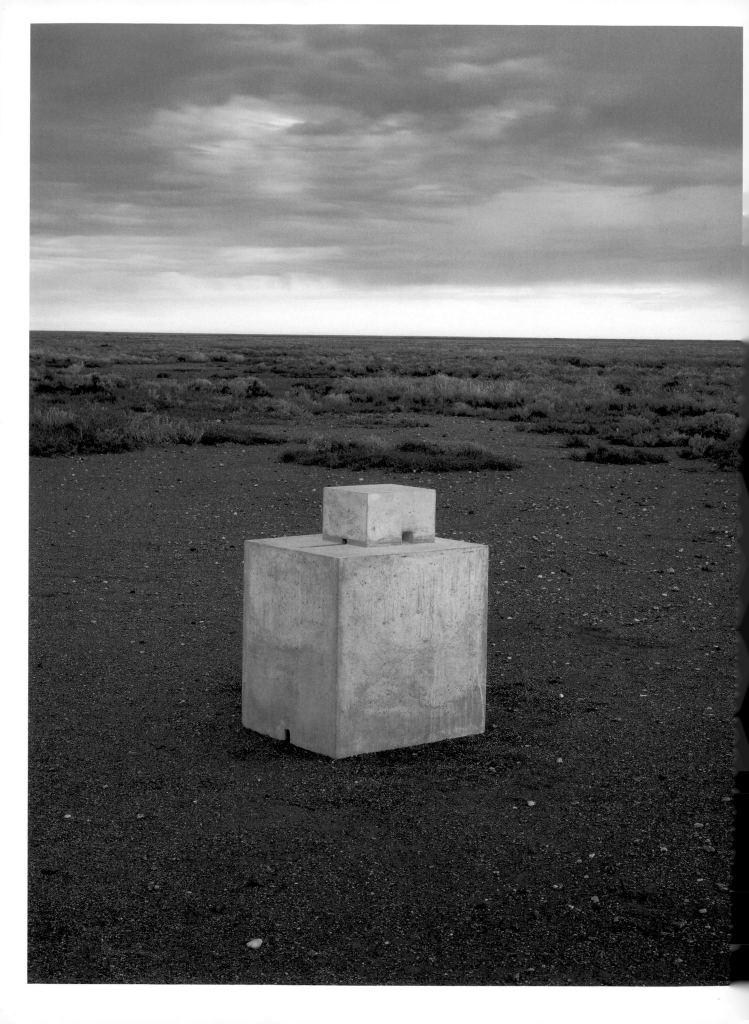

ROOM FOR THE GREAT
AUSTRALIAN DESERT 1989 [60]
Concrete
92 x 58 x 51
Collection of the Art Gallery
of New South Wales, Sydney

BOX 1983 [61]
Lead, fibreglass, air
64 x 60 x 60

Detail of workbook sketch, 1979 [62]

ROOM

'The body is our first habitation, the building our second.'[88]

Field brought the outside world into the gallery. The counterpart to *Field for the Art Gallery of New South Wales* 1989, with its many figures made of desert clay – forming part of the same project and made at the same time – was *Room for the Great Australian Desert* 1989 (fig.60), a concrete box set in the middle of a desert plain in central Australia, around 1,600 kilometres away. Here, Gormley placed a condensed architectural unit in the great outdoors. It proposed another case or container for the space of a squatting body, in the form of a two-tier concrete block; the dimensions of its two cuboid forms – 'body' and 'head' – described the most compact space that the human form could occupy. Gormley has referred to the earlier body-form sculptures of the 1980s as 'not statues in the traditional sense; they are more like architecture of a particularly intimate kind'.[89] *Room*, a body subjected to an extreme abstraction and a dwelling in its most minimal form, signalled Gormley's emerging interest in the relationship between the body and architecture, which he describes repeatedly as 'our second body' or 'the body's second skin'.

The early work with the same title, *Room* 1981, had created the form of an enclosure from shredded clothes, another kind of 'second skin'. For *Box* 1983 (fig.61), one of his early body-case sculptures, Gormley had adopted the most condensed, 'cubic' posture his body was capable of, and early sketches from his workbooks show similarly contracted poses as if the body were encased in a geometric shell. He first used concrete with *Room II* 1987 (fig.63), a man-sized standing form, a 'cell for the human body' in five stacked segments, with small apertures in the position of mouth, ears, penis and anus. In the late

1980s, while making the body forms in lead and iron, Gormley had explored the use of the cubic form as a metaphor for the body in a series of works, each comprising a pair of boxes made of lead (see fig.64). In each pair, one box is pierced with holes that indicate the body's faculties of perception, and the other supports casts or abstractions in alabaster or resin of body organs. These works have been described as 'non-body metaphors for spiritual states'.[90] Rather than being a physical representation of the body, they seemed another expression of Gormley's notion of the body as a 'place of no dimensions'; yet at the same time they acknowledge the body as the origin of all measures, from the Egyptian cubit on: each box was a precise 30-centimetre cube. 'I wanted to give an architectural frame to thought and use the lead box as a module,' as he later put it.[91]

An important series of works in the early 1990s, which followed *Room for the Great Australian Desert*, used concrete – a material associated with buildings ancient and modern – not to represent the body but to indicate its removal or absence. As with the earlier lead body-cases, Gormley began with his own body, adopting a position. A plaster mould was taken from this pose and a wax cast made from it, to be used through the 'lost-wax' process in a second casting in concrete to create the final work, a body-shaped void held within a concrete block.

The first of the series, *Flesh* 1990, indicates the space of a body lying on its back with arms outstretched. The cruciform concrete casing alludes in equal measure to human form, object and building. The artist's body, present at the origin of these works, is doubly not 'there' for the viewer; now only a void, buried within the concrete, it is an invisible absence. Approaching the blocks from some angles, we can read the form of the body within only by intuition; from another point

4

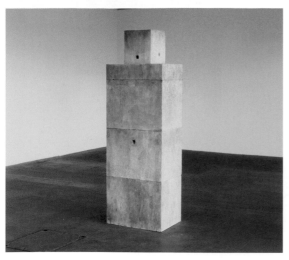

ROOM II 1987 [63]
Concrete
208 x 51 x 66
Installation view, Serpentine
Gallery, London

AUGUR (left) & ORACLE (right)
1989 /93 [64]
Lead, fibreglass, air, alabaster
Two boxes: each 30.5 x 30.5 x 30.5;
two kidneys: each 3.5 x 11.5 x 6

of view, its (one-time) 'presence' is indicated by the simple signs of fingertips and feet that penetrate the surface of the block. Some works encase only the artist's torso, creating rectangular forms with larger apertures that show where legs, arms and neck protruded. *Press* 1993 adopts a kneeling pose; the body is cut off at the level of the brain, and attention is focused on the whole-body gesture of supplication, on the raised hands that emerge, palms outwards, to animate with precise, affective bodily details the smooth concrete surface. In this submission to a self-imposed framework, this thinking of the body as an object, there is a strong sense of performance: the behaviourist and phenomenological works of Bruce Nauman, in the 1960s, again come to mind, bound up closely as they were with ideas of bodily awareness and body position, of 'hiddenness' and accessibility (both physical and psychological), of 'turning things inside out to see what they look like', of spaces in between, of the body as yardstick and as mould.

Base 1993 (fig.66) recalls the earlier *Bed* 1981 in its form. It is not a plinth for a sculpture but a block, containing the shape of a figure with limbs extended. *Sense* 1991 (fig.65) is almost cubic. The block was again taken from a cast of the body from the level of the brain down; through the cavity on the top surface the dark interior is clearly visible. Gormley's comments on *Sense* are revealing:

The block describes the space between the body and a compressed notion of architecture ... The work has always identified the minimum space necessary for a man to occupy but I think the concrete pieces do it in a more intimate, open and direct way. There is a real point of contact with the particularity of my body – slipped from life into art, with every wrinkle of the knuckles embedded in the concrete. Maybe the concrete works have found a new way of engaging

with the central premises of western sculpture: the relationship of idea to raw materials, image to block.[92]

This 'central premise' of sculptural tradition might be taken to refer to Michelangelo's struggle with marble or Jacob Epstein's mastery over alabaster. But the works also confront a more recent premise of modernist sculpture, addressed most notably by minimalism in the 1960s. Gormley's relation to minimalism has been much explored by critics, most notably by Stephen Bann,[93] and the cubic/rectangular nature of these concrete pieces prompts an easy link to the basic formal repertoire of minimalism's 'specific objects': the standard bricks of Carl Andre's sculpture, Robert Morris's L-beams and the cubes or boxes of Donald Judd. Judd and Morris saw their works as mere physical objects. Their materials were to be inert and their forms were to be 'directly apprehensible', free of expression, representing and referring to nothing but themselves. Here Gormley parted company with them: sculpture had always assumed a direct relation to the body and to touch, and these artists' denial of any form of human association in the object was for him an absurdity. As he expressed in a recent interview: 'Judd makes boxes and boxes are like rooms and rooms are like caves and wombs ... we project bodily functions and preoccupations into the containers...'[94]

Judd's 'boxes' and Morris's L-beams of course, like Gormley's concrete forms, bear an undeniable and intimate relation, in their physical dimensions, to the human form. Morris himself had begun, in the early 1960s, with sculptural 'body-oriented performances', making an upright sculpture of a rough pine coffin (*Untitled: Box for Standing* 1961) (fig.68) that exactly fitted his height and width – similar in form to Gormley's standing block, *Immersion* 1991 (fig.67). But there are other, equally relevant ways in which

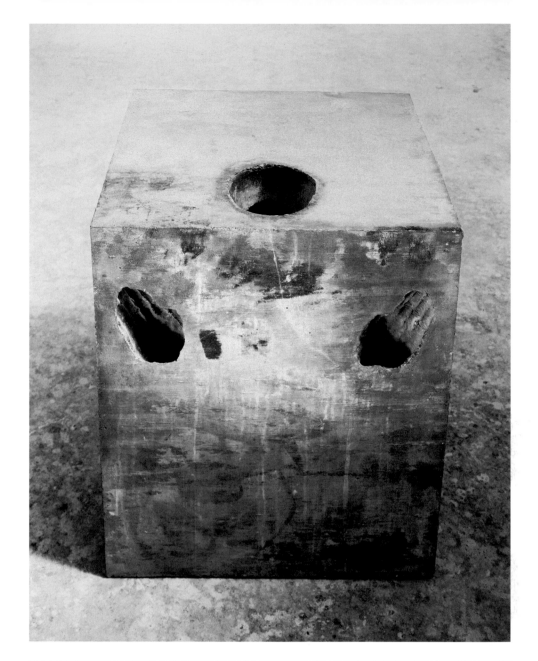

SENSE 1991 [65]
Concrete
74.5 x 62.5 x 60

BASE 1993 [66]
Concrete
32 x 160 x 164.9

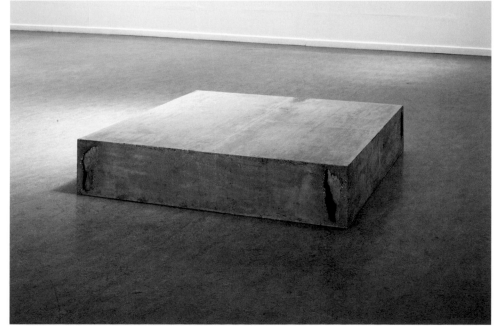

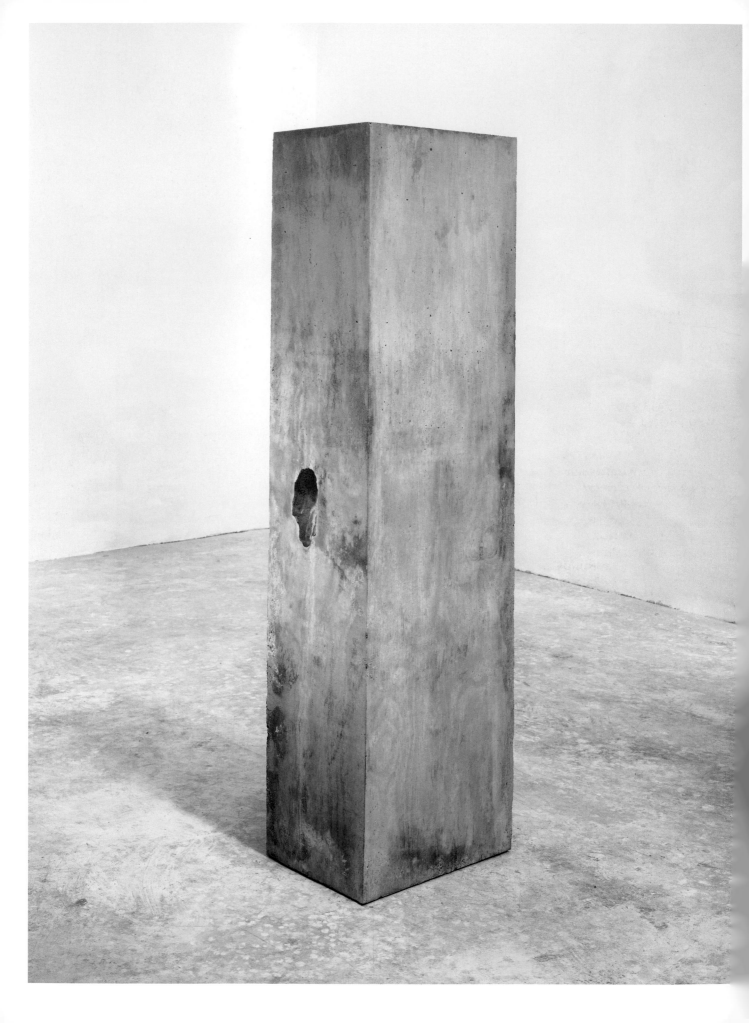

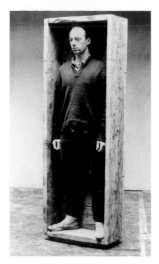

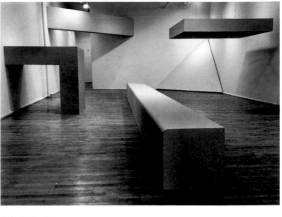

Robert Morris
UNTITLED (BOX FOR STANDING)
1961 [68]
Wooden box in which the artist
(or other performer) stands
Image courtesy Harvard Fine
Arts Library, Visual Collections

Robert Morris
Left to right: UNTITLED (TABLE);
UNTITLED (CORNER BEAM); UNTITLED
(FLOOR BEAM); UNTITLED (CORNER
PIECE); and UNTITLED (CLOUD) [69]
Various media and dimensions
Installation view, Green Gallery,
New York 1964–5

minimalist art of the 1960s implicated the body, particularly minimalism's insistence on the active involvement of the viewer, who shared space with the objects. By the mid-1960s, minimalist artists had come to accept the exhibition space of the gallery as the prime site of encounter between the work and the world, and sculpture's engagement with the space in which it was seen as an integral part of the work's nature and effect. The sculptural object was seen not merely to sit *in* the space, or on the floor, but to activate the space, interrogate it, become one with it in a relationship of uneasy equality. It was their stress on the fundamental importance of placement and viewpoint, and their explicit appeal to the viewer to 'complete' the encounter, which led the influential critic Michael Fried in 1967 to denounce the minimalists' strategy as 'mere theatre'.[95]

Robert Morris's renowned site-specific sculptural installations of his sculpture in the 'white-cube' spaces of Leo Castelli's Gallery or the Green Gallery in New York, disposed works (his *L-Beams, Floor Beams, Corner Pieces* and *Clouds*) across the floor, against walls and suspended in midair to pit them against each other, against the architecture of the space itself and the viewer who moved around and between them. In a similar manner, Gormley drew attention to the surrounding space with his concrete block works, placing them axially in the gallery so that the faces of the blocks related directly to wall and ceiling. In the same year as he made *Sense* 1991, he installed, in the Old Jail in Charleston, South Carolina, (alongside *Field* and *Host*) a large site-specific work, *Learning to Think* 1991 (see frontispiece): five headless body-forms in lead hanging from the ceiling as if truncated at the neck. There were obvious associations to be made with the building's dark past as a place of confinement and worse, but for Gormley it was a liberating gesture,

'aiming to undermine the expected conditions of being-in-a-room.'[96]

A similarly disorientating confrontation of body and architecture and, it would seem, an overt reference to Morris's installations of the mid-1960s, came with the installation *Testing a World View* 1993 (fig.71). Here five rough-cast iron body-forms, identical in their severe posture, a sort of sitting-upright in which the right angles of body and legs echo Morris's L-beam forms, were ranged in differing orientations across the gallery space, touching floor, walls and ceiling. A disquieting installation to move through, the work prompted an awareness of differing relationships between body and body, and body and architecture, from different angles; Gormley has spoken of it as 'a sort of psychological cubism'.[97] For much as it may throw a sharp retrospective light on the bodily allusions of Morris's minimalist installation, and Gormley's own critical interest in the minimalists' concerns, *Testing a World View* stakes out a more intense, because more revealed, confrontation between the body and its architectural environment, 'our second body'. This is taken to a kind of extreme in a later work, *Drawn* (fig.72), which echoes the famous strategy of the Russian constructivists, Vladimir Tatlin and Kasimir Malevich, who placed their works across corners, in the unused margins of the gallery, to project them into 'real space'. In *Drawn*, eight finely cast and (for Gormley) lifelike cast-iron body-forms, arms raised straight and high and legs splayed at right angles, articulate the eight corners of the gallery space at floor and ceiling; what Gormley has termed 'the confining articulation of architecture'.

Shelter or confinement? Cell or sarcophagus, shrine or bunker? For Gormley the architectural container can be any or all of these. He pares the idea of a building down to its essentials, reducing it to a primal

ALLOTMENT 1995 [70]
Reinforced concrete
112 life-size elements derived from
people aged from 1.5 to 80 years;
variable dimensions
Installation view 1995, West coast,
Denmark
Collection of Herning Museum of
Contemporary Art, Herning, Denmark

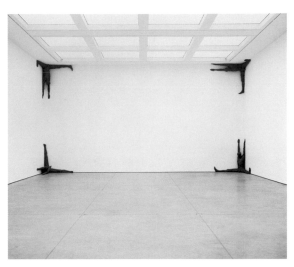

TESTING A WORLD VIEW 1993 [71]
Cast iron
5 figures: each 112 x 47 x 118
Tate
Installation view, Malmö Konsthall,
Malmö, Sweden

DRAWN 2000–2007 [72]
Cast iron
8 elements: each 154 x 133 x 187
Installation view, White Cube,
London 2000

space just as he does the body, and highlights the essential sameness and interdependence of body and building. Citing the urban theorist Paul Virilio's well-known identification of the concrete bunker as the 'ur' form of modernism in architecture, Gormley makes explicit its connection to his own work: 'a bunker has orifices, the anus, the ear, the eye, in solid concrete.'[98] The idea of architecture as a place of confinement came to the fore as Gormley broadened his scope and extended his reference from the intimate, personal space of the room to the communal space, and the urban environment. 'The urban condition of humanity is to live in a body shared with many bodies,' as he put it in an interview in 2008.[99] As clay is primal matter, the earth on which we stand and to which we return, so concrete is part of the world we build, the space we share and contest.

Gormley is drawn to the wilderness, to far-off heights and the world's vastnesses, but he is as an artist a determined urbanist, convinced that the modern condition, and the business of art now, lies in the built environment. Since the mid-1990s, he has been invited to take on public space, to engage with the fabric of towns and cities, and he has increasingly linked the individual and the community, personal and collective experience. Some years after the concrete block works of the early 1990s, Gormley extended the idea of the concrete cast that expressed the dimensions of the body, in two separate versions of a large and important multi-part work. *Allotment I* 1995 (fig.70) was made for a group exhibition at Hvide Sande in Denmark, close to the northern end of the remains of the Atlantic Wall, Hitler's line of concrete coastal fortifications against Allied invasion. Taking a cue from the history of wartime occupation and the outdoor site (an abandoned mink farm that provided a ready-made enclosure with the air of a cemetery), the

work consisted of 112 solid units, arranged in extended rows, each replicating the body dimensions of a different member of the local community. A year later, *Allotment II* 1996 (see pp.76–7) refined and expanded the concept, in an installation originally for the Konsthall in Malmö, Sweden, of individual sculptural units cast according to the detailed body dimensions provided by 300 local inhabitants. These units, concrete shells of habitation, were ranged in differing configurations across an indoor space in a tight grouping of blocks cut through by paths or 'streets'. Unlike the earlier room-size installations (*Field* and *Host*), *Allotment* did not hold viewers at the threshold but asked them to enter, to move between the blocks and explore, to become part of the environment.

Since *Allotment*, the body/building equation in Gormley's work can be traced along two divergent (if occasionally intersecting) paths: one leads to a varied series of figure works that employ the forms (the building blocks) and structural principles of architecture, playing perceptual games with scale; and the other to large, immersive spectacles in space that create an architecture and invite the viewer to inhabit and thus 'complete' the work.

Both *Field* and *Allotment*, in their very different ways, confronted organic (body) forms with architectural and geometric frames. The various series of 'body as building' figures, which Gormley began with *Precipitate* 2001 (fig.73), worked the other way, constructing the space of the artist's body from geometric steel blocks, 'three-dimensional pixellations'. At first, as with the *Apart* series of 2002, the blocks are disposed so as to conform to the rounded contours of the body's surface, or assembled in a jumbled mass to fill the body's volume. By 2004 the blocks within the figures are arranged according to an internal logic of construction that is orthogonal, more openly

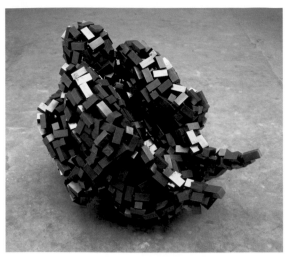

PRECIPITATE 2001 [73]
Mild steel blocks
Overall 81 x 59 x 63; each block
2.5 x 2.5 x 5

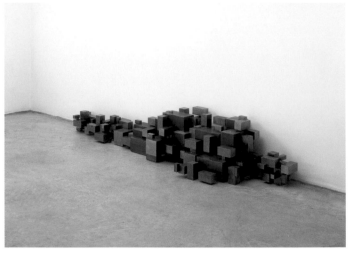

LIE (HABITAT) 2005 [74]
Mild steel blocks
Overall 35 x 206 x 48;
blocks variable:
1.25 x 1.25 x 2.5; 2.5 x 2.5 x 5;
5 x 5 x 10; 10 x 10 x 20

load-bearing, which allows the forms to open out, in a balance between space and mass, to a furthest, most 'open' point at which their structural integrity begins to waver. This point of tension, where the body threatens to break down or dissolve, could of course be seen from the opposite perspective as a 'taking shape', a first moment of coming together or coherence. In some works, such as *Lie (Habitat)* 2005 (fig.74), we waver, too, between competing readings of physical scale that allow us to see the construct both as a recumbent human figure and as an urban sprawl. Either way, our relative point of view changes the equation.

A similar elision of the human scale and grander designs occurs in *Space Station* 2007 (fig.75), a massive work that acted as a centrepiece to Gormley's major exhibition at the Hayward Gallery in London that year. The structure, 6 metres high and made of 23.3 tonnes of corten weathering steel, is despite its immense weight barely grounded; it touches the floor only obliquely, and rises at an angle to fill most of the large gallery space. From the right vantage point, its overall form declares itself as an abstracted figure lying on its side in a compressed, foetal position familiar in Gormley's work. The many individual hollow-steel building blocks that make up the body, their surfaces gridded with regular square perforations, create a dense interplay of volume and space, light and dark, which can also be seen as a model of a city in freefall, off its axis, weightless, floating in space. *Space Station* evokes science fiction fantasies and uncanny, disturbing visions of a possible collective future. It points also to a seemingly inevitable next step for the artist, whether Utopian or realisable, the creation of an inhabitable sculpture on an architectural scale. This ambition was realised the following year with *A Sculpture for the Subjective Experience of Architecture*

2008, a collaboration with the architect David Chipperfield, in the woods in Kivik, southern Sweden – a 'useless building' in concrete conceived as a succession of spatial and perceptual experiences (cave, platform, tower) for one person at a time. A further project, even larger, in the Arctic tundra, awaits its time.

A central assertion of the philosopher Maurice Merleau-Ponty's renowned book *Phenomenology of Perception* (1945) – of obvious significance to Gormley's artistic project – is that our perception of the world is not simply a question of vision, but involves the whole body. The idea of the experience of the body in contained space, which animates Gormley's interest in architecture throughout, leads his work to call on the viewer, ever more insistently, not merely to feel it but to enter, to participate and to become part of the work's coordinates. *Breathing Room* 2006 (fig.76) is a complex, immersive environment, a 'drawing' described in space with rectilinear aluminium tube. The vertices of seven interlocking 'space frames' of different format but equal volume invoke the rigid perspectival rendering of architectural space that has dominated since the Renaissance: it 'hovers between being architecture and being an image of architecture', says Gormley.[100] The viewer is asked to enter the frame, to be inscribed in an architectural matrix, but a matrix of open and interpenetrating spaces in which there is no one centre, no single vanishing point. At its first showing in Gormley's Paris gallery, Thaddaeus Ropac, in 2006 the continuum of time was brought into the spatial equation. Shown only under natural light, the work could be experienced as evening fell; the division of dark frame and light space gradually reversed as the aluminium members of the structural frame, coated in luminous Phosphor H15, returned radiated light, exchanging energy with the surrounding darkness.

SPACE STATION 2007 [75]
Corten steel
600 x 950 x 650
Installation view, Hayward
Gallery, London

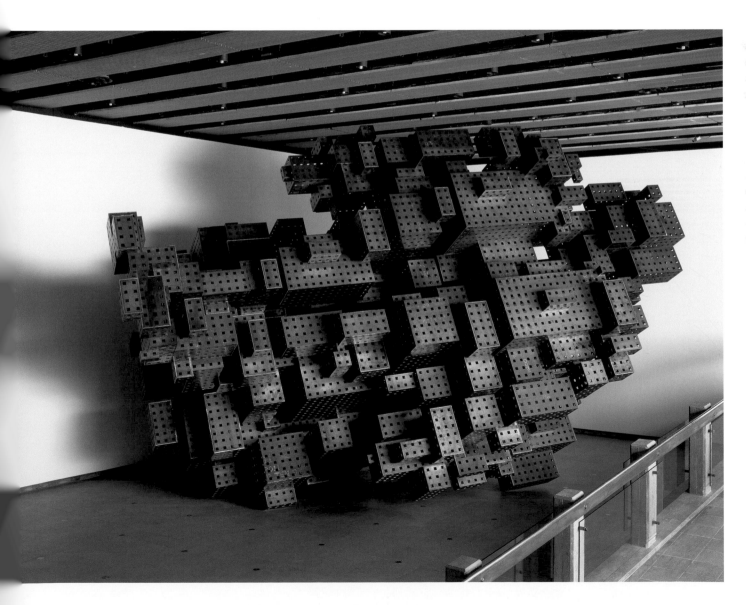

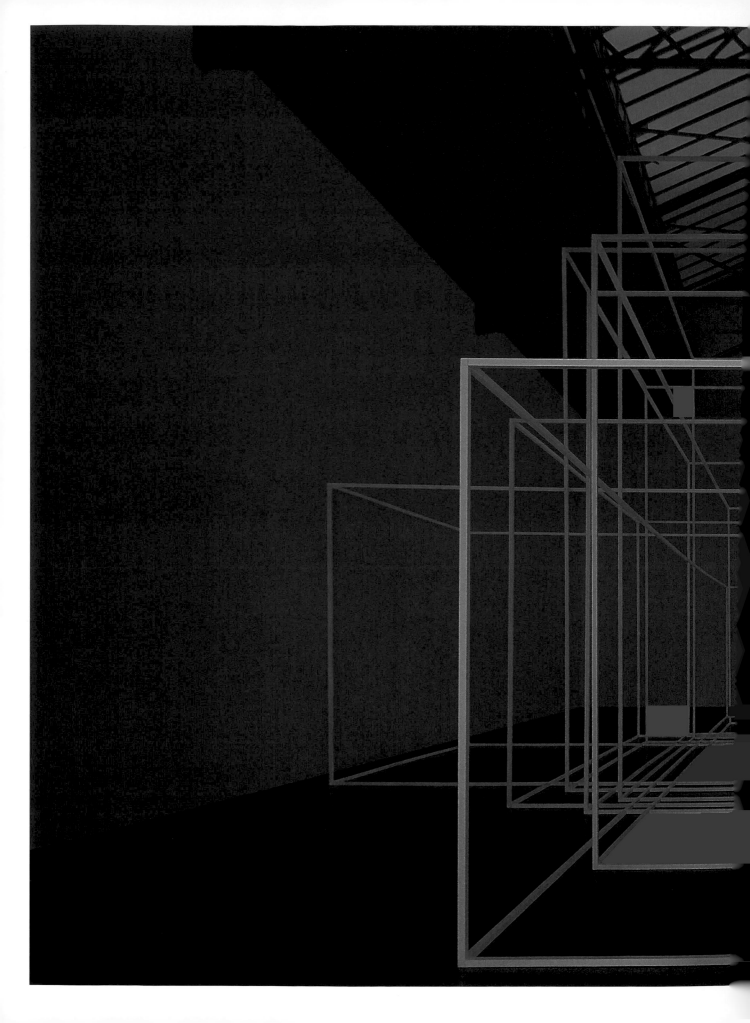

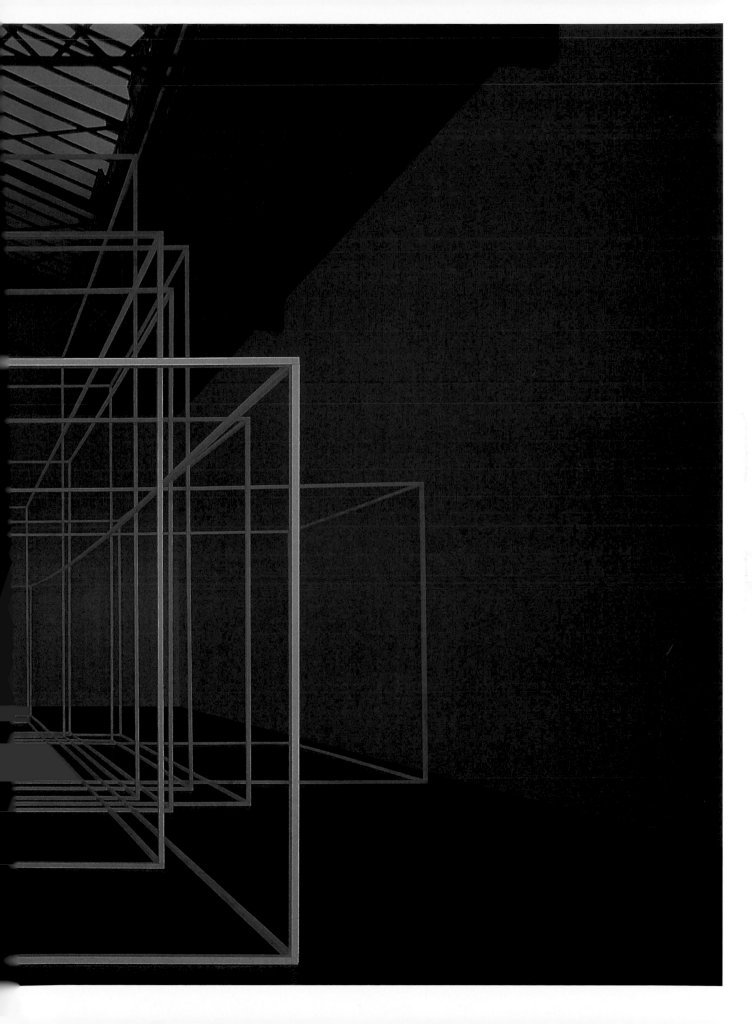

BREATHING ROOM I 2006
(night view) [76]
Aluminium tube (25 x 25 mm),
phosphor h15, plastic spigots
500 x 1000 x 780
Installation view, Galerie
Thaddeus Ropac, Paris

SPACE STATION 2007
(detail) [77]
Corten steel
600 x 950 x 650
Installation view, Hayward
Gallery, London

Hatch 2007 (fig.78) , first shown alongside *Space Station* in Gormley's Hayward Gallery exhibition that year, creates an even tighter structure to relate the body that physically enters the work and the eye that observes from outside, a double physical and optical occupation and penetration of the space of the work. Thin aluminium tubes project into the space from top, bottom and sides, objectifying lines of vision and at the same time forcing the entering viewer to the open space of the centre. There is an element of physical and psychological discomfort and threat here, and a ready reference to the medieval torture chamber, the famous 'iron maiden', a tight box for the body spiked inside with sharp protruding nails. The tubes in *Hatch*, like the peephole of a camera obscura, allowed the exhibition's visitors a refracted view from outside of the internal space, and the bodies within. Peering into the tubes, they were presented with a multiplied image: the bodies occupying the internal space were broken down into a mass of pixellated cubes. *Hatch* is architectural space that neither protects the occupiers nor shields them from the outside, where the very notion of inside and out, and of the architectural shell as a barrier between the two, is cast into doubt. The architecture is no longer a secure 'second body' but a porous screen, undermining our sense of a unified self, our sense of being in space.

HATCH 2007 [78]
Aluminium square tube
(19.1 x 19.1 mm), plywood,
Plexiglas
322.5 x 605.7 x 605.7
Installation view, Hayward
Gallery, London

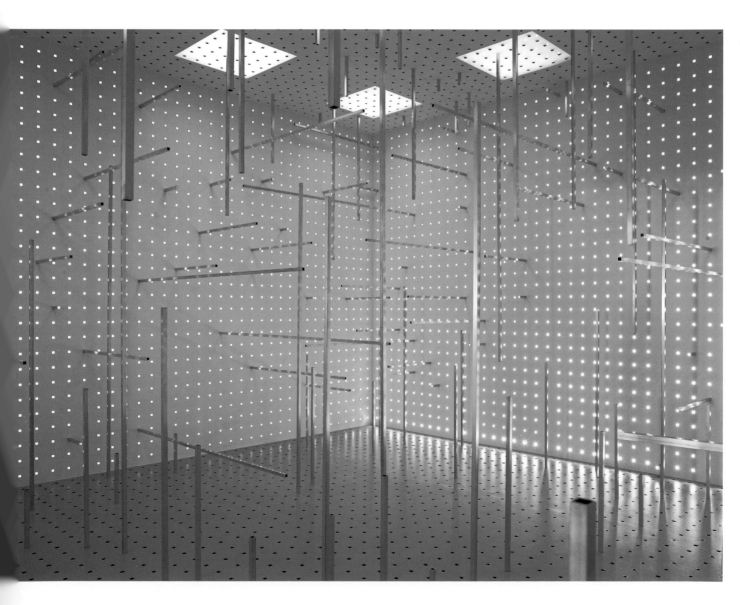

The second large-scale work of Gormley's to solicit the active involvement of a large body of collaborators, *Allotment* 1995, differed from *Field* in many respects. Here the artist involved others in the process of creation at one remove, asking of them not their physical labour but the provision of their vital statistics. He has described the work as an 'anthropological field study'.[101] The second version of *Allotment* began with a proposal, put to the Malmö Konsthall in Sweden in 1996, which read as follows:

I propose to ask 300 local people – men, women and children of all ages – to cooperate with me in making a work. The participants will be asked to have themselves measured standing. The following measurements will be taken:

In front: 1 The total height from the top of the head to the ground. / 2 From the shoulder to the ground. / 3 From the shoulder to the top of the head. / 4 The width of the head. / 5 The height of the top of the ear from the top of the head. / 6 The length of the ear. / 7 The height of the mouth from the division of the lips. / 8 The width of the mouth. / 9 From side to side at the widest. / 10 The height of the anus from the floor.

In profile: 11 From the back to the front at the deepest (i.e. from the buttocks to the toes). / 12 The distance from the tip of the toes to the tip of the nose. / 13 From the tip of the nose to the back of the head. / 14 The distance from the back of the head to the back of the ear. / 15 The distance from the side of the head to the side of the body.

These measurements should then be used to construct three hundred 5 centimetre thick rectangular concrete body cases, with integrated rectangular head cases and apertures at the mouth, ears, anus and genitals. The dimensions of the apertures will be taken from the ear and mouth measurements as will the placement. The anus and genital apertures will be proportioned to the volume of the piece (1.2 square centimetres to a cubic metre). The outside of the ear apertures will be a square based on the length of the ear. The apertures will be angled to an internal opening of 6 square millimetres.

The anus and genital holes will be angled at 45 degrees. The mouth aperture will be square and based on the width of the mouth. The top of the ear holes will be at the position of the top of the ears. The mouth hole will be centred on the line of the lips. The anus and genital holes will be at the anus level on the internal wall of the case.

The pieces will be poured concrete using standard wooden shuttering ply for both the internal void and the external surface, with 5 millimetre galvanised steel reinforcing on a 10 centimetre grid. The pieces will be poured upside down, the head sections poured first, then the body section. The pieces will be cured over a ten-day period. The concrete will be

constituted from seven parts white cement and one part grey cement, four parts silver
sand and eight parts 4 millimetre white quartz chippings.

Once made, the pieces will be placed in a large space: the Malmö Konsthall.

The composite work will evoke a surrogate cityscape with the pieces laid on a grid path
system wide enough for a viewer to pass through. Some will be closely packed next to
each other, some less so. They will face all directions. The viewer, having apprehended the
work initially as a whole, will be able to make his/her way through the composition
engaging with pieces intimately.[102]

Allotment II was staged first in Malmö, and has been seen elsewhere – in Gateshead,
in London, in Bregenz in Austria – each time arranged somewhat differently. The first
impression of the work, as you stand before the blocks, is of weight and mass. You get
a strong sense of a complete, almost stifling occupancy of the gallery space. The blocks are
drained of colour, devoid of feature. The group seems anonymous, impregnable; it is as
if you are surveying a dense urban grid from a high vantage point. Drawn in, you become
more aware of the blocks' particularities, and of the relation of their varying heights to
your own – and to that of the people around you. Tall adults, small children … The mass
breaks down, divides; there are ways in, narrow passageways down which you can move,
shoulder to shoulder with the blocks. You notice the blemishes in the smooth concrete,
the apertures of ears and mouth, incidental details. Your own turns through the maze are
echoed by the changing orientation of the blocks. They stand side by side, face each other,
or turn away, eyeless, sightless. Some are so close as to almost touch; elsewhere, between
tight clusters of blocks there is an opening, a small space. Room to breathe, a momentary
relief from the constriction your body feels, in subconscious empathy with the rigid
concrete forms. Is the space very full, or very empty, alive or dead? Are you alone, or
in a crowd?

Two statements Gormley has made on *Allotment II* reveal some of its concerns:

Modernism rejected the body, yet 90% of the populations of the western world live within the
urban grid. Within this particular spatial system architecture protects and identifies us.
To what extent do we form and to what extent do we conform to the dictates of its organized
geometry? The body is our first habitation, the building our second. I wanted to use the form
of this second body, architecture, to make concentrated volumes out of a personal space
that carries the memory of an absent self, articulated through measurement. I hope that the

ALLOTMENT II 1996 [79]
Reinforced concrete
300 life-size elements derived from the
inhabitants of Malmö, aged from 1.5 to 80 years;
variable dimensions
Installation view, Kunsthaus Bregenz,
Bregenz, Austria 2009

exterior evokes the potential of a hidden interior the same way that a bunker does. Can we ever be outside the outside? Can we make the inside felt? Bodies and buildings, cities and cells, monuments and intimacies, each of the volumes [rooms] in this piece is someone's, is connected to the moving body of an individual, alive and breathing. Each work acts as a marker in the flow of the life of that individual and acts as a witness to the evolution of life in general.[103]

I'm not making a manifesto, there's no political slogan like 'at the end of the twentieth century we have outgrown the city and mankind should colonize the desert'. I'm trying to say 'here we are' and then ask what is 'here', and who are 'we'? Many of the adjectives used about contemporary art: boring, cold, distant, have a certain truth. There's no moral implication, this is an 'objective appraisal' of our condition. Maybe the first job that art has to do is to mirror life but it also has to act as a catalyst for concentrating it so that through art we are put in a position where we can change …

Allotment *asks what happens when we accept the structures necessary to life in large groups. It replicates the social engineering that surrounds us. I pass a tower block in the same way that in the Australian outback I might pass a termite mound. I recognize a habitat that often I don't want to think about. It's the densest level of urban life, but for some, a forgotten strata … The piece isn't a diatribe against the evils of modern city life … I wouldn't live anywhere else. I'm not saying we should all go and live in 'nature'; we can't: anywhere we go is transformed. In making this experiment I'm saying, 'This is where we come from; do we recognize it?*[104]

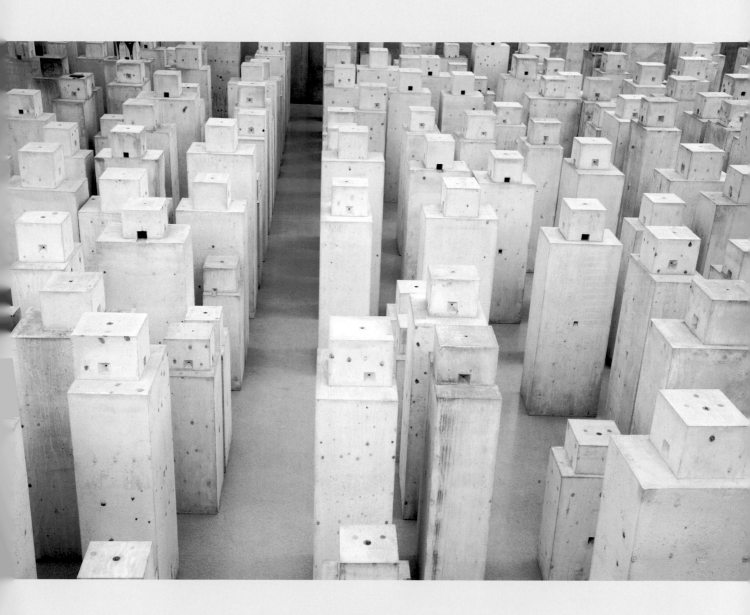

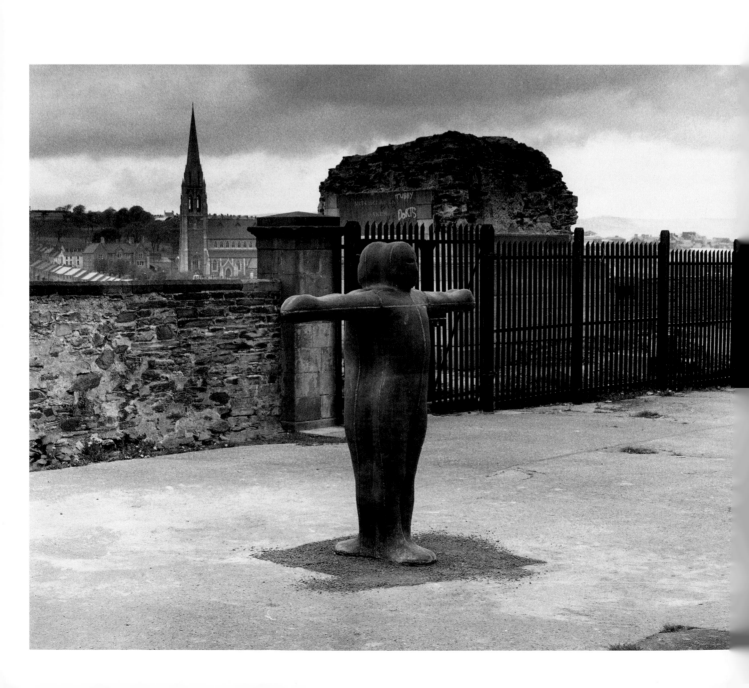

SCULPTURE FOR DERRY WALLS
1987 [80]
Cast iron
3 double figures: each 196 x 193 x 54
Permanent installation, Derry
Collection of Derry City Council

5

THE COLLECTIVE BODY

'The body is the collective subjective and the only means to convey collective human experience, in a commonly understood way.'[105]

From early on, if not from the very beginning, Gormley took the role of the artist in its broad sense, and sought for his own art a broader stage, and the broadest, most 'active' engagement with its public. Art, as he sees it, has from its own beginnings been central to life, and only in modern times has it come to detach itself from life's realities, to inhabit its own spaces and reflect on its own conditions, in its own increasingly private language. 'We need to find ourselves again in art,' is his repeated message. 'Art is a means of understanding what we are, what we are doing … it has to become integrated again.'

So his own art had to engage with the world as a whole and the people in it, to address and be part of a 'common shared reality', to 'make contact'. Hence his original decision to make sculpture: an art that could stand up and 'bear witness', that could act as a focus of collective feeling. Hence, also, his choice of the body as subject; and not just the body, but in particular the 'collective body', the community, of makers and subjects as well as viewers, invoked in those important works discussed earlier, *Field* and *Allotment.*

Gormley's first acts as an artist included placing sticks in the mouth of a cave in Greece, and flinging stones in the Arizona Desert. Lonely acts: he photographed some of his earliest lead figures standing alone against the elements, on the beach at West Wittering in Sussex, in 1981. Speaking of sculpture bearing witness, with reference to his work, Gormley alludes to the Easter Island statues and Constantin Brancusi's *Endless Column* 1938 (fig.89) as readily as to the earthworks of the more recent American Land artists. Sculpture should 'stand apart

from life' not to detach itself from human concerns but to reflect them more clearly. Art, ultimately, speaks of the human condition; it cannot come about, or exist, in a void. It requires a 'social space'.

That said – or maybe *because* of all that – the notion of 'public art' as a particular category or type with its own particular rules, conditions and ambitions, is one Gormley strongly resists. After all, if *all* art deserves and demands a public, how could any art ever be 'private'? To consider separately, for a moment (as we are doing here) Gormley's projects 'in the public domain' from the early 1980s on, is to see them not as a case apart, but as developing alongside and somehow gathering in the full range of the artist's evolving language, particularly the collective making projects such as *Field,* with their embrace of ideas of commonality, community and the collective process. His 'public' projects tend not to engender new forms in his art so much as to give new life to existing forms, to allow them to expand, evolve and accrue new meaning. Made – in general – to commission and for public places, involving consideration of site, history and context, and often protracted public involvement and debate, they fall readily and firmly within the category defined by Gormley himself as 'tribal art'.

To an artist in Gormley's position, a critical engagement with the outset with the legacy of public art, a questioning of its conventions and its history, was inescapable. Public sculpture had lost any confident role in the twentieth century. Art (in the eyes of the avant-garde at least) was no longer expected to impart a sense of dignity or delight, nor encouraged to speak of national or civic pride, to symbolise, commemorate or instruct. It was no longer called on to fulfill that function traditionally ascribed to the monument: to proclaim, as did the 'monumental history' described famously by Friedrich Nietzsche,

TWO STONES 1979–81 [81]
Granite boulder/bronze
Each unit approx. 274 x 152.5
The artist overseeing the work's
permanent installation, Singleton,
near Ashford, Kent 1981.
Commissioned by Kent County Council
and the Arts Council of Great Britain

STILL FALLING 1983 [82]
Portland stone (Tout Quarries, Dorset)
203 x 50 x 15
The Portland Clifftop Sculpture Park,
Dorset

that 'a great thing existed and was possible, and so may be possible again'.[106] How, then, in the late twentieth century, could art speak of collective needs and aspirations rather than merely its own dictates?

The burgeoning of rural and urban sculpture parks, and corporate-sponsored 'trophy' sculpture for the plaza, in Europe and America in the post-war decades, resulted in much work that was bland and timid, or deferred to its location. There were, of course, those who resisted. Sculptors such as Donald Judd in the 1960s had argued strongly the need to detach sculpture from a symbolic role or subservience to architecture. The infamous debacle that surrounded the reception of Richard Serra's combative public work, the massive steel *Tilted Arc* in downtown New York's Federal Plaza, dragged on for eight years from its installation in 1981 until its removal in 1989, and marked a heroic, if ultimately unsuccessful, struggle to assert a permanent and independent place for sculpture in the public environment. Less notable sagas abounded. Redefinitions were urgently required of what constituted public art, or even public space; a new 'site sensitivity' was called for, and an allowance that art – even in public – might adopt a critical rather than simply an affirmative or elegiac voice.

Gormley's first incursions into the public domain played out against a backdrop in which conventional attempts to commission work that might generate corporate or civic identity met a growing will to redefine public understanding of the forms of art itself – the statue, the monument – and what it might mean to talk of an 'art for the people'. And in this confusion, of course, differing views held sway. Gormley acknowledges, but resists, the ambivalent attitude in the post-war era towards publicly commissioned art, and the prevailing suspicion that the social contract entails some form of compromise. But he does accept

that it places particular demands on the work: 'If you agree to work in collective space I think there is a sense in which you agree to take on legibility ... you are making a statement that, because it exists in collective space, to function fully, has to connect with collective experience and memory.'[107]

The artist's earliest 'public sculpture', *Two Stones* 1981 (fig.81), was a conventional enough commission from Kent County Council and the Arts Council for a site near a leisure centre and artificial lake, in the new village of Singleton in Kent. Finding no context or community there to be reflected, Gormley made a work that included a large glacial erratic boulder, sculpted naturally by the action of rock and ice over aeons: a foundation stone for a village with no history. Its own history was soon to begin: the work was almost immediately vandalised. His next commission, for Tout Quarry Sculpture Park on the Isle of Portland, Dorset in 1983, as part of a project with four other artists, resulted in the depiction of an upended or floating figure, scored into the stratified face of the quarried cliff itself: *Still Falling* 1983 (fig.82), an immediate, physical response to the vertiginous nature of the site on which the hand of man had worked for centuries.

Gormley's first two significant experiences of engaging with a resonant site, in both public and architectural terms, were wildly contrasting. *Sound II* 1986 (fig.83), a lead body-case, was installed that year in the eleventh-century crypt of Winchester Cathedral, Hampshire: a single figure standing, head lowered in contemplation in hallowed space beneath the Norman arches, and reflected in the subterranean floodwater that wells up each winter into the crypt and which was used to fill the hollow-lead body of the figure itself. In such an environment it is hard to avoid a religious reading of the work, yet the pose of the figure offers no

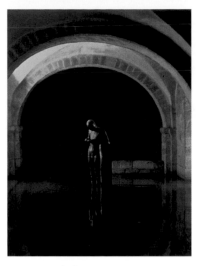

SOUND II 1986 [83]
Lead, fibreglass, water
188 x 60 x 45
Permanent installation, Winchester
Cathedral
Collection of Winchester Cathedral

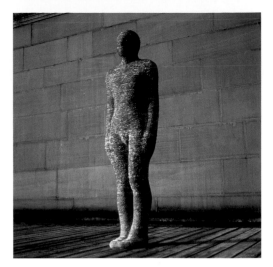

THE BRICK MAN (MODEL) 1987 [84]
Terracotta, fibreglass, plaster
196 x 50 x 38
Collection of Leeds City Art Gallery,
Leeds

specific reference either to identity or to event. Gormley himself disavows any religious message, speaking instead in general terms of the power of the site, and of the 'extraordinary experience of water coming in and out every winter, right there, under the high altar that was there a long time before the cathedral was built ... that breathing of the elements, which is pre-Christian'. [108]

The following year, *Sculpture for Derry Walls* 1987 (fig.80), a publicly-commissioned work comprising three hollow double-body cases made of 'ordnance-quality' cast iron (Gormley's first use of the material), was sited along a highly prominent urban fault line between Catholic and Protestant communities in Northern Ireland. The bodies, arms outstretched, stood conjoined back to back, featureless but for their accentuated eye cavities. Each work, facing out both ways across the divided town was, the artist declared, 'a single case for two crucified bodies: crucified to one another'. [109] In such a highly-charged historical, religious and political situation, the project called for a drawn-out and very public process of consultation and negotiation, and a clear statement of intent: Gormley expressed the hope that the work would 'act as a poultice, and draw thoughts and feelings that might be expressed in more violent ways'. [110] Again, reactions were not long in the drawing: the works were immediately under attack from both sides. One was laid siege to as it was being installed, another torched on its first night.

Gormley himself accepted that the reaction to a poultice might in itself be a violent eruption; he saw this as part of an inevitable accrual of meaning in such a context, and it only served to strengthen his hope that the works might 'act as a catalyst for some kind of healing'. [111] In an early interview he cited the Sri Lankan scholar, philosopher and curator Ananda

Coomaraswamy's view of 'the function of art as cohesive, as providing a necessary point of reflection in an otherwise functional world'; and his public projects are underpinned by a deep-rooted belief in the redemptive power of art, its power to transform and, to 'help us face our own condition'. [112] To evoke a collective memory without resort to the exhortation or symbolic appeal of the commemorative monument required a tolerance of multiple or even misguided interpretations, an acceptance of criticism, and – on occasion – of failure. Gormley's first attempt, in 1987, at a public project on a monumental scale, a 36.5 metre-high *Brick Man* (fig.84) 'made in the material of collective labour', [113] to be sited on a triangle of disused land at Holbeck in Leeds by the Leeds–London railway line, remained unrealised, falling at a late hurdle to a communal failure of nerve: even he could be defeated by the collective body at times.

Iron: Man 1993 (fig.86), an iron body cast almost 7 metres high, 'made with the materials and methods of the Industrial Revolution', [114] is set at an angle off the vertical and embedded up to its calves in the rising swell of central Birmingham's Victoria Square. In its scale and its inclination, the figure sets up an uneasy relationship with the passer-by and with the other buildings and sculptures with which it shares this civic stage: the backward-looking Neo-Classical architecture of the city's golden age, a motley group of contemporary sculpture, and Queen Victoria herself on a plinth. *Havmann* 1994–5 (fig.87), an even larger figure, 10 metres tall and carved from Arctic granite, is by contrast a lonely, isolated and melancholy appeal to the collective memory and history of its particular site, addressing not the built and the urban but the image of nature itself that endures and survives. The plain dark figure rises from the waters of a fjord in Norway, facing out to sea with its back to the small northern

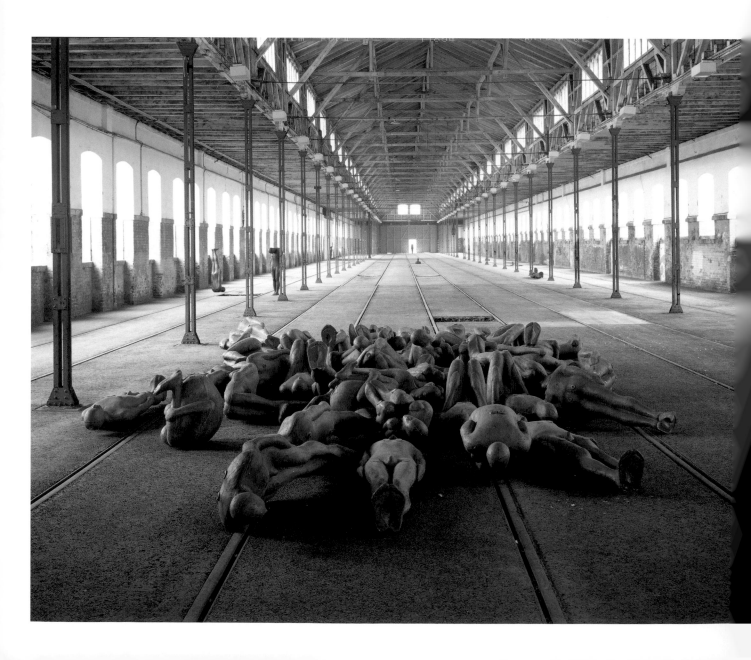

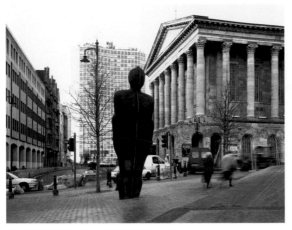

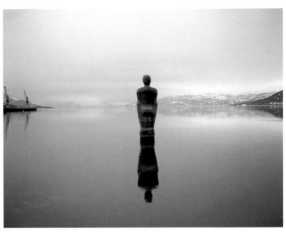

IRON:MAN 1993 [86]
Iron
666 x 185 x 115
Permanent installation,
Victoria Square, Birmingham;
commissioned by TSB Bank

HAVMANN 1994–5 [87]
Granite
10.1 x 3 x 1.9m
Installation view, Mo i Rana,
Norway

town of Mo i Rana. It was a provocative answer to the city fathers' hope for something big and ostentatious. Mo i Rana's history and the poisoned legacy of extraction and exploitation of local iron ore and coke, particularly by the Nazi occupiers during the Second World War, which led to the town's subsequent 'retreat' from the sea, are all alluded to by the sculptor who again describes the work in redemptive terms, as an attempt at a 'reconciliation with a recovered nature'.[115]

The crowning work in this vein, in terms of scale, fame and public visibility, is *Angel of the North* 1998 (fig.1), a giant figure made of 200 tonnes of rusting corten steel that rises 20 metres above ground from a mound (man-made from the ruins of a defunct colliery) overlooking the motorway near Gateshead in the north-east of England. *Angel of the North* evolved out of the series of 'angel' body cases and forms made some years earlier (see pp.44–5). It is 'a transitional object between the industrial and information ages',[116] set appropriately in an area once famous for mining and shipbuilding and now in danger of succumbing to 'post-industrial amnesia'. *Angel of the North* constitutes a public performance in three acts: of conception and consultation; of collaboration and construction; and of coexistence with its location. The very process of *Angel*'s fabrication and erection, a tale of local skills and ingenious problem-solving, the marriage of old industries and new technologies, has all become part of the work's narrative, even its mythology. Though it can be climbed up to, even clambered upon and graffitied at its base, most – indeed millions of people – moving along the busy trunk routes that run beneath the site, encounter the work from the car as they would the ruins of Stonehenge glimpsed across Salisbury Plain: its gigantism is similarly scaled down by distance, and its meanings, too, open to conjecture and change.

While working on *Angel of the North*, Gormley made a work in Austria that he variously described as 'an anti-monument evoking the victims of the twentieth century' (rather than, as more usually, the victors in conflict) and 'a monument for something we hope will never happen'.[117] *Critical Mass II* 1995 (fig.85) was made as a direct response to the space for which it was created, an abandoned tram depot in Vienna. Sixty life-size body forms were arrayed throughout the long building, individually and in groups: bodies in twelve different positions, represented by five casts each, progressing from foetal to standing. The majority lie on the floor in various orientations. Some are suspended from the ceiling; only the occasional figure stands aside as upright witness to the abject scene. As a work that seems to propose a sort of 'cathartic commemoration' of the history of the modern age beyond the confines of the conventional monument, it shares ground with one of the most significant of post-war German works of art, Joseph Beuys's *The End of the Twentieth Century* (1983–5). Beuys's colossal sculptural installation, comprising forty-four basalt blocks that lie in similar haphazard clusters like primeval, mummified bodies, has been taken as an allegorical image of a future world and as a metaphor for the fate of the individual in an over-determinist society of mass manipulation. *Critical Mass*, likewise, speaks of mass production and the fate of masses, and of the individual. There is no redemption here: 'The whole of the work is about falling, is about those who don't fit and have no place in the collective body. The subject … is the loss of social order,' Gormley has said. '*Critical Mass II* is the most helpless thing I have ever made.'[118]

Like Beuys's great work, *Critical Mass* has been installed (differently) in a variety of locations. The august and busy surroundings of the Royal Academy

TOTAL STRANGERS 1996 [88]
Cast iron
195 × 54 × 32
Installation view, Kölnischer
Kunstverein, Cologne 1997

Constantin Brancusi
ENDLESS COLUMN 1938 [89]
Cast iron, steel
Height: approx. 30m
Permanent installation, 2000
Târgu Jiu, Romania

of Arts' forecourt, off Piccadilly in London, where it was displayed in 1998, were a far cry from the Vienna tram shed, and prompted new responses. The 'migration' of works came to the fore in Gormley's work of the 1990s, as he began to explore an increasingly expansive notion of public site and social situation, and as demand increased for his projects across the globe. In the *Total Strangers* 1996 project (fig.88), figures spilled out from the 'hallowed space' of the host gallery, the Kölnischer Kunstverein, to the ground outside, on to the pavement and across the street, there silently to accost the passer-by, to force a stop and a confrontation and to voice questions of what their form and presence might signify, free of the Gallery's rhetoric, amidst the ebb and flow of the Cologne pavements. Some could be seen from the gallery itself, turned to face the glass windows and the people within, in a reversal of the customary roles of audience and artwork, viewer and viewed. For Gormley, the narratives that might be conjured in such confrontations did not reside in the standing figures themselves: 'the sculpture's only real place is in the imagination of the viewer.'[119]

Broken Column 2003, realised in the Norwegian town of Stavanger some years later, continued this process of extension from the gallery into the larger social world. Twenty-three life-size standing figures were disposed across the town, in sites from museum to courthouse, public baths, school classroom and private apartment, kerbside and dock, meticulously pitched at progressive heights above sea level, each one some 1.95 metres higher than the one before. The figures cohered, on paper and in the mind's eye, as a stratification across the fabric of the city, a 'virtual' column of figure upon figure, dispersed through space, and in spaces of widely different standing. The whole project in Stavanger took several years to

resolve amidst a highly transparent and democratic civic exercise of persuasion, public dissension and debate – over politics, and money, and art – among the commissioners and the locals. Argument continued long after the battle to build had been won; the work stood, in more than one sense, as an attempt to 'use the space between people'.[120]

Together – in concept – the figures in *Broken Column* represent a variant of the artist's earlier *Mind-Body Column* 2000 (fig.90), a double column of steel body-forms rising out of the ground two together, couple on couple, to a height of almost 15 metres, set in a city square in Osaka, Japan. The weathered steel column asserted the continuity of life beneath the insistent surface of the present, the earth's memory, a genealogy of the generations, of the buried dead back through time to our common ancestry: a 'chain of being' that stood as a foil to the sleek facades of the anonymous high-rise buildings all around it. And this work in turn paid homage to an icon of twentieth-century sculpture, Brancusi's *Endless Column* 1938, at Targu Jiu in Romania (which after years of neglect had been restored in 2000 to its original state), an 'archaic mythologic totem' whose repeated geometrical units forged an indissoluble link between the deep earth in which it was rooted and the deeper sky towards which it soared.

Time Horizon 2006 (fig.92) is installed among the Roman remains of the Parco di Scolacium in Catanzaro, at the southern tip of Italy. Here, in a sort of equivalent to *Broken Column* on an extended horizontal plane, a field of 100 cast-iron figures are set at the same height above sea level across the part-excavated forum, hoisted above the ground or embedded within it as the land itself rises in height, like a gathering wave, away from the coast. Ranged across space, rooted in place, the work extends also

MIND-BODY COLUMN 2000 [90]
Cast iron
1450 x 48 x 70
Installation view, Garden City,
Osaka

EVENT HORIZON 2007 [91]
31 elements: each 189 x 53 x 29
Installation view, Hayward
Gallery, London
Commissioned by the
Hayward Gallery, London
(following page)

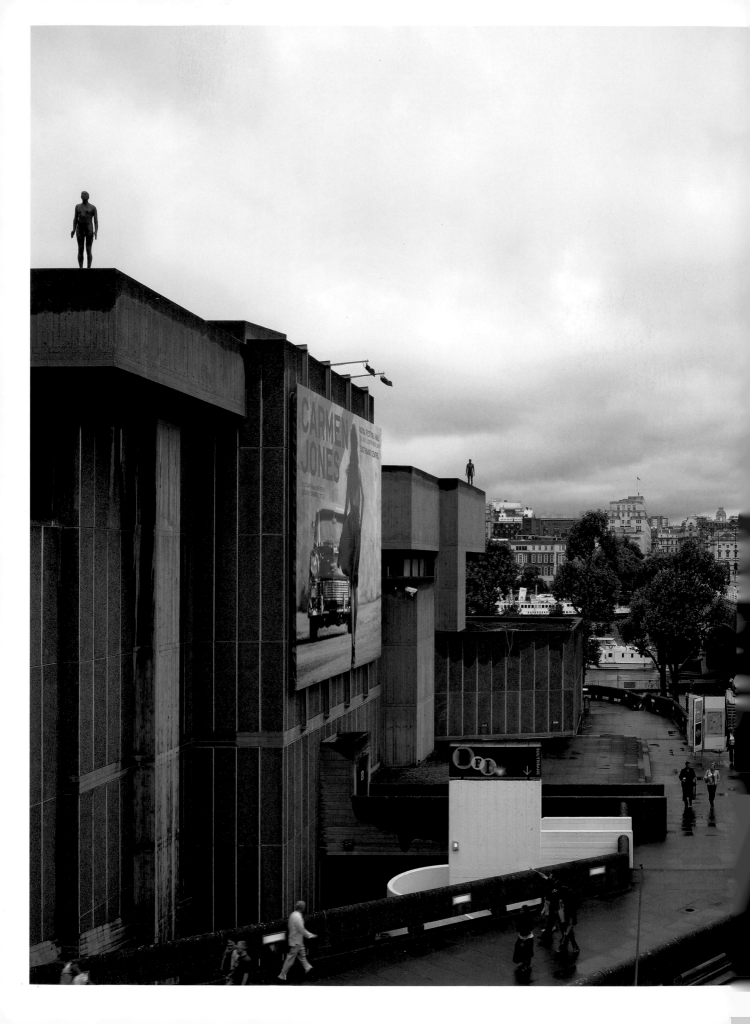

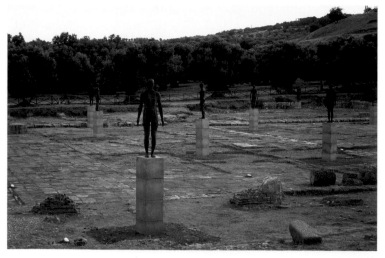

TIME HORIZON 2006 [92]
Cast iron
100 elements: each 189 x 53 x 29
Installation view, Parco
Archeologico di Scolacium,
Roccelletta di Borgia, Catanzaro

Sketch for Fourth Plinth proposal,
2008 [93]

ONE & OTHER 2009 [94]
The Fourth Plinth Commission,
Trafalgar Square, London

through time. As Gormley comments: 'I think of this piece as a form of acupuncture, activating the living human time of the viewer, the biological time of the trees, the geological time of the earth, using the industrial time of mechanical reproduction.'[121] *Time Horizon* is a confrontation with a highly charged site of antiquity and a meditation on place and on history itself – a history both erased and revealed by time and geological tide. People come and go, sculpture remains.

Event Horizon 2007 (fig.91), an outdoor counterpart to Gormley's major exhibition at the Hayward Gallery, adopted a different perspective. The words of the title denote the boundary of the observable universe, and this work, extending to the limits of vision from the gallery itself, was a London-wide installation. Thirty-one life-size figures, twenty-seven on buildings and four on the ground, set up another field from public thoroughfare to inaccessible rooftop. Each distant figure faced inward toward the gallery, inverting and returning the gaze of viewers there. The work as a whole was resolutely anti-monumental in its intent: the figures, 'tiny whispers of human presence',[122] were remarkably faithful representations of the human body, unemphatic, still and upright, standing against the urban stage of London. They remained in place, above and in the city, only for a long summer. Sculptures come and go; people remain.

Speaking of his unrealised project for a colossal *Brick Man* in Leeds in 1987, a 36.6-metre-tall brick-built figure with a hollow interior, Gormley once described his vision of the work: 'My ideal use for this would simply be for one person at a time to stand in that inner space and experience what it is like to stand in a body that size.'[123] *One & Other* 2009 (fig.94), Gormley's project for the Fourth Plinth commission in London's Trafalgar Square, proposed a similar idea: of a single person set, for a short time, on the unused plinth once built for a statue, in public space, in the midst of the collective body, art audience, tourist and Londoner alike. Two thousand, four hundred people, each for one hour over a continuous period of a hundred days through the summer. In a press interview Gormley described this daring, almost reckless public project as 'about trying to democratise this space of privilege, idealisation and control. This is about putting one of us in the place of a political or military hero ... I'm interested in how people's view of the world changes by being exposed in such a public place.' In the 1980s Gormley had made body works that stood as a record of a private, studio-bound ritual or performance, of a lived moment, a real body in real time; with *One & Other* the experience at the core of the work, played out on the plinth in public space, is no longer his, nor even under his control; it belongs to the people who respond to his idea and make it their own. *One & Other* was an open work, prompting open questions, not least from Gormley himself: 'Is this sculpture or isn't it? Can you use time as a medium? Can you use real life as a subject?'[124]

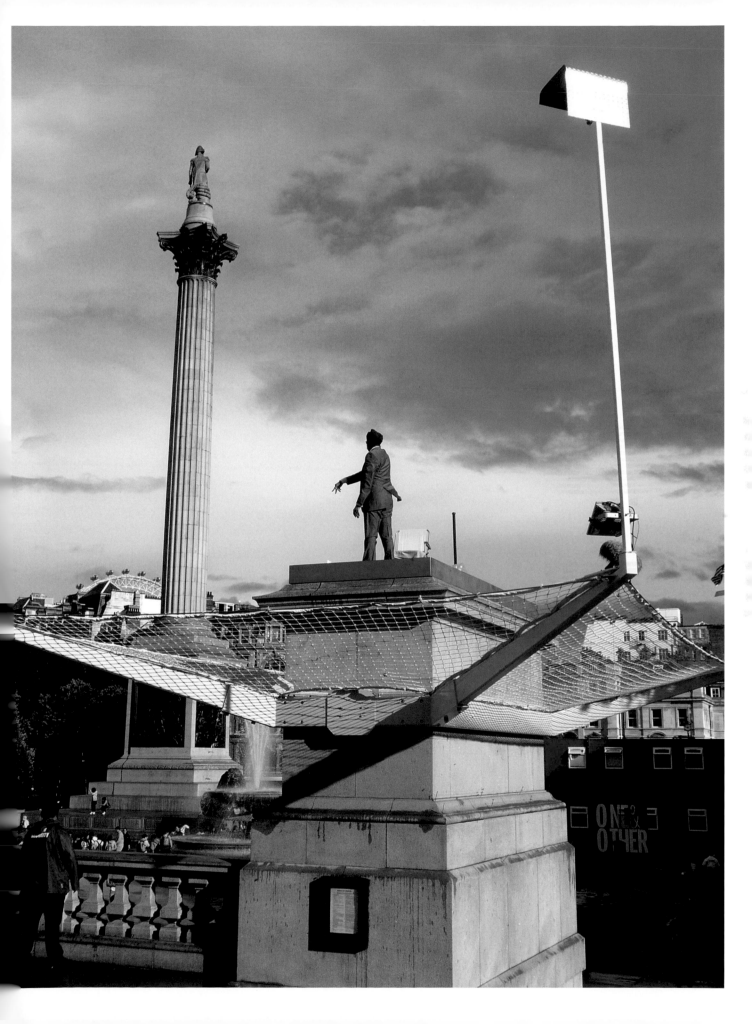

Another Place was conceived for a site on the mudflats outside the town of Cuxhaven in Germany, near the mouth of the Kiel Canal and the busy River Elbe that links the inland port of Hamburg to the North Sea. Gormley's proposal, invited in 1995 by the Cuxhavener Kunstverein and the town itself, was his most expansive to date:

To install a hundred solid cast iron bodyforms along the coast to the west and south of the Kugelbake. The work will occupy an area of 1.75 square kilometres, with the pieces placed between 50 and 250 metres apart along the tideline and one kilometre out towards the horizon, to which they will all be facing. Depending on the fall of the land, the state of the tide, the weather conditions and the time of day the work will be more or less visible. The sculptures will be installed on a level plane attached to two-metre vertical steel piles. The ones closest to the horizon will stand on the sand, those nearer the shore being progressively buried. At high water, the sculptures that are completely visible when the tide is out will be standing up to their necks in water.

The sculptures are made from seventeen body-casts taken from my own body (protected by a thin layer of wrapping plastic) between 19 May and 10 July [1997]. The sculptures are all standing in a similar way, with the lungs more or less inflated and their postures carrying different degrees of tension or relaxation.[125]

The actual work, installed in July 2005 for a period of almost eighteen months, was more extended than originally proposed, the individual figures placed an average of 500 metres apart along 3 kilometres of almost flat coastline, the innermost buried up to their thighs in sand. *Another Place* stood against the comings and goings of the visitors on the beach and the passing container ships on the horizon and the vagaries of North Sea weather – an extended *Field*, reworking and extending many of Gormley's most enduring preoccupations.

The figures themselves, like the clay forms of *Field*, play on the absorbing effects of sameness and difference. Their own cycle of breathing, the in and out movement of the chest, mirroring the ebb and flow of the tide, is barely discernible in the cast forms. They are subtly differentiated in their range of poses, manifesting life, and individuality, in the flex and position of upper body, hands and knees; Gormley recognises in them a 'collision between industrial production (which is serial production) and organic form'.[126] And yet the focus here is no longer – as with the hollow-lead body cases – simply on the space within the body. It is on the space between and beyond the upright figures, extending to the horizon: the place of man in nature. The location of *Another*

ANOTHER PLACE 1997 [95]
Cast iron
100 elements: each 189 x 53 x 29
Installation view, Cuxhaven
Permanent installation, Crosby Beach,
Liverpool

Place, between land, sea and air, recalls photographs of Gormley's early work of that title (*Land, Sea and Air II* 1982; fig.17). Photographs of the Cuxhaven installation present, selectively, wildly opposing images: they vary from the isolated single figure, silhouetted against a vast blue nothingness and eternity of sea and sky – a sublime
to recall the paintings of Caspar David Friedrich – to a scene of interaction and social encounter, with the figures en masse, firm and upright in an ever-shifting setting of beachgoers, ships or seafront architecture. Even when viewed in reality, the work can be only partially taken in, its exact extent indiscernible as it recedes into distance or beneath the waves.

The relation of man and nature here involves both an immediate confrontation, between the standing sculpture, the moving onlooker and the crashing wave, and a longer resistance, a slower co-mingling over time: the daily cycle of tidal flow, of immersion and revelation, and the processes of exchange and erosion brought about by the action of water, salt and air on the 'earth material', iron. ('Iron rusted is living,' wrote John Ruskin in 1859; he described rust as 'the most perfect and useful state of iron', evidence of an exchange between elements, a submission to loss and change.)[127] 'I always look at and engage with site as part of the social world', Gormley has asserted, even when confronting the most barren of environments.[128] *Another Place*, with its standing figures gazing in unison towards the ships that pass and a world beyond, is a meditation on the movement of people and peoples, with all the yearnings and losses that this subject evokes. Gormley's statement on the project broadens the scope:

In placing art at the sea's edge I am asking about our relationship with nature, or our nature in nature, and the seaside is a good place to do this. Here time is tested by tide, architecture by the elements, and the prevalence of sky seems to question the earth's substance. In this work human life is tested against planetary time.[129]

The work itself, so rooted in a sense of place, has in fact itself moved several times: to a Norwegian fjord near Stavanger in 1998, to the Belgian beach resort of De Panne, in 2003 and finally (and permanently) to Crosby beach on Merseyside in 2005. Its placement there required protracted negotiation; its stay was threatened, and only after long, loud and vociferous debate and campaigning was *Another Place* granted leave to remain in perpetuity. This final location, close to the busy marine and human traffic of past and present, and the burden of maritime and colonial history that Liverpool carries, bears a strong relation to its first at Cuxhaven. But *Another Place* is, ultimately, a place not of the world but of the imagination. Gormley has always insisted on the work as an 'open space' for interpretation; each new viewer, finding for themselves a new meaning in it, is, he believes, 'making it again'.

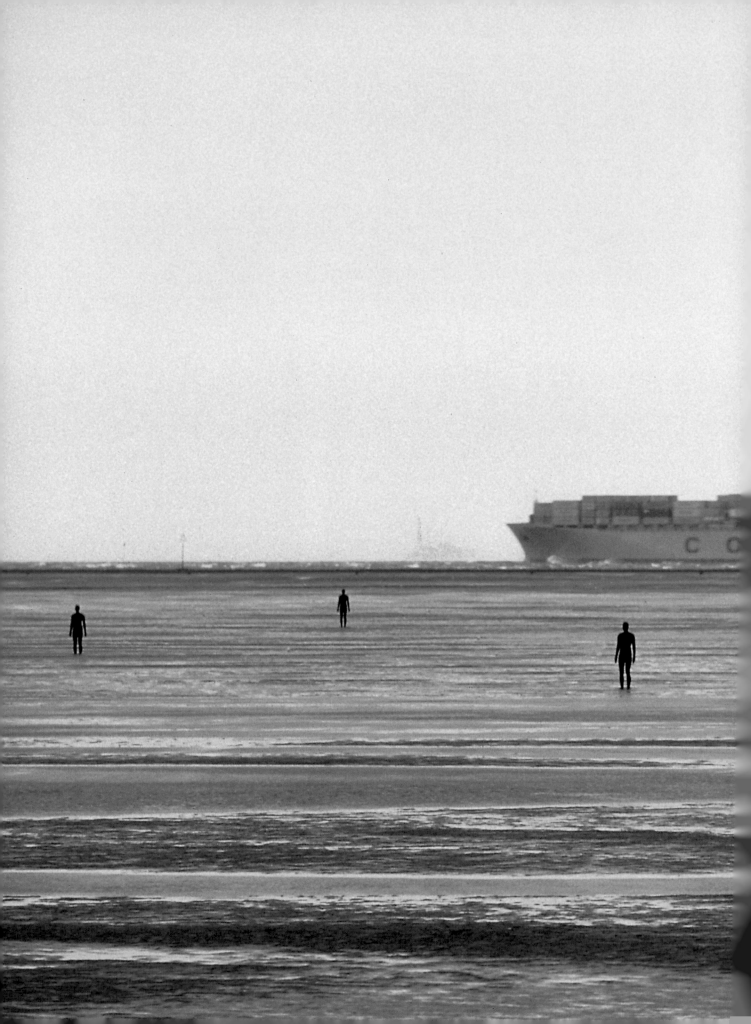

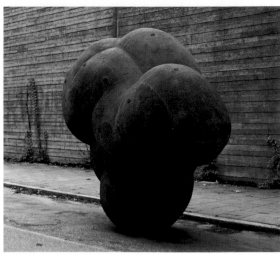

FREEFALL 2007 [96]
2mm square section
stainless steel bar
290 x 185 x 180

EXERCISE BETWEEN BLOOD
AND EARTH 1979–81 [97]
Chalk on wall
Diameter: 1.84m

STILL RUNNING 1990–93 [98]
Cast iron, air
317 x 276 x 148
Collection of Umedalen Sculpture
Foundation, Umeå, Sweden

CONSTELLATION

'Spontaneously the body exploded.'[130]

From the first, Gormley has spoken, in relation to his art, of the body as the site of experience, as space rather than as an object. He has described how, through meditation, he 'experienced consciousness at the centre of a transitive field of energy, in which the "me" of the ordering world was expelled'.[131] He has come to see our skin not as a 'boundary' between what is inside us and what is outside but as porous, 'a constellation rather than an unbroken surface'.[132] Since the late 1990s his sculpture has sought to convey this central idea, to find forms in which 'the body isn't presented as a thing at all, but rather a process or a place where things happen'.[133]

Much of this recent sculpture develops ideas that can be traced in his early work. In a drawing, *Running Man* 1979, remade and retitled as *Exercise Between Blood and Earth* 1981 (fig.97), the contours of a running figure are restated again and again in lines, both inwards, towards the body's core, and out into space, where they extend until they form a rough circle – marking the furthest extension of the artist's arm and a point where the potential of the figure gives out, exhausts itself: the limits of an energy field. 'I have made a diagram of the fields of active influence that surround a man,' he said at the time.[134] The movement of the work flows both ways, between blood and earth; 'both elements are mutually supportive'.

This idea of the energy field surrounding the body was expressed in three-dimensional form in a series of large and heavy works in cast iron that he made in the early 1990s. The 'Expansion' works, as they are known, mark his 'obsession with renegotiating the skin'.[135] Each work began with a plaster cast taken from the artist's body striking a static pose as if in action – running or jumping. Taking a cue from the early

drawings, they described a process of extending the form layer upon layer beyond the contours of the body to recreate the extended, rounded shape of an energy field. Gormley devised a method of doing this in three dimensions with the use of wooden sticks of fixed length, radiating out from all points of the body's surface to delineate a further, 'expanded', bulbous form. Some of these, like *Still Running* 1990–3 (fig.98), rest on the ground; others, such as *Body* and *Fruit*, both 1991–3 (see fig.99), are suspended in midair, bodies in space. They are body abstractions: the forms of *Body, Fruit* and *Earth* suggest cellular or organic growth. 'I regard them all as contained explosions,' said Gormley.[136]

He has described the largest of these works, the 11.2-tonne *Earth* 1991–3, as 'the biggest expanded breath'.[137] The act of breathing in and out is of course critical to his body works, and the related idea of expansion and contraction is an insistent one throughout his work. After the maximum expansion of *Earth*, Gormley turned to the opposite extreme, to arrive at a body structure in its most concentrated, contracted form, with a large series of cast-iron figures begun in 1997. The *Insider* (fig.100) sculptures suggest, at first sight, something of the studied intensity of Alberto Giacometti's emaciated bronze figures, but they are based on a particular and programmatic process of making. Each *Insider* figure derives from the vital dimensions of a human body – first the artist's and later, with the *Inside Australia* project that began in 2002 (fig.120), those of a whole community – subjected to a form of abstraction, an 'objective mathematical reduction', which involved shrinking the body's breadth to an extreme degree while retaining its height. The resulting figures, which comprise one-third of the real body's mass, not only present the physical core of the body but also, in the artist's view,

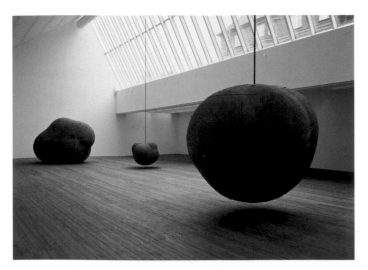

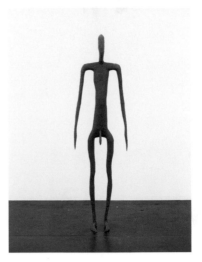

EARTH, FRUIT and BODY 1991–93 [99]
Cast iron, air
EARTH: 260 x 230 x 290; FRUIT: 104 x 125
x 120; BODY: 229 x 259 x 219
Installation view, Malmö
Konsthall, Malmö 2003

INSIDER I 1997 [100]
Cast iron
195 x 55 x 26

QUANTUM VOID VI 2009 [101]
6mm square section mild steel bar
370 x 275 x 127

reveal a sort of emotional concentrate, a sense of the body's attitude, strange yet still recognisable. This is not the skeleton; it is the energy of the living figure at its most contained. For Gormley the figures in this series arrived at some kind of furthest point – a critical mass? – with only one possible outcome, as he explained later: 'We ended up with the residue, which I associate with pain. There was nowhere else to go after this final contraction. Spontaneously, or a result of desperation, the body exploded, and that's where I am.'[138]

Gormley once claimed: 'the ideal sculpture is a bomb that contains time, but also contains its destruction.'[139] Explosion, the release of matter and energy into space in a split second, is a telling metaphor for what was to happen to Gormley's work around the turn of the millennium: a liberation and a proliferation of sculptural possibilities as significant as the 'escape' from the studio that *Field* had afforded ten years earlier. Gormley's understanding of the body as 'a place of becoming, where events happen,'[140] derives in large part from his early experiences of Buddhist meditation in India. He has made frequent mention of the Buddhist belief in the essential interconnectedness of mind and body – in fundamental contrast to the tradition of Western thought and belief which finds expression in Plato's idealism (the separation of the idea from experience), in the Christian separation of spirit (consciousness) from body and the material world, and which is perhaps best summed up in the famous assertion of René Descartes in the seventeenth century: 'My essence consists in this alone, that I am a thinking thing ... And though perhaps I have a body with which I am closely conjoined ... I am truly distinct from my body, and can exist without it.'[141]

This Western notion of the separation of mind from matter is reflected also in the common understanding of the 'single reality' of Newtonian physics, as a

deterministic, reductionist vision of the physical realities of the universe in which matter and space, solid particles and wave motions/energies are considered as separate entities. Of course post-Newtonian physics, in the twentieth century, exploded this model: quantum, or post-particle, physics recognised a system of multiple, opposing realities, expressed in such fundamental concepts as the wave/particle duality, encapsulated in Heisenberg's uncertainty principle, which asserts that we can measure wave properties or particle properties, but not at one and the same time; that we cannot measure the properties of the wave/particle duality itself. In the later twentieth century, the implications of this rewriting of the physical laws of the universe were increasingly applied to the realm of human consciousness and creativity – described as a 'physics of the mind' or a 'quantum psychology'.[142]

Many writers have sought to bring the implications of quantum theory from the sub-atomic level to bear on our experience of everyday reality, to formulate new models of human consciousness distinct from the 'alienating' implications of Cartesian philosophy and Newtonian physics, in which man is detached from the fabric of the universe. One such, the writer Danah Zohar, has described a 'quantum world view' which 'transcends the dichotomy between mind and body, or between inner and outer', prompting a less fragmented, more holistic way of looking at ourselves and our relations with the world, and 'a creative dialogue between mind and matter'.[143] This has strong connections to another cosmological formulation, the 'implicate order' of the physicist and philosopher David Bohm, who in attempting to resolve the contradictions between relativity and quantum theory, wrote in 1980 (and subsequently) of the order of the universe in terms of a flow or undivided whole, in

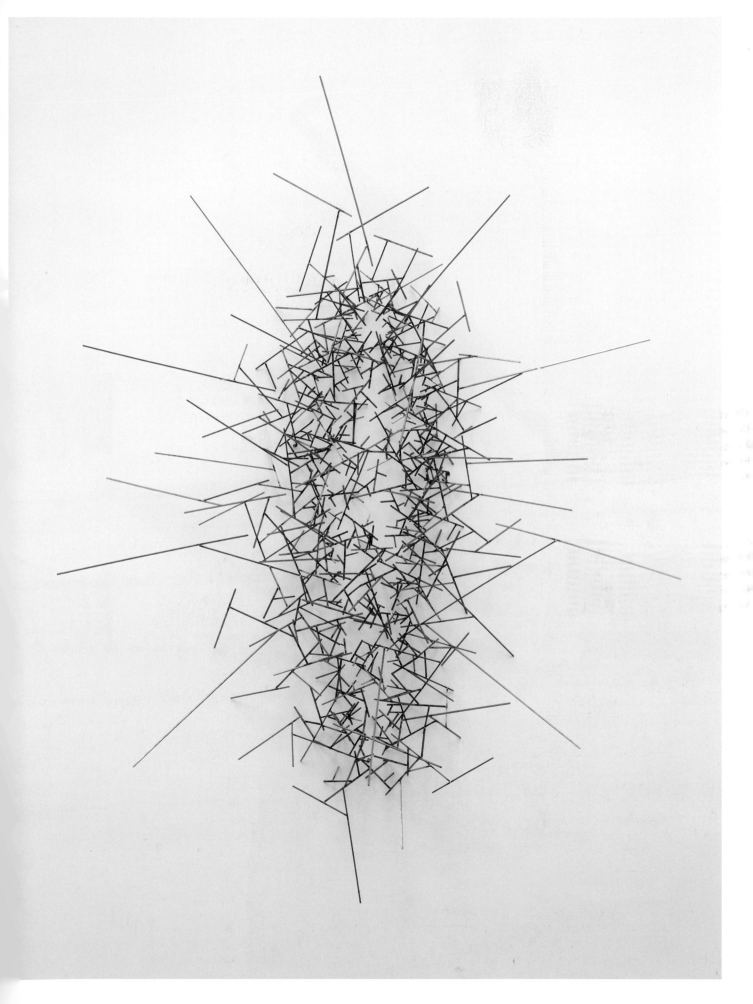

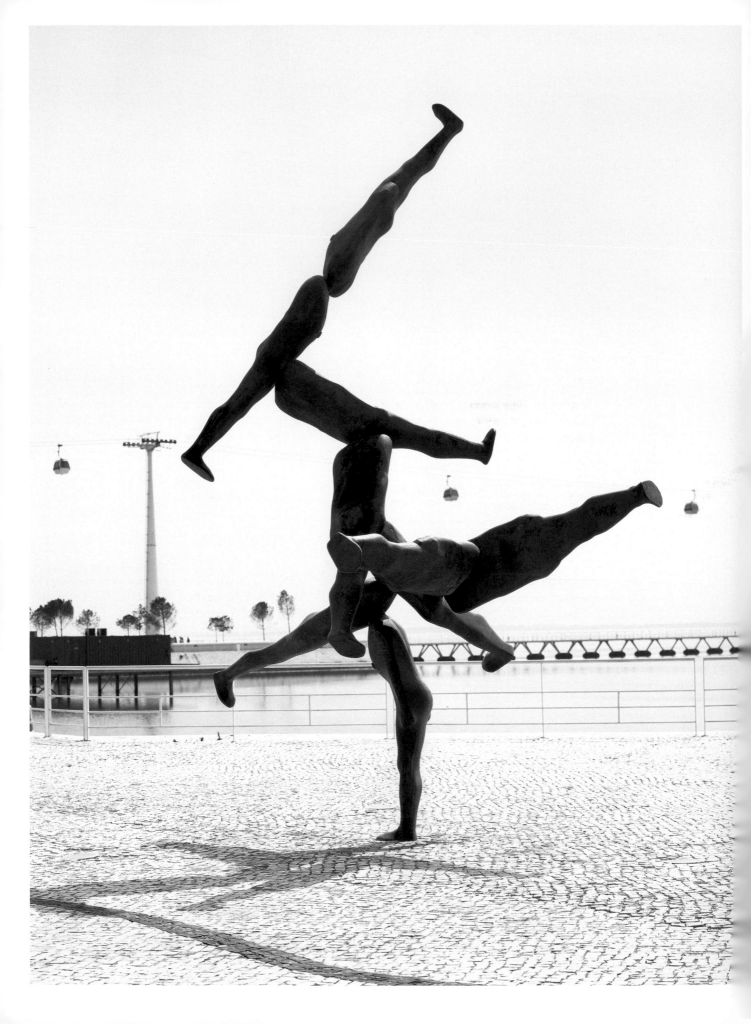

RHIZOME II 1998 [102]
Cast iron
498 x 380 x 340
Installation view, Parque
Expo '98, Lisbon

CELL CYCLE I 1997 [103]
Square steel wire (4mm)
97 x 95 x 102

which nothing is entirely separate or autonomous. Such notions, of course, are as contentious as they are widespread, but the general implications of the new science, in both its physical and its psychological aspects, have influenced Gormley profoundly, as he has acknowledged:

I suppose physics is the closest thing to sculpture in science ... I am more interested in notions of energy, and the wave/particle dichotomy as a model of the uncertainty ... Post-particle physics is at the meeting point of mind and matter. It is trying to find a model for the formation of truth that comes very close to the one that I am engaged in.[144]

From the mid-1990s Gormley had been looking for ways to take the body beyond a unitary form, to see in it an assertion and reflection of universal principles. His sculpture *Cell Cycle I* 1997 (fig.103) alludes to molecular and evolutionary processes, in macrocosm and microcosm: to the relation of the body, in one way, to planetary bodies, and in the other, to the individual cell. It seems to adopt something of the language of Alexander Calder's kinetic sculptures constructed from wire of the 1930s and 1940s, in which nuclei in space and spheres-within-spheres evoked cosmic relationships and celestial phenomena. (Calder wrote in 1951 that his work since 1930 had derived its 'underlying sense of form from the system of the universe or part thereof.')[145] Gormley's *Rhizome* series, begun in 1998–9 (fig.102), suggests a similar sense of the interconnectedness of human life (the rhizome, as an organic structure of which any point may be connected to any other, is a compelling natural model for postmodernist thought and virtual systems of knowledge transfer).

Explaining, recently, the processes of expansion and contraction of the human form that led to the 'explosion' of the body in his work, Gormley made direct reference both to Buddhism and to the New Physics. Rather than 'trying to reconcile the dialectic of mass and space by inversion or concentration (turning the body into a space is inversion, and turning the space of the body into a solid mass is a concentration)', he advances a concept of the body 'which is more contemporary and closer to [the] post-particle physics of David Bohm, Heisenberg and Niels Bohr ... I agree with the Buddhist proposition that the western idea of an absolute individual with an everlasting soul has to be replaced by the idea of the individual as provisional, mutable and non-lasting.'[146] So saying, he attempts to rethink the idea of sculpture as an absolute object in space in favour of the construction of a 'provisional energy field in space'.[147]

The series of single body works all entitled *Domain* that began in 1999 envisage the body as an open structure or 'field', a random matrix of thin steel bars of varying lengths arranged within the bounds of the body's invisible skin. As with earlier body works, the form and pose of the figure is provided by a plaster cast taken from the artist's body; but the open, extendable implications of this constructive principle also found a natural expression in a significant collaborative project: for *Domain Field* 2003 (fig.104) Gormley enlisted a community of volunteers to create an installation of many individual bodies, first shown at the Baltic Centre for Contemporary Art in Gateshead. *Domain Field* resulted in an extraordinary occupancy of a large gallery space by 287 wraith-like abstracted figures, a forest of thin steel rods in which sameness and difference were held in a tense balance, dominated by a strange sense of human vulnerability.

The *Quantum Cloud* series that developed alongside *Domain*, also from 1999, adopted a similar matrix of steel bars randomly joined, but here the matrix extends beyond the surface of the body into surrounding space,

DOMAIN FIELD 2003 [104]
Square stainless steel bar (4.76mm)
287 elements derived from moulds
of local inhabitants of Newcastle and
Gateshead, aged from 2.5 to 84 years;
various sizes
Installation view, BALTIC Centre for
Contemporary Art, Gateshead
Commissioned by BALTIC, Centre for
Contemporary Art, Gateshead

QUANTUM CLOUD IX 1999 [105]
Mild steel bar (4 x 4mm)
222 x 127 x 106
Collection of Kunsthalle Bremen

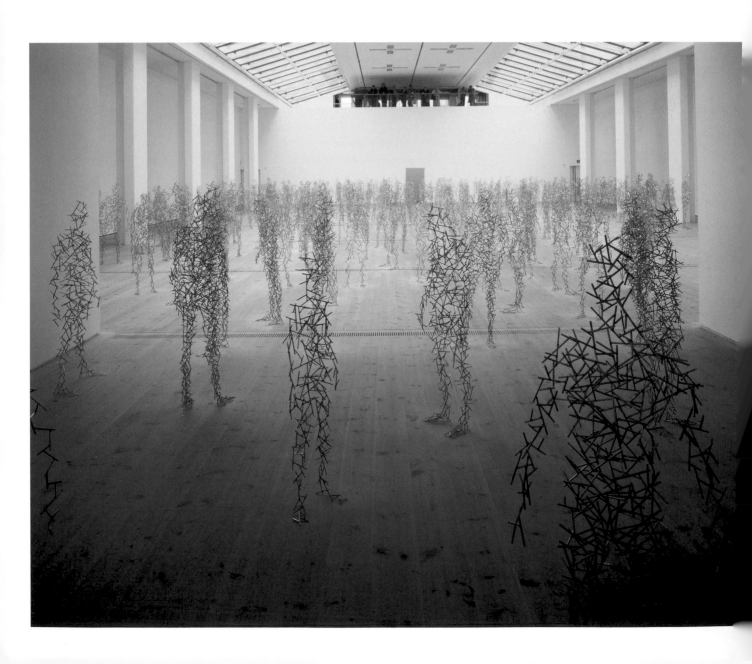

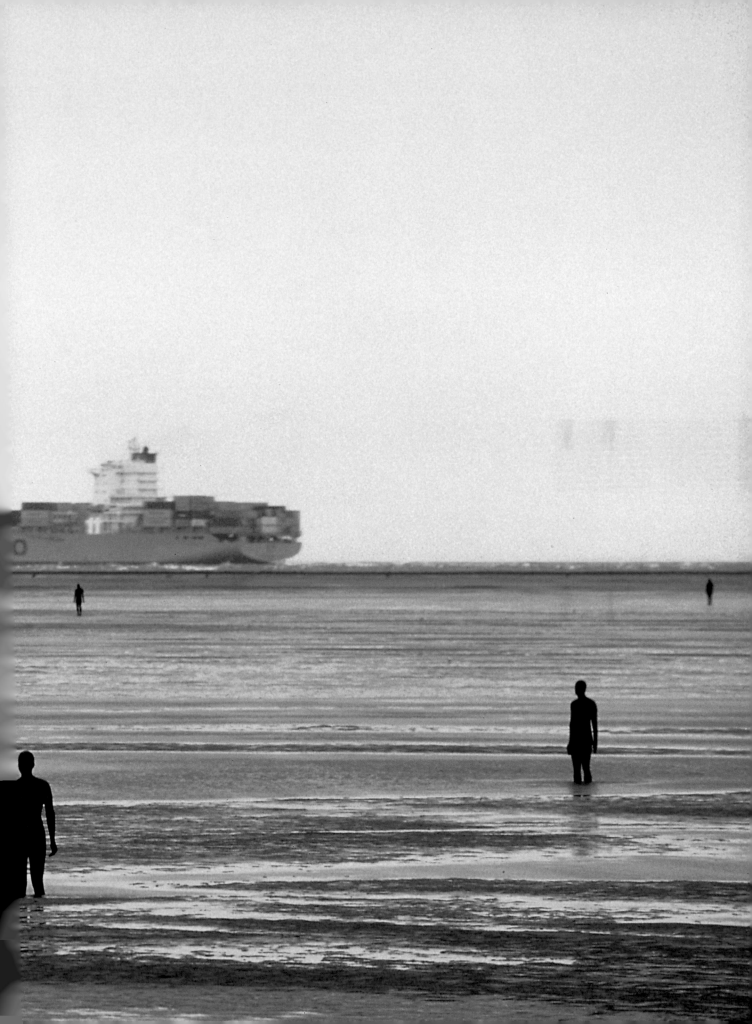

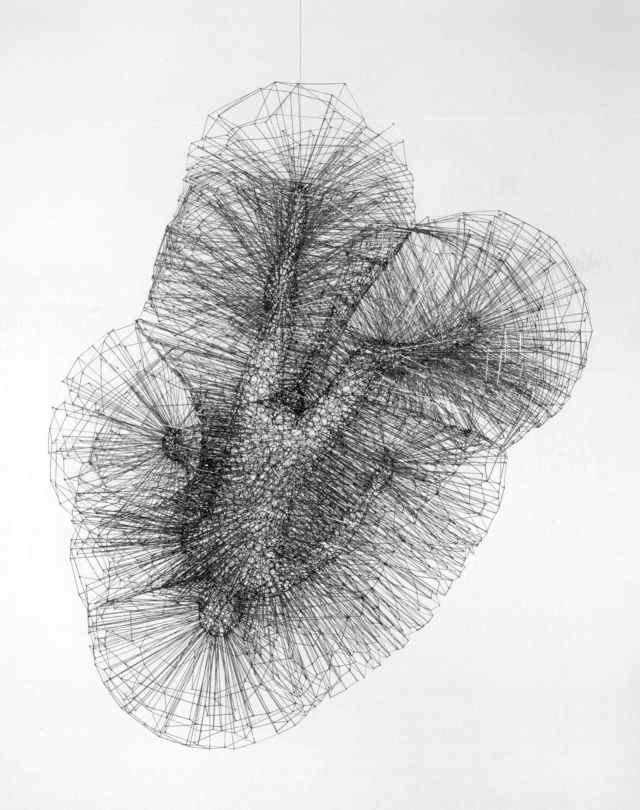

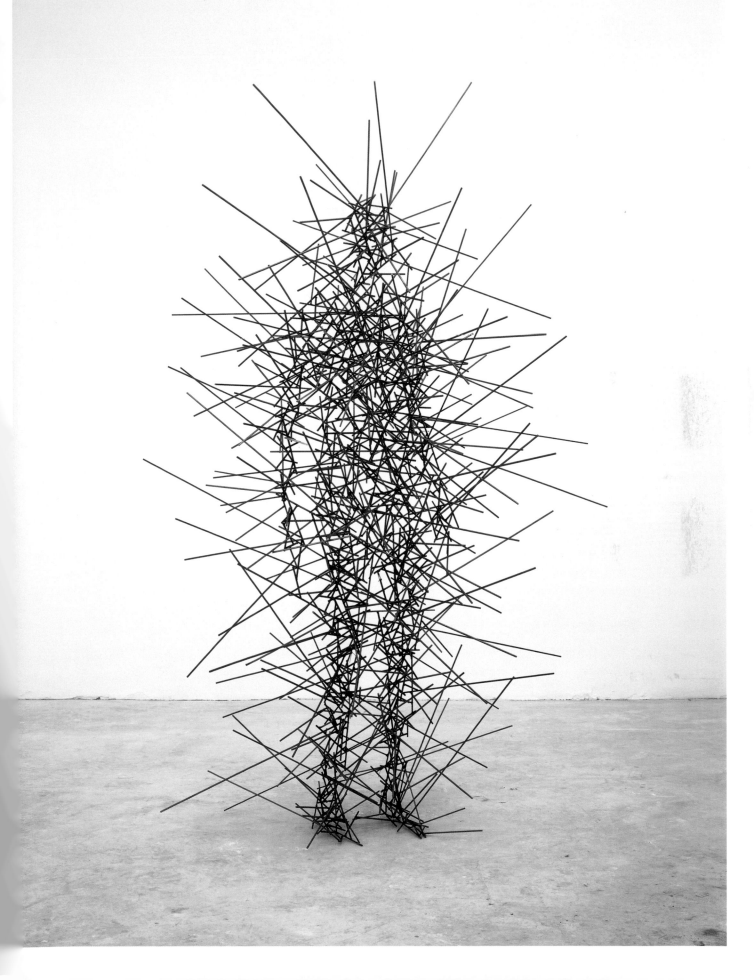

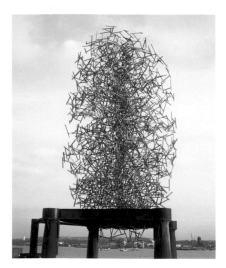

QUANTUM CLOUD 2000 [106]
Galvanised steel
29 x 16 x 10m
Installation view, Greenwich,
London

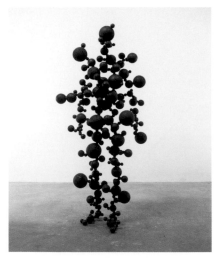

BODIES IN SPACE V 2001 [107]
Forged ball bearings
200 x 106 x 70

FEELING MATERIAL I 2003 [108]
Rolled mild steel hoops
(3.25 x 3.25mm; various diameters)
205 x 154 x 128

signalling a diffused field of energy around the denser core of the still-discernible human form (fig.105). As the series evolves, changes in the configuration of the steel bars, and in the relative density of bars within and 'beyond' the figure, lead to a breakdown in the appearance of the body, which approaches – but stops just short of – a complete dissolution of the human form. The body remains, on the edge of visibility, to cohere or disappear depending on the viewer's position as they circle round it. Or, in some cases, depending on the changing angle of view that the work itself presents, for some of the *Quantum Clouds* hang and slowly revolve in midair, in suspension. Like a constellation of stars, the relationship of parts and the apparent structure of the whole depends on the point of view. Gormley stresses the uncertainty, in our reading of these structures, as to whether it is the energy field that emanates from the body, or the body that emerges from the field. The *Quantum Cloud* series arrived at a defining version – though by no means an end point – with the erection of *Quantum Cloud* 2000 (fig.106), a 30-metre-high steel structure located on the Thames outside the Millennium Dome on the Greenwich peninsula in London. The work, viewed from below against the sky, acted as a 'dematerialised monument'. In later works, and in a new series, the *Quantum Voids*, perhaps inevitably, the body disappears altogether, leaving only an empty space to mark its place at the centre of a cluster of parts.

Alongside the *Domains* and the *Quantum Clouds*, other extended series have evolved. In these, the logic of their constructive principle relates to their different component elements: steel balls (tightly packed in *Bodies at Rest* 2000, and more open or molecular in structure in *Bodies in Space* 2001; fig.107); rods, adhering to the body's core like iron filings to a magnet (*Capacitor* 2001; see cover); blocks (the pixellated 'body-as-building' forms of *Concentrate* 2003 and *Precipitate,* from 2004); rings, tubes and rolled steel wire (*Feeling Material,* from 2003; fig.108).

The wire figures of the *Feeling Material* series are often referred to by the artist as 'drawings in space', and space, here, can be conceived on any scale – the scale of proton paths around the nucleus or of planets around a star. Each 'figure' describes a vortex formed of orbits around a body. Through the series there is a gradual loosening of the structural principle, which takes the figure, at its core, in two directions: towards the dense concentration of the *Insider* figures, in which the human form stands firm in contrast to the expanding lines of surrounding energy; or towards a gradual loss of the core form, in which the interior of the body – often crouching, sometimes suspended – disappears from some angles, or is made visible as a void at the centre of a spiralling energy field. There is a tension here, for more is at stake than a mere loss of the body: the sculptures are more than a demonstration of physical principles and forces. It is important for Gormley that we continue to recognise them as bodies and recognise ourselves in them. The possibility must still be there for a response of empathy: the 'material' must retain 'feeling'. If the works are propositions, he insists, they remain imaginative propositions.

Clearing 2004 (figs.110–111), an installation first shown at the artist's London gallery, White Cube, demanded such an effect, calling on the viewer literally to inhabit the work. Like many of the artist's large-scale works of recent years, it draws together concerns discussed in separate chapters of this account, interweaving the skeins of his art. *Clearing* describes an energy field within architectural space, made of 4.5 kilometres of thin square-section aluminium tube curved and coiled in spirals within the confines of the room – a field with the potential for infinite extension,

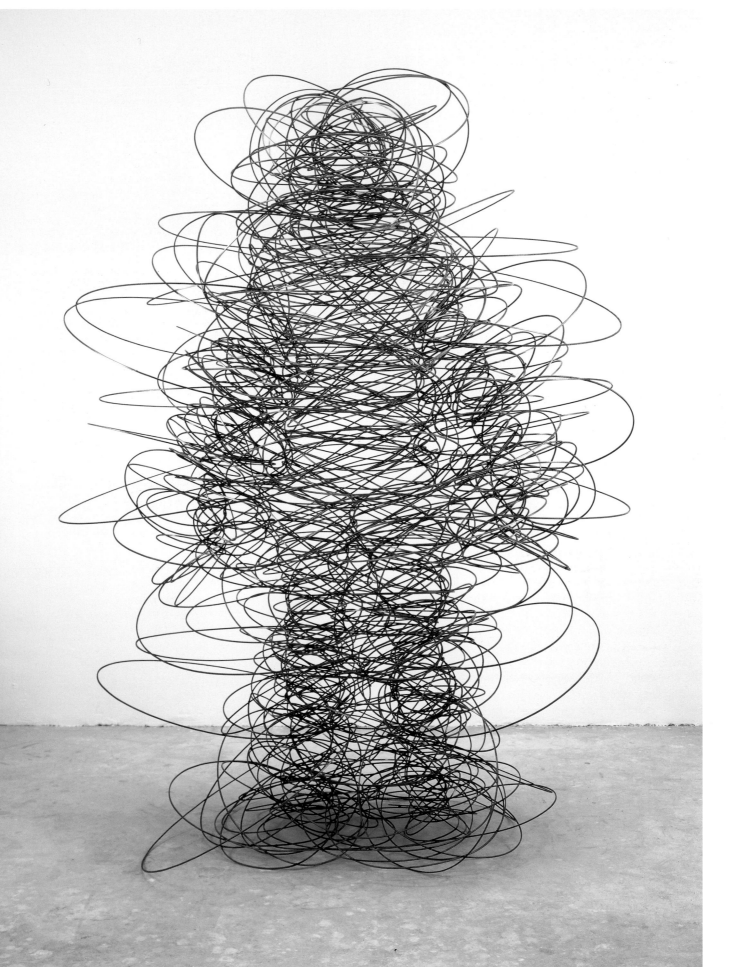

EXERGY I 2007 [109]
Square section stainless
steel bar (3mm)
230 × 210 × 210

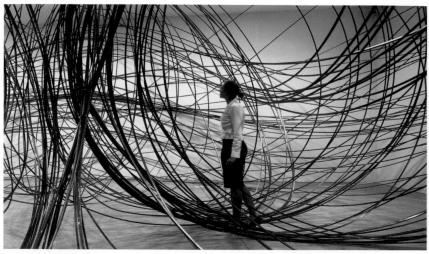

CLEARING IV 2005 [110]
Aluminium tube
(6km of 12.7 × 12.7mm, 16swg)
Dimensions variable
according to room size
Installation view, Sean Kelly
Gallery, New York

CLEARING I 2004 [111]
Aluminium tube
(10km of 12.7 × 12.7mm, 16swg)
Dimensions variable
according to room size
Installation view, White Cube
Gallery, London

contained in an architectural case. Viewed from afar through the entrance doorway, *Clearing* reads almost like one of Gormley's gestural abstract drawings, black arcs bounding energetically across a field of white space. But the energy and complexity of *Clearing* can be fully experienced only by penetrating (with considerable difficulty) to the work's core. More, perhaps, than any previous work of Gormley's, *Clearing* demands a very physical engagement: our arms and legs as well as our eyes are called upon to negotiate the resonating metal tubes, which yield to or resist our weight and touch. A sense of uncertainty, even of danger, infects the relationship between our bodies in their ungainly movement and the pent-up force of the constrained loops of metal. There is no centre to find within the work, no core, no inside or out. Absorbed in unfamiliar terrain, we and those around us make slow progress. For Gormley, *Clearing* is 'a four-dimensional drawing in space/time'.

Clearing, like *Breathing Room* in 2006, was an attempt to frame space, and in this sense both works are related to all the figure series that followed for Gormley; 'once the body explodes and dematerialises through a rendering of the skin as porous, I am in the realm of the space frame, and I'm interested in finding the most effective way of engaging in and structuring space … the most economic way of evoking a place of emotional potential. I am also trying to uncover principles, to base the work on clear analytical structures.'[148] The structural principle that he came upon in 2006, and on which so much of his recent work has been based, is that of the bubble matrix. This irregular polyhedral form, which encloses volume within the minimum possible surface area, has provided him with a fascinating and flexible construct: it is, he explains, 'both rigorous in its geometry but also most extreme in the diversity of the application of

that geometry'; it allows 'the association of very very large volumes with very tiny ones that conform to the same basic geometrical pattern'.[149] In such structures each element has an equal and yet unique place within the whole: the relevance to Gormley's broader thinking, in relation to the individual and the collective, the body and its constituent parts and its place in the universe, is unmistakable.

The application of the bubble-matrix principle in Gormley's recent sculptures such as *Exergy* 2007 (fig.109) and *Freefall* 2007, both through practical model-making in the studio and, increasingly, through digital mapping on computer, has led to an extraordinary range of forms of incredible complexity and, at the same time, openness:

the matrices and expansions are the closest I get to Brancusi's notion that you can turn an object into light. He did it by polishing sculptures, whereas I have tried to do it by abandoning weight and mass and dissolving surface. These bundles of nothing are the most dematerialised works I have ever made. The bodies are free, lost in space, weightless, and with no internal determination. They appear as emergent zones.[150]

Computer technology now facilitates, even drives, much of the evolution of Gormley's work. It allows for immediate and complex three-dimensional drawing. It offers 'the ability to map, not simply surface, but space itself; finite and infinitely extendable spaces. All the work I'm working on now has the implication of infinite extension.'[151] Two recent and significant installations give a glimpse of this expanding field of possibilities, and a summation of all Gormley's current – and enduring – concerns, his world view. *Firmament* 2008 (fig.112) is a vast polygonal structure of steel elements, a scaled-up body pressed against ceiling and walls, barely readable as you enter the space and

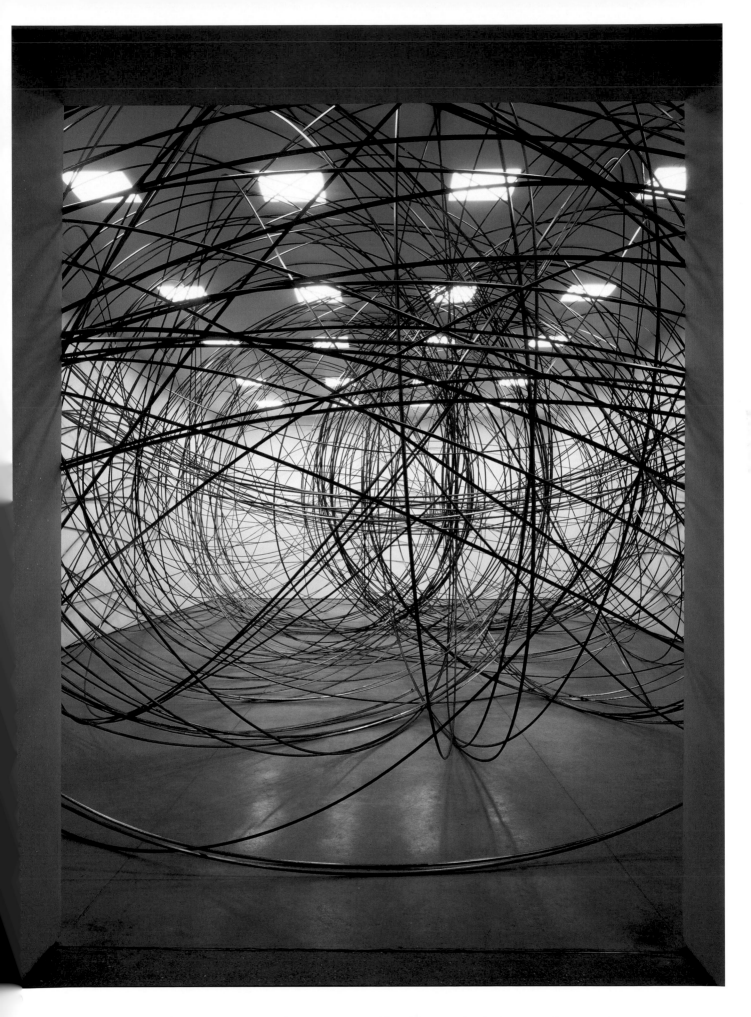

struggle to make structural sense of the sprawling matrix of volumes that all but engulfs you.[152] Firmament: the solid vault of the skies ... for Gormley, the work 'tries to get an idea of the space relations of stars in the night sky and the internal condition of the body within the defining characteristics of architecture'. The work's counterpoint, providing an alternative image of infinite extension, is *Another Singularity* 2008 (fig.113), an installation first mounted in a gallery in Umeå, northern Sweden. Gormley describes it as a 'body matrix made of rope' and as a cosmological moment of explosion and origination. Its force lines, tensely strung ropes emanating from a vast body void suspended above our heads as we stand in the space, extend outwards and pierce the surrounding frame of the gallery walls. Here, says the artist, 'I'm trying to reconcile the idea of body space, the subjective space of the individual, with the idea of the expanding universe ... the idea of how our history fits into something much larger'.

These latest works propose an open-ended dynamic of mass and space, emergent and dissolving form. No longer is the body, the sculptural object, a form displacing space: it becomes one with the surrounding space itself, at once an infection and a cohesion.

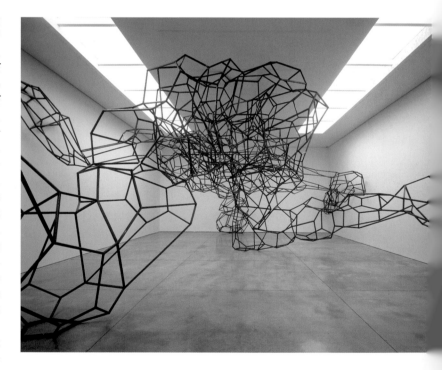

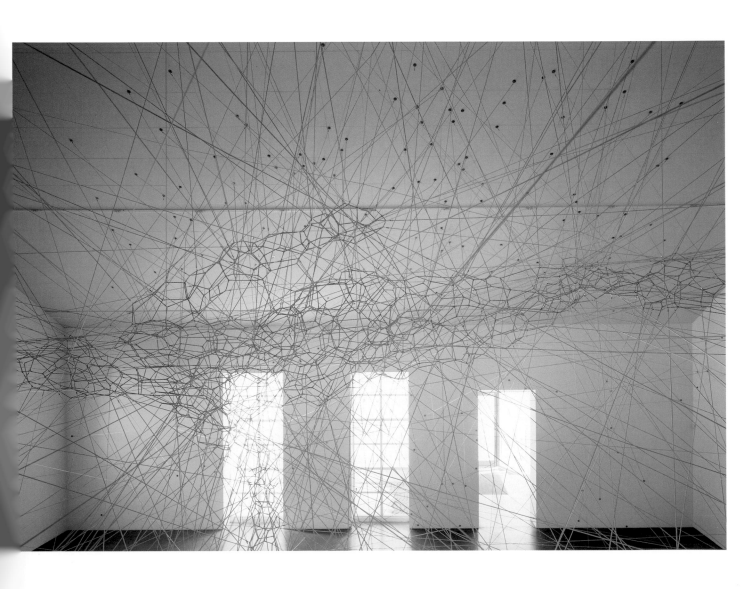

Gormley's exhibition at the Hayward Gallery in London, in the summer of 2007, was his most ambitious to date. He saw it as more a 'laboratory of exploration'[153] than a conventional retrospective, and yet it acted as a powerful summation of his preoccupations. In the robust and cavernous spaces of the gallery he gathered, along with some early works, figures from the *Critical Mass* series, more recent matrices and 'Expansion' works , and a series of major environmental sculptures, most of them shown for the first time: *Allotment II* 1996, *Drawn* 2000–7, *Hatch* 2007 and *Space Station* 2007. Each of these drew on the character of the building and its urban context, and involved an interplay of architectural space and sculptural form that immersed many viewers in the work: they became participant and subject, to be observed in turn by others. The exhibition attracted great publicity, before and throughout its run; the works that drew most comment were *Event Horizon*, the figures visible from outside the gallery ranged across the 'lost horizon' of the city's skyline, and inside, at the heart of the exhibition, the work from which the exhibition took its title, *Blind Light* 2007.

Blind Light was envisaged as 'a very brightly-lit glass box filled with a dense cloud, where people will vanish as they enter the chamber but might emerge as shadows for the viewers on the outside of the box'.[154] The proposition – the intrusion into architectural space of an external elemental condition – is as straightforward as that of his earlier mud installation, *Host* 1991. Its effect is just as complex and unsettling. Shown at the Hayward Gallery in the centre of a large, high, off-square room, otherwise unlit, it took the form of a large glass structure, each side roughly 10 metres wide and 3 metres high, with an open entrance one side. Inside it was a cooled atmosphere of around 90 per cent humidity, which under the impact of 7000 lux of intense fluorescent light rendered a visibility of less than an arm's length: a bright, cuboid cloud.

Blind Light is the first work by Gormley to list light itself as an integral element. Modern artists had co-opted light, in its material and immaterial form, in their work throughout the twentieth century. In the 1960s and 1970s, in particular, it had been employed to create – either through its near absence or its intense presence, through darkness or brightness – contained, immersive environments that aimed to induce sensations of heightened consciousness or bodily awareness, isolation, irritation or awe, in the entering spectator. Interesting connections suggest themselves here between *Blind Light* and Gianni Colombo's perceptual experiments with abstract form and linear perspective in darkened environments such as *Elastic Space* 1967; with Bruce Nauman's ultra-bright *Yellow Room (Triangular)* 1973; and with Lucio Fontana's white labyrinthine *Ambiente Spaziale* 1968. Water, of course, has coursed through artworks since the first

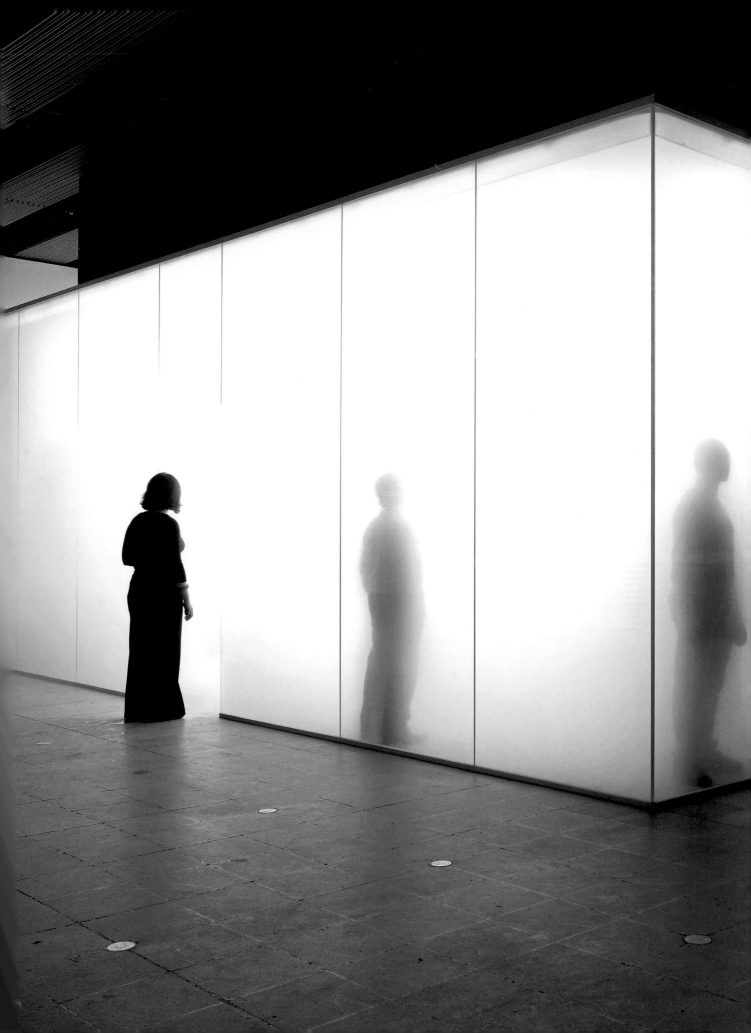

BLIND LIGHT 2007 [114]
Fluorescent light, water, ultrasonic
humidifiers, toughened low iron
glass, aluminium
320 x 978.5 x 856.5
Installation view, Hayward
Gallery, London 2007
(previous page)

BLIND LIGHT 2007 (detail) [115]
Installation view, Sean Kelly Gallery,
New York

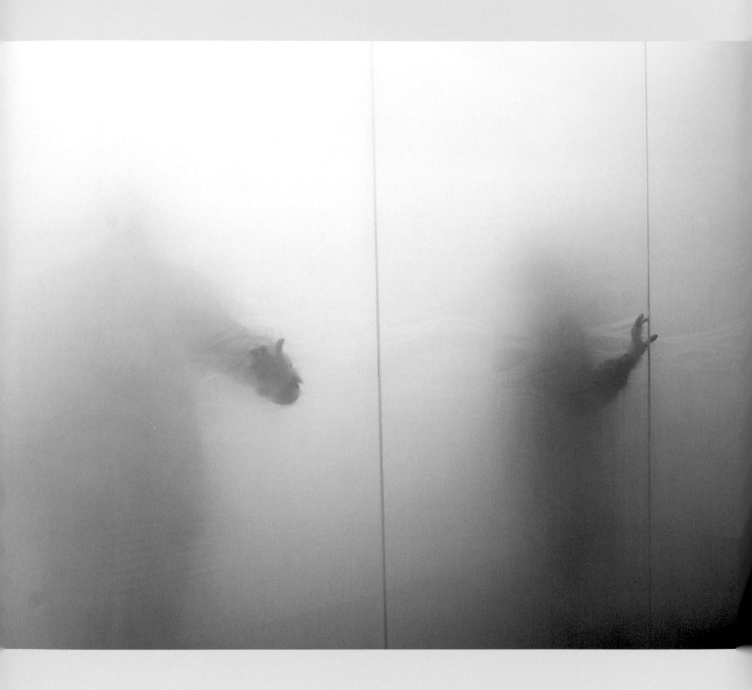

fountain. In more recent times, the American artist Hans Haacke worked with natural processes, water and air currents, in his early small-scale works such as *Rain Tower* 1962 and *Condensation Cube* 1963–5, in which water held inside a sealed transparent acrylic cube reacted to changes in heat and light; Haacke described these as 'transparent event containers'. The architects Diller and Scofidio, for the Swiss National Expo in 2002, had crowned their *Blur Building* with a cloud of perpetual artificial mist which could be entered via walkways, but which, uncontained, reacted variously with prevailing weather conditions. But *Blind Light*, as an experience and as a technical challenge, a precisely-created and regulated environmental phenomenon, had no immediate precedents; for Gormley it was a new step, and a fascinating development of his exploration of the body in space – or, as he put it, of 'real bodies interacting with a conceptually-structured elemental space'.[155]

Its effect is all-enveloping, like a natural phenomenon, yet from the outside *Blind Light* reads as a defined volume, yet another take on the transparent modernist cube. It is a 'room', but not one that affords any sense of shelter or security. Those who enter are immediately lost to view, to reappear, suddenly to those watching outside, close-to the inner side of the glass wall, hands outstretched, emerging from within to touch the 'outside' like the absent body in Gormley's concrete-block work, *Sense* 1991. To walk into *Blind Light* is to lose all optical clues, all sense of the work's proportion and confines: to lose, rapidly, that awareness of our body in relation to its surrounding space that we take for granted; to locate and feel ourselves in another, less familiar way. Inside is a moist, cool, unsettling world either of total, enveloping isolation or of disembodied voices and the sudden looming appearance of others – for, if we feel a need to find ourselves or to be found, it is other people who provide our most ready, perhaps our only coordinates.

Gormley describes *Blind Light* as 'a glowing chamber in which you disappear, not only to others but to yourself; you become, in a way, consciousness without a body'.[156] It might recall childhood dreams or visions of an afterlife. It is a work full of conundrums: it contains an effect, the action of light on moisture, which both fills a space and remains space itself; and, as the artist said, 'the most important thing about *Blind Light* is suggested by the title: the idea that light itself can be the opposite of illuminating'.[157] For Gormley, though, the phenomenon is as much a social as a natural one: 'With *Blind Light* you could say that light is the environment, but actually people are the environment. It's about these very close encounters with the other ... It's a kind of social experiment. The idea of separating people from all the things that make them certain about where they are or maybe who they are.'[158]

SEEING AND BELIEVING: GORMLEY'S APPEAL

Gormley works today in a studio near King's Cross in North London, designed for him by the architect David Chipperfield and built in 2004. A restrained design, freestanding, factory-style and daylit, its proportions follow those of the artist's previous studio in Peckham, but magnified by a factor of seven. Its structure took 108 tonnes of steel girder, and its footprint provides 650 square metres of floor able to bear loads of up to 45 tonnes. Its main space, 10 metres high, accommodates mock-ups of the artist's large works, and from its ceiling hang wire figures, bodies in space. Gormley describes the studio as 'an industrial unit dedicated to creative work', an 'organism and a generative instrument, an open ground for experimentation'. 'Sculpture is collaborative. It always has been. That's one of its joys, actually.'[1] Gormley's work is generated within a 'field of social relationships', a large, shifting series of networks and engagements across projects, galleries and museums worldwide, and the studio is its epicentre. It accommodates a host of co-workers, artists and technicians, and, more latterly, computer imagers and designers, without whom no large-scale work or project could be realised: new physical forms are plotted digitally, and Gormley now has an avatar, ready to be deployed to test, in virtual terms, the place of his body and the place of each new work in actual space, in the real world.

Gormley's brief to the architect was that the studio provide him with 'Light, space, silence'. On occasion, and in places, it does. The building has two external staircases at its front. One leads to the shared workspaces of communal activity and the other provides sole access to his 'drawing room', a space that provides rare but regular solitude, and allows an activity parallel to his sculptural work that since the very beginning has been a crucial and necessary part of his practice. 'A day passed without drawing is a day lost.'[2] Drawing is, for Gormley, 'a completely different activity to sculpture … a seedbed out of which ideas come'.[3] Like sculpture, it is a physical activity, but in another register. It can involve his whole body, often both arms at once, in moves and marks that are intuitive and unguided, fluent and rapid. On occasion the figure may appear as an image on the paper, but more often the body is present only as the generator of a physical process with a physical result; it is 'not so much seen from the outside as felt from the inside'.[4] Drawing is a release, affording him freedom to think. Or, as he says, 'Drawing is an attempt to fix the world, not as it is, but as it exists inside me … Drawing is not so much a mirror, or a window, as a lens which can be looked at in either direction, either back towards the retina of the mind, or forward towards space.'[5] *Mind & Body* is the title of one of his drawings from the 1980s. Another is *In & Beyond*.

Gormley's titles play with words and meanings. The words he uses may be those that described the world created by the First Maker in the Book of Genesis – *Earth, Form, Void, Darkness, Light, Night, Day, Firmament, Fruit, Seed, Host, Field* – or those that define the nature of the universe in Quantum field theory, chemistry or astrophysics – *Domain, Event Horizon, Trajectory Field, Critical Mass, Singularity* … There is a kind of all-encompassing sense, a completeness and totality about these titles. In them, everything flows, and everything connects. They embrace the space and place of all existence: *Home and the World, Creating the World, Fruits of the Earth, Earth Above Ground*. His single-word titles favour words that stand as both verb and noun, words of doing and being: *Mould, Fold, Keep, Press, Sense,*

SYSTOLE/DIASTOLE 2008 [116]
Carbon and casein
on paper
77 x 111

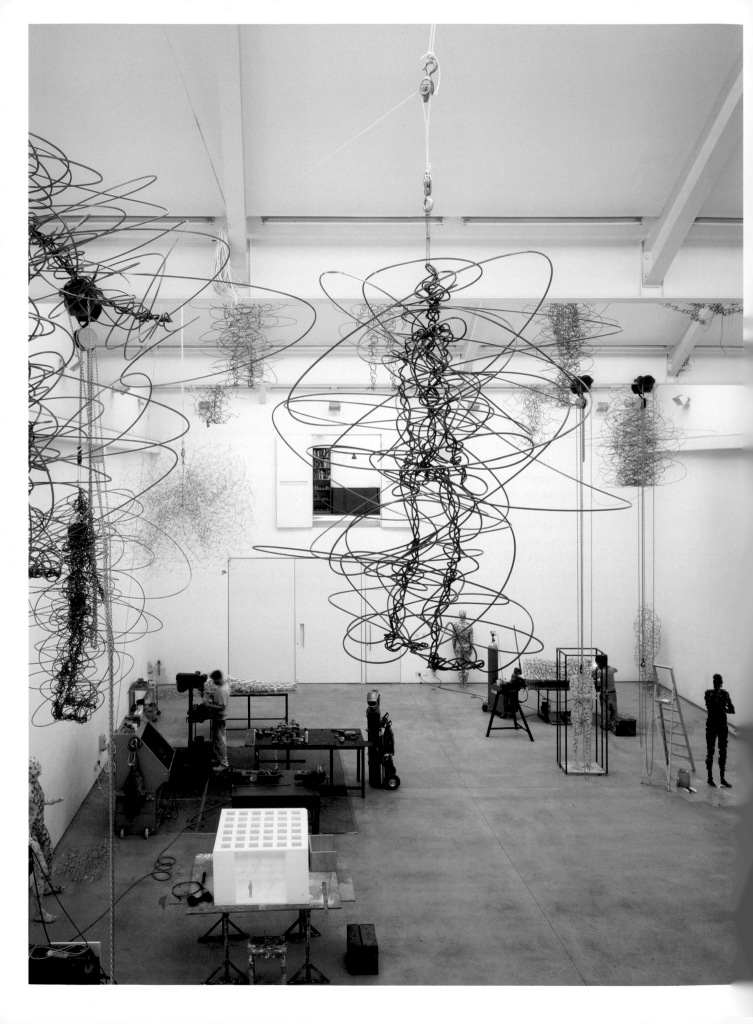

Witness, Scale, Draw, Fall, Pier, View, Test, Object. His two-word titles also propose dualities: oxymorons – *Still Falling, Still Running, Drawn Apart, Blind Light* – and polarities – *Night and Day, Form and Content, Mind and Body. Seeing and Believing.*

Gormley has described his sculpture *Seeing and Believing* 1988 (fig.118) as 'a meditation on sculpture as a mind / body process: the gestation of the imagination'.[6] It is a classic work of its period: a lead body-case, a standing figure, rigidly symmetrical, with arms extended in an open gesture, facing us with – a question, a choice, a proposition? What demands does it make on our imagination, what does his work ask of us? What is Gormley's appeal?

The word 'appeal', of course, has more than one meaning itself: it is understood most commonly, perhaps, as the *power to attract or interest*; but to 'appeal to' is also *to call upon; to make a demand on the feelings of; to make supplications or earnest request to; to resort for verification or proof to; to remove to a higher court.* An appeal can be *a call to a witness, a calling to account, a challenge …*

Gormley's appeal – in the sense of his *power to attract or interest* – is hardly in doubt. The sheer scale of his endeavour, the ubiquity of the work, its capacity to generate comment and to make waves, is remarkable, and rare in the world of contemporary art beyond the narrow zone of fashion and celebrity, in which he would fit uneasily and unwillingly. It is the work, not the man, that receives most attention. Success breeds demand, and Gormley's work is much in demand: major projects with budgets in the millions vie with each other for his attention, and hardly a month goes by without an exhibition opening somewhere – in Mexico, the Basque Country, Sweden, Austria, Japan … Some of Gormley's work is small-scale, hand-held, intimate or even hidden. But his dominant notion of sculpture as a thing that stands apart, that is noticed and that has an effect, demands in many cases a certain stature in relation to its environs, an 'occupation' of a site and an authority. Successive projects tend to stand on each other's shoulders, stakes rise and scale increases, naturally: Angels grow bigger, columns taller; Fields and Horizons expand.

It's not just the scale of the work, but the extent of its engagement with his public that is notable, and this achievement can be double-edged. Popular renown comes at a price. References in the press to Gormley as the 'people's artist' can be taken either as high praise or as a mild put-down. Gormley's very success and his prolific output have – as so often – led to charges of 'populism', of repetition, of over-exposure. The 'legibility' of his art, which he accepts as a responsibility of working in the real world before a broad audience can be read, instead, as a tendency to seek the easier, more-travelled route, or a sort of 'ready appeal'. And there are those who view his use of other people, in the creation of his work, as a form of manipulation, of exploitation. While much of the world seeks him out, there is – he would admit – a resistance from some quarters, a sense that his work stands as a challenge to the beliefs and orthodoxies of the avant-garde, its spoken and unspoken codes and conventions. Thirty years ago, he was aware that his outlook, the direction he was taking with his work, was unfashionable, running counter to the prevailing winds. Now, when he is in so many senses an 'established' figure, and vindicated to an extent by the subsequent revival of interest in the body as a vehicle for artistic expression, Gormley still feels himself 'unintegrated' into the story of contemporary art as written by the mainstream museums, the curators and critics, taste-makers and

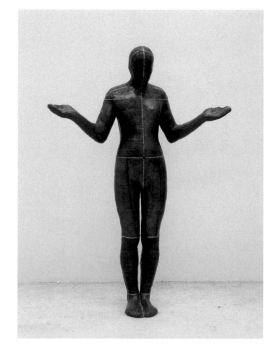

tudio view 2006 [117]

EEING AND BELIEVING 1988 [118]
ead, fibreglass, plaster
2 x 155 x 38

validators. While the notion of a brotherhood of artists has always appealed to him and so much of his work has been to do with interaction and collective behaviour, while he refers often to the origins of art in tribal production, he still, in some ways, ploughs a lonely furrow. 'I'm alone in this game,' he stated in 2000.[7] This may seem an irony or an inevitability, depending on one's view of the state of contemporary art in an anthropological sense. The staking out of unique territory, the establishment of a 'brand', has risen high as a factor in the validation of the contemporary artist, and there is a sense of the need to play by the rules of obligatory transgression. All of which seems, to Gormley, narrow, confining, short-circuited. The individuality Gormley is interested in emerges, as he puts it, 'out of deep relationalism'.[8]

On occasion he has been forced to consider his work in the longer tradition of wayward English 'eccentricity' (William Blake, Jacob Epstein, Stanley Spencer, Francis Bacon); in general his location of his own interests and inspirations, and his own appeal to artists and art of the past – his search for a 'lineage'– has been broad-based, anything but nationally bounded, reaching beyond his contemporaries and recent predecessors, beyond traditions and schools, in search of affinities of spirit and outlook, an equivalent 'sense of purpose'. He might recognise these affinities in the work of Richard Serra, Constantin Brancusi or Henri Gaudier-Breszka, in Rodin, or in the unnamed sculptors of ancient Egypt or India. Such a range of association extends beyond the field of art itself – at least as defined by current convention. Confronting the human condition in its broadest sense, and claiming this as the proper ambition of art from its origins, he has appealed to and won the attention of commentators from almost every field and perspective.

Some, such as Ernst Gombrich and Stephen Bann, have sought to set his work in conventionally art historical contexts, albeit broad ones; others have approached it in terms ranging from the anthropological (Stephen Levinson, Hugh Brody) and the archaeological (Colin Renfrew, Rod Mengham) to the sociological (Richard Sennett), the phenomenological (Anthony Vidler, W.J.T. Mitchell), the neurological (Antonio Damasio) and the spiritual (Thomas McEvilley).[9]

If Gormley's art appeals broadly and in a broad range of contexts, the fundamental questions it asks – What is art? Who is it for? How is value attached to it? – are, broadly speaking, anthropological. Gormley's appeal is, first and foremost, a *call upon* the individual, the person in the body, and upon the collective, the social world in which the individual locates him or herself. His repeated belief in the body as the 'collective subjective', the place or site in which each of us recognises our own nature and our place within the wider world, defines his position and his singularity as an artist. It's a belief that presumes an inclusivity, a fundamental sameness of human experience which is on one level undeniable – we all inhabit a body, feel and see the world, aspire, believe, connect, live and die – and on another is hotly contested. Human experience is wildly different depending on where and when we live, our state and estate, our calling, beliefs, race and gender. To assert, and to call on us to recognise, our inherent sameness is, perhaps, both the simplest of appeals and the most difficult. It is, put simply, the 'wager of the work', the effect by which it stands or falls: the *demand on the feelings* of us, the viewers.

Gormley's faith in the work's ability to engender a bodily, emotional empathetic effect, to allow us to 'feel what he feels', underpins his art. Only in retrospect has he allowed his own doubt: in a recent interview he

conceded the possibility that his lead body-case sculptures of the 1980s 'depended on a notion of empathy that I had no right to expect', and thus failed in their effect.[10] And he has, rather predictably, been challenged on occasion by those who assert that the tall (still young-looking) male figure represented by those works is not one whose bodily experience they can readily share. It's a challenge he resists; the recognition he aims to prompt is to do with consciousness, not physical equivalence or identification. It is recognition of something in ourselves, of where we are, of how we relate to others. It might be understood as a recognition of the work's vulnerability, or evocation of vulnerability; or, conversely, an awareness of its permanence, of the way it stands apart from us and endures – as, self-evidently, all the sculpture we know from past ages has done.

Important shifts in the trajectory of Gormley's work have, more than once, moved the encounter, and the 'appeal', from confrontation – the viewer faced by his (or her) sculptural double – towards participation and actual physical involvement, a direct appeal to engage. It happened with *Field*, with *Allotment* and *Domain Field*, all of which co-opted the bodies and actions of others in the shaping of the work; and, somewhat differently, with the 'immersive' experiences afforded by *Clearing*, *Blind Light*, *Breathing Room* and *Hatch*, which require of the viewer an entrance into the space of the work and a physical engagement with it. The most recent experiments, such as *Clay and the Collective Body* and *One And Other,* have seen the artist setting the terms, establishing the conditions and the context of the work and then standing back, leaving centre stage to his audience who then become the players. Appearing on the video that invited the public's participation in *One & Other,* seeking temporary occupants for the Fourth Plinth in Trafalgar Square, Gormley concludes: 'Without your participation we are nowhere ... I've got an idea: You can make it real.'[11]

And what of appeal in the sense of *removal to a higher court*? Gormley's art, though political in the way that all art set in the social realm is political, subscribes to no particular doctrine. And though he may appear on occasion to borrow the language or strike the attitudes of recognised belief systems, he is adamant that his work is not religious; he resists the comforts (or dangers) of 'revelation truths'. I don't have the answers, he says; he is wary of the pointed attack or the specific target, and he proposes no particular path to redemption. But there is, nevertheless, a sense of *supplication* in the works. They do ask questions, and he is often ready to interpret for us what those questions may be, to articulate the 'mute appeal' of his figures, their *challenge*. They raise, he insists, the issues that art has always addressed: our relation to the earth, 'our survival, our fear of death and hopes for the continuance of life in a hostile natural environment'.[12] Of the figures in *Another Place*, he offered, in a newspaper interview: 'They are asking questions ... The underlying questions they ask are about whether humans can carry on living the way we are without destroying ourselves and the planet.'[13] That the environment itself is most at threat in the twenty-first century, with more than fifty per cent of the population boxed and surveyed in urban masses, the planet topped and tailed by melting ice caps and encircled by a gathering and potentially explosive orbit of obsolete space hardware is, of course, an inescapable and intrusive fact. And yet the work refuses to abandon hope, believing that in acting to force a recognition in us of our condition, our predicament, it can continue to do what art does and should do: to redeem, to heal.

To engage. It's a big belief, in the twenty-first century, and one that much current art shuns in favour of the smaller frame, the safer terrain, the comfort of convention … It carries with it dangers, for expressions of belief, of whatever kind, can all too easily prompt a counter-response of disavowal. Gormley's appeal, nevertheless, is always to people, to individual experience and joint endeavour, to a 'sharedness', to communication and connection. He seeks common ground.

To ask 'can art be everyone's?' as Gormley does[14], or to assert that we are all makers, is to invoke a recurrent call in modern and contemporary art, issued perhaps most loudly and famously by Joseph Beuys. 'Every human being is an artist,' proclaimed Beuys, advancing his radical and expansive notion of modern art as social sculpture/ social architecture in 1973.[15] Beuys's stance, bolstered by the personal heroic mythology he built up around him, was to become a defining force in late twentieth-century avant-garde art. His understanding of art as 'anthropological', his belief in the transformative nature of art and its therapeutic value, have an obvious resonance here. Beuys's embrace of mysticism and primitivism, his cultivation of the role of artist as shaman or healer, contributed to his cult following, but also continue to divide critical opinion on the artist long after his death. His art was one with his personality, his actions, his performance. The critic Donald Kuspit, acknowledging all this, situates him 'between Showman and Shaman', and asserts: 'He became a showman to further his shamanistic goal.'[16] Gormley might find much in common with many of Beuys's attitudes, particularly his belief in the transformative and healing potential of art, but he resists the notion of the artist as showman or performer, as a purveyor of illusion. 'I think I'm a sculptor … I think I deal with stuff. I get fed up dealing with illusion,' he said in 1994.[17] Gormley remains a maker of things, and – despite his readiness to provide interpretations – wary of placing himself between the work he makes and its audience. For him the greatest value of art is not its advance of a position but its provision of an experience, through which we come to recognise better our own position, our predicament and our potential. Still, to set the terms for a direct, open, intimate and personal engagement – a transformative experience – between work and viewer is not always easy. 'We live in an age in which art aspires to the condition of cinema, and wants to be a show, an event,' said Gormley in an interview in 2002.[18] His tone was critical at the time, but even he may have succumbed on occasion. *One & Other* 2009, a 'snapshot of Britain', was also a global media event playing out in real time, from Trafalgar Square to Australia, where the 'form' of the work was as much the live video-streaming as the solitary figure, up on the plinth, alone and together with the world. Gormley's arrival at this point, even before the event of the work itself, left him musing as to whether he had led himself once again to the brink of something different, and new.

Such moments of apparently radical change have punctuated the development of Gormley's work over almost four decades. And they have come about despite – or maybe *because of* – the insistent and logical continuities of thought that underlie his practice and manifest his surprisingly consistent world view. Equally, the 'newness', the frequent moves into unfamiliar territory, arise less from a self-conscious urge to innovate (in the modernist avant-garde sense) than from an adherence to the values and potentialities he recognises in art across time, and his need to re-explore and re-assert them.

In the late 1970s – when Gormley was just starting out – the American art critic and theorist Rosalind Krauss wrote of radical developments in sculpture in America in the late 60s and 70s which appeared to call for a new understanding of the medium, its aims and conventions, which took sculpture far beyond the traditional 'logic of the monument', in which it was figurative and vertical, with a fixed relation to its site. Regarding the work of the – mainly minimalist – artists of her time, she wrote of 'sculpture in the expanded field', employing a 'new syntax'. Krauss saw this work as a radical break from the dominant sculpture that immediately preceded it. She asserted its continuity, instead, with the work of Rodin and Brancusi at the beginning of the century. These earlier sculptors, she argued, working with the figure, had detached the outward appearance of the body from its inner structure, relocating meaning from the body's inner core to its surface. *'The sculpture of our own time'*, she wrote, *'continues this project of decentering through a vocabulary of form that is radically abstract. The abstractness of minimalism makes it less easy to recognise the human body in those works and to project ourselves into the space of that sculpture . . . yet our bodies and our experience of our bodies continue to be the subject of this sculpture...'*[19]

Of Michael Heizer's *Double Negative* 1969, for example, (the massive earthwork which Gormley searched for in vain in the Nevada desert in 1979) Krauss wrote: *'Because of its enormous size, and its location, the only means of experiencing this work is to be in it – to inhabit it in the way we think of ourselves as inhabiting our bodies. Yet the image we have of our own relation to our bodies is that we are centred inside them ...'*[20] Unlike the viewer's occupancy of this desert earthwork, our occupation of our bodies allows us 'complete knowledge of ourselves', or 'transparency to our own consciousness', as Krauss puts it.

Throughout his career Gormley has drawn on this complete knowledge and transparency: it is a fundamental of his work and its effect. Accepting from the start the view that sculpture, with and after modernism, was profoundly and irrevocably changed, and himself profoundly affected by much of the work that Krauss analysed, from Brancusi and Rodin on to Heizer, Robert Morris, Bruce Naumann and Richard Serra in the 60s and 70s, Gormley has consistently explored this terrain that forces (in Krauss's words) the intervention of the outside world into the body's internal being .'[21] Acknowledging that sculpture now operates in an expanded field, he continues to seek ways of locating that expansion beyond the formal and conceptual concerns of the avant-garde which held sway when he started.

So what does it mean to regard Gormley's output over four decades as a 'body of work'? It may seem an irony, given the high public profile and physical presence of so many of his works, but the heart of Gormley's project lies less in the artworks as material objects than in their proposition, in the action of the work, its appeal and its effect. Gormley's ongoing quest is to locate and to open up new spaces for sculpture and for art, and to expand the ways in which it is regarded and enacted, the ways in which it is made to work with and for us.

INSIDE AUSTRALIA 2003 [120]
Cast alloy of iron, molybdenum, iridium, vanadium and titanium
51 elements based on 51 inhabitants of Menzies, Western Australia
Commission for 50th Perth International Arts Festival, Western Australia 2003
Permanent installation, Lake Ballard

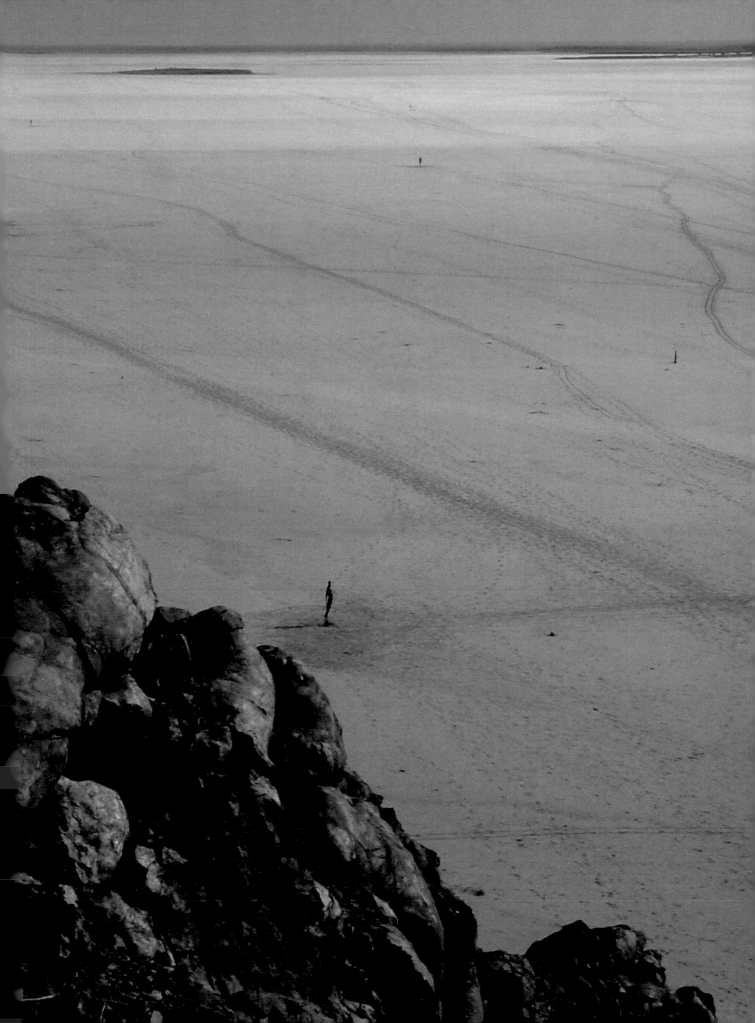

Notes

1 Gormley in introduction to M. Mack (ed.), *Antony Gormley*, Göttingen 2007, p.9.

2 Gormley in 'Antony Gormley talking to Paul Kopecek', *Aspects*, no.25, Newcastle, Jan. 1984.

3 *Antony Gormley: Making Space*, film, directed by Beeban Kidron, 2007.

4 Gormley, interview with Declan McGonagle, in *Antony Gormley*, exh. cat., Malmö Konsthall, Sweden; Tate Gallery, Liverpool; Irish Museum of Modern Art, Dublin; London 1993, p.41.

5 Interview with Philip Dodd, *Nightwaves*, BBC Radio 3, May 2007.

6 Kidron 2007.

7 Gormley, 'Talking with Adrian Searle', in *Antony Gormley: Making Space*, exh. cat., Baltic Centre for Contemporary Art, Gateshead 2004, p.133.

8 Gormley in *Gormley/Theweleit*, exh. cat., Kunsthalle zu Kiel and Cuxhavener Kunstverein, Germany 1999, p.51.

9 Ibid.

10 Gormley, interview with Sui Jianguo, in *Asian Field*, exh. cat., British Council, London 2003, p.202.

11 Conversation with the author, 7 May 2009.

12 Ibid., 27 June 2008.

13 Gormley, from a discussion with Colin Renfrew, British Museum, 29 Nov. 2002; published in Neil Brodie and Catherine Hills (eds.), *Material Engagements: Studies in Honour of Colin Renfrew*, Cambridge 2004, p.28.

14 The first phrase is Lynne Cooke, 'Between Image and Object: The "New British Sculpture"', in *A Quiet Revolution: British Sculpture since 1965*, exh. cat., Museum of Contemporary Art, Chicago 1987, pp.34–53; the second is Stuart Morgan, 'A Rhetoric of Silence: Redefinitions of Sculpture in the 60s and 70s', in *British Sculpture in the Twentieth Century*, exh. cat., Whitechapel Art Gallery, London 1981, p.197.

15 William Tucker, *The Condition of Sculpture*, exh. cat., Hayward Gallery, London 1975, p.6.

16 Flanagan, 'A letter and some submissions', *Silence*, no.6, Jan. 1965; quoted in *British Sculpture in the Twentieth Century* 1981, p.201.

17 Gormley in *Asian Field* 2003, p.203.

18 Gormley, unpublished lecture, Arnolfini Gallery, Bristol 1981.

19 Ibid.

20 Ibid.

21 Quoted in Rosalind E. Krauss, *Passages in Modern Sculpture*, New York 1977, p.276.

22 Conversation with the author, 27 June 2008.

23 Gormley, unpublished lecture, Arnolfini 1981.

24 From an unpublished conversation with Vicken Parsons, quoted in Lynne Cooke, *Antony Gormley*, exh. cat., Salvatore Ala Gallery, Milan and New York, 1984, p.xii.

25 From an interview with Antony Gormley on art in collective space, in Jan Inge Reilstad (ed.), *Broken Column*, Stavanger, Norway, 2004, p.240.

26 *Asian Field* 2003, p.204.

27 *Objects and Sculpture*, exh. cat., Institute of Contemporary Arts (ICA), London, and Arnolfini Gallery, Bristol, 1981, p.5.

28 John Roberts, 'Objects and Sculpture', *Artscribe*, no.30, August 1981, p.50.

29 Interview with Iwona Blazwick, in *Antony Gormley: Some of the Facts*, exh. cat., Tate St Ives, Cornwall 2001, p.135.

30 Gormley, unpublished lecture, Arnolfini 1981.

31 Gormley in *Objects and Sculpture* 1981, p.18.

32 Gormley, interview with Sandy Nairne, in *Antony Gormley*, exh. cat., Städtische Galerie Regensburg and Frankfurter Kunstverein 1985, p.48.

33 Gormley, interview with Udo Kittelman, in *Antony Gormley: Total Strangers*, exh. cat., Kölnischer Kunstverein, Cologne 1999, p.21.

34 Gormley in Mack 2007, p.81.

35 In essay by Yehuda Safran, *Antony Gormley: Learning to See*, exh. cat., Galerie Thaddaeus Ropac Gallery, Paris and Salzburg 1993, pp.33–5.

36 Gormley in Mack 2007. p.81.

37 Conversation with the author, 8 Sept. 2008.

38 Gormley in Kopecek, *Aspects*, 1984.

39 Ibid.

40 'Notes by the Artist: Oct. 1985', in *Antony Gormley*, exh. cat., Serpentine Gallery, London 1987, unpag.

41 Quoted in Lewis Biggs, 'Learning to See: an Introduction', in *Antony Gormley* 1993, p.22. Biggs notes the influence here on the artist of Rainer Maria Rilke's writings on Rodin.

42 Gormley, in Mina Roustanyi, 'An interview with Antony Gormley', *Arts Magazine*, Sept. 1987, p.21.

43 Conversation with the author, 8 Sept. 2008.

44 Timothy Hyman, 'Figurative Sculpture since 1960', in *British Sculpture in the Twentieth Century* 1981, p.185.

45 'A Prefatory Note by Paul Tillich', in Peter Selz (ed.), *New Images of Man*, exh. cat., Museum of Modern Art, New York 1959, pp.9–10.

46 Gormley, interview with E.H. Gombrich, in John Hutchinson *et al.*, *Antony Gormley*, London 2000, p.10.

47 Gormley, interview with Declan McGonagle, in *Antony Gormley* 1993, p.50.

48 Ibid.

49 Gormley, interview with Sandy Nairne, 25 July 1984, quoted in *Antony Gormley* 1985, p.50.

50 Gormley in Illuminations (ed.), *Art Now: Interviews with Modern Artists*, London and New York 2002, p.11.

51 Gormley, interview with Edek Bartz, in *Antony Gormley: Critical Mass*, exh. cat., StadtRaum Remise, Vienna 1995, p.159.

52 Gormley in Sandy Nairne, *State of the Art: Ideas and Images in the 1980s*, London 1987, p.104.

53 Gormley, interview with Sui Jianguo, in *Asian Field* 2003, p.209.

54 Gormley, interview with E.H. Gombrich, in Hutchinson *et al.* 2000, p.18

55 Daniel Birnbaum, 'Remembering the Future: On Antony Gormley', in *Antony Gormley: Still Moving: Works 1975–96*, exh. cat., Museum of Modern Art, Kamakura, Japan 1996.

56 Bruce Nauman, quoted in Marcia Tucker and Jane Livingston, *Bruce Nauman: Work from 1965–72*, exh. cat., Los Angeles County Museum of Art, Los Angeles 1972, p.35.

57 Gormley, interview with Udo Kittelman, in *Antony Gormley: Total Strangers* 1999, p.24.

58 *Antony Gormley: Total Strangers* 1999, p.22

59 Gormley, in 'Field Activities: A Conversation between Antony Gormley, Ralph Rugoff and Jacky Klein', in *Antony Gormley: Blind Light*, exh. cat., Hayward Gallery, London 2007, p.51.

60 Gormley, lecture at Moderna Galerija, Ljubljana, 22 March 1994 , transcribed in *M'ars*, Ljubljana, vol.3.4, 1994.

61 Gormley, www.antonygormley.com, 9 May 2009.

62 Gormley, interview with Declan McGonagle, in *Antony Gormley* 1993, p.47.

63 Gormley in Illuminations 2002, p.20.

64 Gormley, unpublished lecture, Arnolfini 1981.

65 Conversation with the author, 27 June 2008.

66 Michael Heizer in a brochure for Galerie H, Graz, 1977, cited in Irving Sandler, *American Art of the 1960s*, New York 1988.

67 Conversation with the author, 27 June 2008.

68 Ibid.

69 Gormley, interview with Declan McGonagle, in *Antony Gormley* 1993, p.41.

70 Conversation with the author, 27 June 2008.

71 Gormley, www.antonygormley.com, 9 May 2009.

72 Conversation with the author, 27 June 2008.

73 Gormley, interview with Marjetica Potrč, in *Antony Gormley: European Field*, exh. cat., Moderna Galerija, Ljubljana, Slovenia 1994.

74 Ibid.

75 Rod Mengham, 'Body Count', in *Antony Gormley: Between You and Me*, exh. cat., Kunsthal, Rotterdam; Musée d'Art Moderne, St-Etienne; Artium de Álava, Vitoria-Gasteiz, Spain 2008, p.38.

76 Adrian Searle in *Field for the British Isles*, exh. cat., Hayward Gallery, London 1996, unpag.

77 *Asian Field* was always shown in conjunction with these photographs, by Zhang Haier, many of which are reproduced in *Asian Field* 2003.

78 Gormley in *Asian Field* 2003, p.178.

79 Gormley, interview with Declan McGonagle, in *Antony Gormley* 1993, p.38.

80 Theweleit in *Gormley/Theweleit* 1999, p.97.

81 Gormley, in a discussion with Paolo Herkenhof, Helsinki, 16 April 2009, www.ihmeproductions.

82 Gormley, as reported by Hu Fang, 'Five Days

Out For Life', in *Asian Field* 2003, p.188.

83 Gormley, 'Making Field', in *Field*, exh. cat., Museum of Fine Arts, Montreal 1993, p.30; (previously published in the exhibition guide, 'An installation by Antony Gormley', Corcoran Gallery of Art, Washington 1993).

84 Gormley, interview with Declan McGonagle, in *Antony Gormley* 1993, p.41.

85 Theweleit in *Gormley/Theweleit* 1999, p.27.

86 'Making Field', in *Field* 1993, p.30.

87 Interview with Declan McGonagle, in *Antony Gormley* 1993, p.52.

88 Gormley, 1997, quoted in *Blind Light* exhibition guide, Hayward Gallery, London, 2007, p.5

89 Gormley, interview with Sui Jianguo, in *Asian Field* 2003, p.206.

90 The phrase is Lewis Biggs's, in correspondence with the author, Jan. 2007

91 Gormley, commentary on his work, www.antonygormley.com, accessed 5 May 2009.

92 Gormley, interview with Declan McGonagle, in *Antony Gormley* 1993, p.51.

93 Stephen Bann, 'The Raising of Lazarus', in *Antony Gormley* 1993, pp.63–6.

94 Gormley, interview with Iwona Blazwick, in *Antony Gormley: Some of the Facts* 2001, p.146 .

95 Michael Fried, 'Art and Objecthood', first published in *Artforum*, New York, June 1967; reproduced in Charles Harrison and Paul Wood (eds.), *Art in Theory 1900–1950*, Oxford and Cambridge 1992.

96 Gormley, interview with Declan McGonagle, in *Antony Gormley* 1993, p.40.

97 Mack 2007, p.305.

98 Gormley, interview with Pierre Tillet, in *Antony Gormley: Between You and Me* 2008, p.55

99 Ibid., p.51.

100 Gormley in Mack 2007, p.471.

101 Gormley in *Betong: Miroslaw Balka, Antony Gormley and Anish Kapoor*, exh. cat., Malmö Konsthall, Sweden 1996, pp.60–61.

102 Ibid.

103 Ibid.

104 Gormley, 'Allotment: Interview with Hans Anderson', in Hutchinson *et al.* 2000, p.148.

105 Gormley, interview with Udo Kittelman, in *Antony Gormley: Total Strangers* 1999, p.22.

106 Friedrich Nietzsche, *On the Use and Abuse of History for Life*, 1873

107 Gormley, interview with Iwona Blazwick, in *Antony Gormley: Some of the Facts* 2001, p.152.

108 Gormley in Illuminations 2002, p.18.

109 Gormley in Mack 2007, p.93.

110 Gormley, quoted in Richard Calvocoressi, 'Some Thoughts on the Work of Antony Gormley', in *Antony Gormley* 1985, p.18.

1 In Roustanyi 1987, p.21.

2 Ibid., p.24.

3 Ibid.

4 Gormley in Mack 2007, p.157.

115 Ibid., p.167

116 Conversation with the author, 30 May 2009.

117 Gormley in *theEYE: Antony Gormley*, video, directed by John Wyver, Dec. 2001; www.illuminationsmedia.co.uk

118 Gormley, interview with Pierre Tillet, in *Antony Gormley: Between You and Me* 2008, p.51.

119 Gormley, interview with Kittelman, in *Antony Gormley: Total Strangers* 1999, p.25.

120 Gormley in *Broken Column* 2004, p.14.

121 Gormley in Mack 2007, p.459.

122 Gormley, interview with Philip Dodd, *Nightwaves*, BBC Radio 3, 2007.

123 Gormley, in Roustanyi 1987, p.24.

124 Gormley, quoted by Alistair Sooke, 'Fancy turning yourself into a work of art?', *Daily Telegraph*, 28 Feb. 2009, p.10.

125 Gormley, reproduced in Hutchinson *et al.* 2000, p.158.

126 Gormley in *Gormley/Theweleit* 1999, p.23.

127 John Ruskin, 'The Work of Iron, in Nature, Art and Policy', in *The Two Paths: Collected Essays, Essay v*, first published 1859.

128 Gormley, interview, *Broken Column* 2004, p.232.

129 Gormley, interview with E.H. Gombrich, in Hutchinson *et al.* 2000, p.158.

130 Gormley in Wyver 2001.

131 Gormley, interview with Jane Hart, *Journal of Contemporary Art*, vol.4, no.3, fall 1991.

132 Gormley, 'Drawing on Space', in *Domain Field*, exh. cat., Baltic Centre for Contemporary Art, Gateshead 2003, p.13.

133 Gormley, from a discussion with Colin Renfrew, in Brodie and Hills 2004, p.12.

134 Gormley, unpublished lecture, Arnolfini 1981.

135 Gormley in Mack 2007, p.125.

136 Gormley, 'Making the Expansion Works', in *Antony Gormley: Making Space* 2004, p.182.

137 Gormley, in Illuminations 2002, p.10.

138 Ibid.

139 Gormley, interview with Adrian Searle, in *Antony Gormley: Making Space* 2004, p.134.

140 Gormley, interview with Iwona Blazwick, in *Antony Gormley: Some of the Facts* 2001, p.140.

141 Rene Descartes, from the sixth meditation in *Meditations in First Philosophy*, 1641.

142 Danah Zohar, *The Quantum Self*, New York 1990.

143 Ibid.

144 Gormley, from a discussion with Colin Renfrew, in Brodie and Hills 2004, pp.12–13

145 Alexander Calder, 'What abstract art means to me', *Museum of Modern Art Bulletin*, spring 1951, quoted in Guy Brett, *Force Fields: Phases of the Kinetic*, exh. cat., Hayward Gallery, London 2000, p.11.

146 Gormley, interview with Pierre Tillet, in *Antony Gormley: Between You and Me* 2008, p.59

147 Ibid.

148 Conversation with the author, 7 May 2009.

149 Ibid.

150 Gormley in *Antony Gormley: Blind Light* 2007, p.52.

151 Conversation with the author, 7 May 2009.

152 A collaboration with Tristan Simmonds, then of the Advanced Geometry Unit at Arup, who has continued to work closely with Gormley.

153 Gormley, quoted by Tillet in *Antony Gormley: Between You and Me* 2008, p.62.

154 Gormley in *Antony Gormley: Blind Light* 2007, p.53.

155 Ibid., p.52.

156 Gormley, from his introduction to 'Imagining the City' symposium, South Bank, London, June 2007; recording on www.antonygormley.com.

157 Ibid.

158 Ibid.

Seeing and Believing

1 Gormley, 'The Function of the Artist's Studio', a public discussion at the Courtauld Institute of Art, London, 20 May 2009.

2 Gormley, quoted in the introduction to *Antony Gormley: Acts, States, Times, Perspectives*, exh. cat., Edition Copenhagen, Denmark 2008.

3 Gormley, from a discussion with Colin Renfrew, in Brodie and Hills 2004.

4 Michael Newman, 'Antony Gormley's Drawing', in *Antony Gormley*, exh. cat., Contemporary Art Gallery, Seibu Department Stores, Tokyo 1987.

5 Conversation with the author, 7 May 2009.

6 Gormley, interview with Jorge Molder, in *Antony Gormley: Mass and Empathy*, exh. cat., Fundação Calouste Gulbenkian, Lisbon 2004.

7 Gormley in *Omnibus: The Naked Sculptor*, television programme, directed by Adrian Sibley, 2000.

8 Gormley, interview with Philip Dodd, *Nightwaves*, BBC Radio 3 May 2007.

9 See bibliography for references to these writers.

10 Gormley, interview with Hans Ulrich Obrist, in *Antony Gormley*, exh. cat., Museo de Arte Contemporáneo de Monterrey, Mexico 2008.

11 Gormley, www.oneandother.co.uk, 7 Jun 2009.

12 Conversation with the author, 7 May 2009

13 Gormley, quoted by Cole Moreton, *Independent* 13 May 2007, p.37.

14 Gormley, interview with Adrian Searle, in *Antony Gormley: Making Space* 2004, p.139.

10 Joseph Beuys, 'I am Searching for a Field Character', first published in English in Caroline Tisdall (ed.), *Art into Society, Society into Art*, London 1974; reproduced in Harrison and Wood 1992, pp.902–4.

16 Kuspit, 'Between Showman and Shaman', in David Thistlewood (ed.), *Joseph Beuys: Diverging Critiques*, Liverpool 1995, p.34.

17 Gormley, interview with Marjetica Potrč, in *Antony Gormley: European Field* 1994.

18 Gormley, interview in Illuminations 2002, p.20.

19 Krauss 1977, p. 279

20 Ibid., p.280

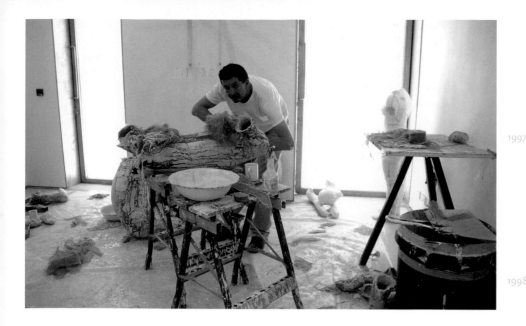

Biography

Selected Solo Exhibitions

Clearing, White Cube, London
Clearing, Galerie Nordenhake, Berlin

2005 *New Works*, Sean Kelly Gallery, New York

2006 *Altered States*, Galleria Mimmo Scognamiglio, Naples
Time Horizon, Parco Archeologico di Scolacium, Roccelletta di Borgia, Catanzaro, Italy
Breathing Room, Galerie Thaddaeus Ropac, Paris
You and Nothing, Galerie Xavier Hufkens, Brussels

2007 *Blind Light*, Hayward Gallery, London
Spacetime, Mimmo Scognamiglio Arte Contemporanea, Milan
Bodies in Space, Georg Kolbe Museum, Berlin
Feeling Material, Deutscher Bundestag Gallery, Berlin
Blind Light, Sean Kelly Gallery, New York

2008 *Acts, States, Times, Perspectives*, Edition Copenhagen
Another Singularity, Galleri Andersson Sandström, Umeå, Sweden
Antony Gormley: Drawings 1981–2001, Galerie Thaddaeus Ropac, Paris
Between You and Me, Kunsthal, Rotterdam, touring to Musée d'Art Moderne de Saint-Etienne Metropole, Saint-Etienne; Artium de Alava, Vitoria-Gasteiz, Spain (2008–9)
Antony Gormley, Museo de Arte Contemporàneo de Monterrey, Mexico

2009 *Clay and the Collective Body*, Helsinki (Pro Arte Foundation)
One & Other, Fourth Plinth commission, Trafalgar Square, London
Ataxia II, Galerie Thaddaeus Ropac, Salzburg
Antony Gormley, Kunsthaus Bregenz, Austria
Domain Field, Garage Centre for Contemporary Culture, Moscow
Aperture, Galerie Xavier Hufkens, Brussels
Another Singularity, Galleria Continua, Beijing

Selected Group Exhibitions

1981 *Objects and Sculpture*, Institute of Contemporary Arts, London, and Arnolfini, Bristol
British Sculpture in the Twentieth Century, Whitechapel Art Gallery, London

1982 *Figures and Objects: Recent Developments in British Sculpture*, John Hansard Gallery, Southampton
Biennale di Venezia, Aperto section, Venice
Objects and Figures, Fruitmarket Gallery, Edinburgh

1983 *New Art*, Tate Gallery, London
The Sculpture Show, Hayward Gallery and Serpentine Gallery, London

Transformations: New Sculpture from Britain, XVII Bienal de São Paulo and Museu de Arte Moderna, Rio de Janeiro, touring to Museo de Arte Moderno, Mexico City; Fundação Calouste Gulbenkian, Lisbon

1984 *1984: An Exhibition*, Camden Arts Centre, London
An International Survey of Recent Painting and Sculpture, Museum of Modern Art, New York
The British Art Show, Arts Council of Great Britain, touring to Birmingham, Edinburgh, Sheffield, Southampton
Metaphor and/or Symbol: A Perspective on Contemporary Art, National Museum of Modern Art, Tokyo, touring to National Museum of Art, Osaka
Human Interest, Cornerhouse Gallery, Manchester

1985 *Walking and Falling*, Plymouth Arts Centre, touring to Kettle's Yard, Cambridge; Interim Art, London
The British Show, Art Gallery of New South Wales, Sydney, touring to Art Gallery of Western Australia, Perth; Queensland Art Gallery, Brisbane; National Gallery, Wellington

1986 *Prospect '86: Eine Internationale Ausstellung aktueller Kunst*, Frankfurter Kunstverein, Frankfurt
The Generic Figure, Corcoran Gallery of Art, Washington, D.C.

1987 *Avant-Garde in the Eighties*, Los Angeles County Museum of Art
TSWA 3D, City Walls, Derry
The Re-emergent Figure, Storm King Art Center, Mountainville, New York

1988 *The Impossible Self*, Winnipeg Art Gallery touring to Vancouver Art Gallery
Starlit Waters: British Sculpture 1968–88, Tate Gallery, Liverpool
ROSC 88, Guinness Hop Store and Royal Hospital Kilmainham, Dublin

1990 *British Art Now: A Subjective View*, British Council exhibition, Asahi Shimbun, Japan, touring Japan

1991 *Places with a Past: New Site-Specific Art at Charleston's Spoleto Festival*, Charleston, South Carolina
Inheritance and Transformation, Irish Museum of Modern Art, Dublin
Colours of the Earth, British Council, London, touring India and Malaysia

1992 *Arte Amazonas*, Museu de Arte Moderna, Rio de Janeiro, touring to Staatliche Kunsthalle, Berlin (1993); Ludwig Forum, Aachen (1994)

1993 *Recent British Sculpture from the Arts Council Collection*, South Bank Centre, London (National Touring Exhibition)
The Human Factor: Figurative Sculpture Reconsidered, Albuquerque Museum, New Mexico
The Raw and the Cooked: New work in Clay in

Britain, Barbican Art Gallery, London, touring to Museum of Modern Art, Oxford (1994); Glynn Vivian Art Gallery, Swansea (1994); The Shigaraki Ceramic Cultural Park, Japan (1995)
The Body of Drawing: Drawings by Sculptors, South Bank Centre, London, touring to Graves Art Gallery, Sheffield; The Mead Gallery, University of Warwick; Aberdeen Art Gallery; Victoria Art Gallery, Bath (1994); Oriel Mostyn, Llandudno, Wales (1994)

1994 *Sculptors' Drawings from the Weltkunst Collection*, Tate Gallery, London
The Turner Prize 1994, Tate Gallery, London

1995 *Here and Now*, Serpentine Gallery, London
After Hiroshima, Hiroshima City Museum of Contemporary Art
Kwangju Biennale, Seoul, South Korea
New Art in Britain, Muzeum Sztuki, Lodz, Poland

1996 *Un Siècle de Sculpture Anglaise*, Galerie Nationale du Jeu de Paume, Paris
Sculpture in the Close, Jesus College, Cambridge
Betong: Miroslaw Balka, Antony Gormley, Anish Kapoor, Malmö Konsthall

1997 *Bodyworks*, Kettle's Yard, Cambridge
L'Empreinte, Musée National d'Art Moderne, Centre Pompidou, Paris
Material Culture: The Object in British Art of the 1980s and 90s, Hayward Gallery, London
Breaking the Mould: British Art of the 1980s and 1990s, Irish Museum of Modern Art, Dublin

1999 *Reality and Desire*, Fundació Joan Miró, Barcelona
La Casa, Il Corpo, Il Cuore, Museum Moderner Kunst Stiftung Ludwig, Vienna

2000 *Between Cinema and a Hard Place*, Tate Modern, London

2003 BEAUFORT 2003, De Panne Beach, Belgium [*Another Place*]

2004 *A Secret History of Clay: From Gauguin to Gormley*, Tate Liverpool
From Moore to Hirst: Sixty Years of British Sculpture, National Museum of Art of Romania, Bucharest

2006 *Zones of Contact: 15th Biennale of Sydney*, Pier 2/3, Walsh Bay [*Asian Field*]

2007 *Turner Prize: A Retrospective 1984–2006*, Tate Britain, London

2008 *Genesis – The Art of Creation*, Zentrum Paul Klee, Bern
Kivik Art 08: Antony Gormley and David Chipperfield, Kivik Art Centre, Sweden
Statuephilia: Contemporary Sculptors at the British Museum, British Museum, London

2009 *Sculpture in the Close 2009: Caro, Gormley, Kiefer*, Jesus College, Cambridge
Summer Exhibition 2009, The Royal Academy of Art, London

Selected Books and Articles

1981 *Objects and Sculpture*, exh. cat., Institute of Contemporary Arts, London, and Arnolfini, Bristol; texts by Lewis Biggs, Iwona Blazwick and Sandy Nairne

1983 *Transformations: New Sculpture from Britain*, exh. cat., Bienal de São Paulo; text by Stuart Morgan

1984 'Antony Gormley talking to Paul Kopecek', *Aspects*, no. 25, Newcastle, Jan.
Antony Gormley, exh. cat., Salvatore Ala Gallery, New York; text by Lynne Cooke

1985 *Antony Gormley*, exh. cat., Städtische Galerie Regensburg and Frankfurter Kunstverein; texts by Veit Loers and Sandy Nairne
The British Show, exh. cat., Art Gallery of New South Wales, Sydney; text by Sandy Nairne

1987 Mina Roustayi, 'An Interview with Antony Gormley', *Arts Magazine*, New York, Sept.
Sandy Nairne, *State of the Art: Ideas and Images in the 1980s*, London; in collaboration with Geoff Dunlop and John Wyver

1989 *A Field for the Art Gallery of New South Wales / A Room for the Great Australian Desert*, exh. cat., Art Gallery of New South Wales, Sydney; texts by Anthony Bond and Antony Gormley
Antony Gormley, exh. cat., Louisiana Museum of Modern Art; texts by Richard Calvocoressi and Oystein Hjort

1991 *Antony Gormley: Field and other Figures*, exh. cat., Modern Art Museum of Fort Worth, Texas; texts by Richard Calvocoressi, Antony Gormley and Thomas McEvilley

1993 *Antony Gormley*, exh. cat., Malmö Konsthall, Malmö; Tate Gallery, Liverpool; Irish Museum of Modern Art, Dublin; pub. London 1993; texts by Stephen Bann and Lewis Biggs; interview with Gormley by Declan McGonagle
Learning to See, exh. cat., Galerie Thaddaeus Ropac, Paris/Salzburg; text by Yehuda Safran; interview with Gormley by Roger Bevan

1994 *Field for the British Isles*, exh. cat., Arts Council Collection, Oriel Mostyn, Llandudno; touring the UK 1994–5; texts by Lewis Biggs, Caoimhín Mac Giolla Léith and Marjetica Potrč

1996 *Antony Gormley: Still Moving: Works 1975–96*, exh. cat., Japan Association of Art Museums, Tokyo; texts by Stephen Bann, Daniel Birnbaum, Antony Gormley, Tadayasu Sakai and Kazuo Yamawaki
Betong: Miroslaw Balka, Antony Gormley, Anish Kapoor, exh. cat., Malmö Konsthall, Malmö; introduction by Sune Nordgren; texts by Daniel Birnbaum, Antony Gormley and Ola Wedebrunn

1998 *Making an Angel*, London; texts by Gail-Nina Anderson, Stephanie Brown, Beatrix Campbell, Neil Carstairs, Antony Gormley and Iain Sinclair

1999 *Gormley/Theweleit: Host, Field, Another Place: A Conversation with Klaus Theweleit and Monika Theweleit-Kubale*, exh. cat., Kunsthalle zu Kiel (Host, Field) and Cuxhavener Kunstverein (Another Place), Germany
Antony Gormley: Total Strangers, exh. cat., Kölnischer Kunstverein, Cologne; texts by Antje von Graevenitz and Ingrid Mehmel; interview with Gormley by Udo Kittelman

2000 John Hutchinson et al., *Antony Gormley*, London (revised edition; first published 1995); E.H. Gombrich in conversation with Antony Gormley; texts by Antony Gormley, John Hutchinson, and Lela B. Njatin; additional text by W.J.T. Mitchell

2001 *Antony Gormley: Some of the Facts*, exh. cat., Tate St Ives, Cornwall; interview with Gormley by Iwona Blazwick; texts by Stephen C. Levinson and Will Self

2002 *Antony Gormley*, exh. cat., Centro Galego de Arte Contemporáneo, Santiago de Compostela; texts by Lisa Jardine and Michael Tarantino, interview with Gormley by Enrique Juncosa
Antony Gormley: Workbooks I 1977–92, Centro Galego de Arte Contemporaneo, Santiago de Compostela; artist's book with text and drawings by Gormley
Illuminations (ed.), *Art Now: Interviews with Modern Artists*, London and New York; text by Sandy Nairne, interview (2001) with Gormley by John Wyver
Antony Gormley Drawing, exh. cat., British Museum, London; text by Anna Moszynska

2003 *Asian Field*, exh. cat., British Council, London, touring in China, Japan and Singapore; texts by Hu Fang and Richard Noble; interview with Gormley by Sui Jianguo
Domain Field, exh. cat., Baltic Centre for Contemporary Art, Gateshead; text by Darian Leader

2004 *Antony Gormley: Making Space*, exh. cat., Baltic Centre for Contemporary Art, Gateshead; texts by Darian Leader, Andrew Renton and Richard Sennett; interview with Gormley by Adrian Searle
Antony Gormley: Mass and Empathy, exh. cat., Fundação Calouste Gulbenkian, Lisbon; texts by Paulo Herkenhoff and Maria Filomena Molder; interview with Gormley by Jorge Molder
Broken Column, Jan Inge Reilstad (ed.), exh. cat. Stavanger, Norway; texts by Stephen Bann, Trond Borgen, Kjartan Fløgstad and Siri Meyer
Neil Brodie and Catherine Hill (eds.), *Material Engagements: Studies in Honour of Colin Renfrew* with a discussion between Antony Gormley and Colin Renfrew: 'A Meeting of Minds: Art and Archaeology' (held at the British Museum, London, 29 Nov. 2002)

2005 *Antony Gormley: Inside Australia*, London; texts by Anthony Bond, Hugh Brody, Shelagh Magadza and Finn Pederson

2006 *Antony Gormley: Breathing Room*, exh. cat., Galerie Thaddaeus Ropac, Paris; texts by Michael Doser, Catherine Ferbos-Nakov, Antony Gormley, Ann Hindry, Marc Hindry, Paolo Molaro and David Quéré
Burning Ice: Art and Climate Change, Cape Farewell Project, London; texts by David Buckland, Peter Clegg, Ian McEwen, Rachel Whiteread et al.

2007 M. Mack (ed.), *Antony Gormley*, Göttingen; texts by Richard Noble and Antony Gormley
Antony Gormley: Blind Light, exh. cat., Hayward Gallery, London, 2007; texts by W.J.T. Mitchell, Susan Stewart and Anthony Vidler; conversation between Antony Gormley, Jacky Klein and Ralph Rugoff
F. David Peat, 'The Inner Darkness of the Body: An Interview with Antony Gormley', in *The Pari Dialogues: Essays in Science, Religion, Society and the Arts*, Pari, Grosseto, Italy, vol.1, July

2008 *Antony Gormley*, exh. cat., Monterrey, Mexico; texts by Jorge Contreras and Mark Cousins; interview with Gormley by Hans Ulrich Obrist
Antony Gormley: Acts, States, Times, Perspectives, exh. cat., Edition Copenhagen; text by Poul Erik Tøjner
Antony Gormley: Between You and Me, exh. cat., Kunsthal Rotterdam; Musée d'Art Moderne de Saint-Etienne Metropole; Artium de Alava, Vitoria-Gasteiz, Spain; pub. Rotterdam; texts by Fernando Huici March and Rod Mengham interview with Gormley by Pierre Tillet

2009 *Antony Gormley*, exh. cat., Kunsthaus Bregenz; texts by Antonio Damasio, Yilmaz Dziewior and Markus Steinweg
Antony Gormley: Ataxia II, exh. cat., Galerie Thaddaeus Ropac, Paris/Salzburg; text by Rod Mengham

Works In Public Collections

Cambridge, Jesus College
Edinburgh, Scottish National Gallery of Modern Ar
Leeds, City Art Gallery
London, Arts Council Collection; British Council; British Museum; Science Museum; Tate; V&A
Manchester, Manchester Art Gallery
Oxford, Ashmolean Museum
Perry Green, Herts., Henry Moore Foundation
Peterborough Sculpture Trust
Southampton, City Art Gallery
Witley, Worcs., Jerwood Foundation

Australia, Melbourne, National Gallery of Victoria; Sydney, Art Gallery of New South Wales
Austria, Vienna, Museum Moderner Kunst Stiftung Ludwig Wein (MUMOK)
Belgium, Brussels, Lhoist Collection
Canada, Montreal, Musée des Beaux-Arts
China, Guangdong, Museum of Art
Denmark, Herning, Kunstmuseum; Humlebaek, Louisiana Museum of Modern Art
Finland, Espoo Art Museum; Saastamoinen Foundation Art Collection
France, Paris, Musée National d'Art Moderne, Centre Pompidou; Rennes, Musée des Beaux-Arts
Germany, Kassel, Neue Museum; Bremen, Kunsthalle; Künzelsau, Museum Würth
Holland, The Hague, Caldic Collection
Ireland, Dublin, Irish Museum of Modern Art
Israel, Jerusalem, Israel Museum
Japan, Fukushima, Iwaki City Art Gallery; Hakone, Open-Air Museum; Hokkaido, Sapporo Sculpture Park; Kirishima Sculpture Park; Nagoya, City Art Museum; Tokyo, City Opera, National Museum of Modern Art; Tokushima Modern Art Museum; Wakayama, Prefectorial Museum
Norway, Oslo, Astrup Fearnley Museet for Moderne Kunst; Museet for Samtidskunst
Portugal, Lisbon, Fundação Calouste Gulbenkian; Sintra, Fundação Berardo
Sweden, Malmö, Konsthall; Stockholm, Moderna Museet; Umeå, Umedalen Sculpture Foundation
Switzerland, Zurich, Weltkunst Foundation
USA, Florida, Marquiles Foundation; Texas, Modern Art Museum of Fort Worth; Los Angeles, Museum of Contemporary Art; Minneapolis, Walker Art Center; San Diego, Museum of Contemporary Art

Works In Public Places

Out of the Dark, Martinsplatz, Kassel, Germany 1987
Sculpture for Derry Walls, Derry, Northern Ireland 1987–2001
Sound II, Winchester Cathedral, Hampshire, UK 1989
Open Space, Place Jean Monnet, Rennes, France 1993
Iron:Man, Victoria Square, Birmingham, UK 1994
Havmann, Mo I Rana, Norway 1995
Clearing III, Tongyoung City, South Korea 1997
Angel of the North, Gateshead, UK 1998
Rhizome II, Expo Parque, Lisbon, Portugal 1998
Quantum Cloud, Greenwich, London, UK 2000
Well, Ministry of Health, Welfare and Sport, The Hague, Holland 2000
Passage, Caumont, Picardy, France 2000
Site of Remembrance, Oslo, Norway 2000
Mind-Body Column, Osaka, Japan 2000
Steht und Fällt, Jakob-Kaiser-Haus, Berlin, Germany 2001
Here and Here, Höganäs, Sweden 2001
Planets, British Library, London, UK 2002
Inside Australia, Lake Ballard, Australia 2002–3
Broken Column, Stavanger, Norway 2003

Another Place, Crosby Beach, Merseyside, UK 2003
Fai Spazio, Prendi Posto, Poggibonsi (part of Arte all'Arte 9), Italy 2004
You, The Roundhouse, London, UK 2007
Resolution, Shoe Lane, London, UK 2007
Another Time XI, Exeter College, Oxford, UK 2009
Plant, McDonald Institute for Archaeological Research, Cambridge, UK 2009
Architecture for Subjective Experience (with David Chipperfield), Kivik Art Centre, Kivik, Sweden, 2008

For a full biography and exhibitions history please visit www.antonygormley.com

Copyright

Photocredits

Index